Published and Distributed by
RotoVision SA
Route Suisse 9
CH-1295 Mies
Switzerland

RotoVision SA
Sales and Editorial Office
Sheridan House
112/116a Western Road
Hove. BN3 1DD, UK

Tel: +44 (0)1273 72 72 68
Fax: +44 (0)1273 72 72 69
E-mail: sales@rotovision.com
Web: www.rotovision.com

ISBN 2-88046-824-8

Book designed by Struktur Design
Photography by Roger Fawcett-Tang

Originated by Hong Kong
Scanner Arts

Printed and Bound in China by
Midas Printing

Compiled and edited by Roger Fawcett-Tang
Essays by William Owen

Mapping

An illustrated guide to graphic navigational systems

RotoVision

		00	Mapping
001	Half title page		
002	Imprint		
003	Title page		
004	Contents		
005	Contents	00	Introduction
006	Contents		
007	Contents		
008	Chapter divider		
009	Chapter divider		
010	Beyond the horizon _ William Owen		
011	Beyond the horizon _ William Owen	01	Representation and space
012	Beyond the horizon _ William Owen		
013	Beyond the horizon _ William Owen		
014	Chapter divider		
015	Chapter divider		
016	You are here... _ William Owen		
017	You are here... _ William Owen		
018	Willi Kunz Associates _ Information posters		
019	Willi Kunz Associates _ Information posters		
020	Imagination _ The Journey Zone		
021	Imagination _ The Journey Zone		
022	The Kitchen _ USR Records		
023	The Kitchen _ USR Records		
024	Base _ MoMA QNS identity		
025	Base _ MoMA QNS identity		
026	Simon Patterson _ J.P.233 in C.S.O. Blue		
027	Simon Patterson _ The Great Bear		
028	Simon Patterson _ Untitled: 24hrs		
029	Simon Patterson _ Rhodes Reason		
030	Cartlidge Levene _ Christmas Cards 1995/1997		
031	Cartlidge Levene _ Christmas Cards 1998/1999		
032	Fibre _ Cre@teOnline		
033	Fibre _ Cre@teOnline		
034	John Crawford _ Parc de la Villette		
035	John Crawford _ Parc de la Villette		
036	Cartlidge Levene _ Eye advertising		
037	Cartlidge Levene _ Eye advertising		
038	The Kitchen _ Studio floorplan		
039	The Kitchen _ Studio floorplan		
040	Jeremy Johnson _ A visual record of the entire contents of a typecase		
041	Jeremy Johnson _ A visual record of the entire contents of a typecase		
042	John Crawford _ Open Week poster		
043	John Crawford _ Open Week poster		
044	Mark Diaper/Michael Landy _ Breakdown		
045	Mark Diaper/Michael Landy _ Breakdown		
046	sans+baum _ Facts of Life gallery guide		
047	sans+baum _ Facts of Life gallery guide		
048	Cartlidge Levene _ Selfridges Birmingham brochure		
049	Cartlidge Levene _ Selfridges Birmingham brochure		
050	Build _ TRVL.		
051	Build _ TRVL.		
052	Nick Thornton-Jones and Warren Du Preez _ Human mapping		
053	Nick Thornton-Jones and Warren Du Preez _ Human mapping		
054	Sinutype _ AM7/The Sun Years		
055	Sinutype _ AM7/The Sun Years		
056	Sinutype _ AM7/The Sun Years		
057	Sinutype _ AM7/The Sun Years		
058	Sinutype _ AM7/File Exchange		
059	Sinutype _ AM7/File Exchange		
060	Lust _ Lust Map		
061	Lust _ Lust Map		
062	Browns/John Wildgoose _ 0°		
063	Browns/John Wildgoose _ 0°		

02 Inhabitable space

064 Chapter divider
065 Chapter divider
066 The inhabitable map _ William Owen and Fenella Collingridge
067 The inhabitable map _ William Owen and Fenella Collingridge
068 Projekttriangle _ Krypthästhesie
069 Projekttriangle _ Krypthästhesie
070 Lust _ Atelier HSL web site
071 Lust _ Atelier HSL web site
072 Cartlidge Levene _ Process type movie
073 Cartlidge Levene _ Process type movie
074 Tomato Interactive _ Sony Vaio interface
075 Tomato Interactive _ Sony Vaio interface
076 Fibre _ Diesel StyleLab
077 Fibre _ Diesel StyleLab
078 Fibre _ cc2000
079 Fibre _ cc2000
080 Spin _ Tourist
081 Spin _ Tourist
082 sans+baum _ Future Map exhibition
083 sans+baum _ Future Map exhibition
084 Lust _ Open Ateliers 2000
085 Lust _ Open Ateliers 2000
086 Frost Design _ Give & Take
087 Frost Design _ Give & Take
088 Lust _ Risk Perceptions carpet
089 Lust _ Risk Perceptions carpet
090 Peter Anderson _ Cayenne interior
091 Peter Anderson _ Cayenne interior
092 Intégral Ruedi Baur et Associés _ Kalkriese
093 Intégral Ruedi Baur et Associés _ Kalkriese
094 Intégral Ruedi Baur et Associés _ Centre Pompidou
095 Intégral Ruedi Baur et Associés _ Centre Pompidou
096 Peter Anderson _ Poles of Influence
097 Peter Anderson _ Poles of Influence
098 The Kitchen _ Ocean
099 The Kitchen _ Ocean
100 MetaDesign London _ Bristol City signage
101 MetaDesign London _ Bristol City signage
102 North _ Selfridges interior signage
103 North _ Selfridges interior signage
104 Pentagram _ Canary Wharf signage
105 Pentagram _ Canary Wharf signage
106 Pentagram _ Croydon signage
107 Pentagram _ Croydon signage
108 Pentagram _ Stansted Airport signage
109 Pentagram _ Stansted Airport signage
110 Base _ PASS
111 Base _ PASS
112 Farrow Design _ Making the Modern World
113 Farrow Design _ Making the Modern World

		03	Information and space
114	Chapter divider		
115	Chapter divider		
116	Measuring the dataspace _ William Owen		
117	Measuring the dataspace _ William Owen		
118	Lust _ Stad in Vorm		
119	Lust _ Stad in Vorm		
120	Lust _ Fietstocht door Vinex-locaties Den Haag		
121	Lust _ Fietstocht door Vinex-locaties Den Haag		
122	Lust _ Fietstocht door Vinex-locaties Den Haag		
123	Lust _ Fietstocht door Vinex-locaties Den Haag		
124	Sandra Niedersberg _ London Connections		
125	Sandra Niedersberg _ London Connections		
126	Sandra Niedersberg _ London Connections		
127	Sandra Niedersberg _ London Connections		
128	Lust _ I³ Map		
129	Lust _ I³ Map		
130	UNA (London) designers _ Lost and Found exhibit		
131	UNA (London) designers _ Lost and Found exhibit		
132	Lust _ HotelOscarEchoKiloVictorAlphaNovember		
133	Lust _ HotelOscarEchoKiloVictorAlphaNovember		
134	Lust _ HotelOscarEchoKiloVictorAlphaNovember		
135	Lust _ HotelOscarEchoKiloVictorAlphaNovember		
136	Damian Jaques _ The MetaMap		
137	Damian Jaques _ The MetaMap		
138	Lust _ kern DH Map		
139	Lust _ kern DH Map		
140	Lust _ kern DH Map		
141	Lust _ kern DH Map		
142	Sinutype _ AM7/Die Deutsche Flugsicherung Frankfurst/Langen		
143	Sinutype _ AM7/Die Deutsche Flugsicherung Frankfurst/Langen		
144	Jeremy Johnson _ Colours		
145	Jeremy Johnson _ Colours		
146	Hochschule für Gestaltung Schwäbisch Gmünd _ Arbeitssuche im netz		
147	Hochschule für Gestaltung Schwäbisch Gmünd _ Arbeitssuche im netz		
148	Hochschule für Gestaltung Schwäbisch Gmünd _ f.i.n.d.x.		
149	Hochschule für Gestaltung Schwäbisch Gmünd _ f.i.n.d.x.		
150	The Attik _ Ford 24.7		
151	The Attik _ Ford 24.7		

152	Chapter divider
153	Chapter divider
154	I saw a man he wasn't there _ William Owen
155	I saw a man he wasn't there _ William Owen
156	UNA (Amsterdam/London) designers _ 1999/2000 Diary
157	UNA (Amsterdam/London) designers _ 1999/2000 Diary
158	UNA (Amsterdam) designers _ 2001 Diary
159	UNA (Amsterdam) designers _ 2001 Diary
160	UNA (Amsterdam) designers _ 2002 Diary
161	UNA (Amsterdam) designers _ 2002 Diary
162	A.G. Fronzoni _ 365 diary
163	A.G. Fronzoni _ 365 diary
164	Tonne _ Calendar52
165	Tonne _ Calendar52
166	Irwin Glusker _ Phases of the Moon 2000
167	Irwin Glusker _ Phases of the Moon 2000
168	Büro für Gestaltung _ Calendars 1998–2001
169	Büro für Gestaltung _ Calendars 1998–2001
170	Secondary Modern _ Rokeby Venus
171	Secondary Modern _ Rokeby Venus
172	NB: Studio _ Knoll Twenty-First Century Classics
173	NB: Studio _ Knoll Twenty-First Century Classics
174	Proctor and Stevenson _ Calendar 2001
175	Proctor and Stevenson _ Calendar 2001
176	Struktur Design _ 1998 Kalendar
177	Struktur Design _ Seven Days 1999
178	Struktur Design _ Perpetual Kalendar
179	Struktur Design _ Twentyfour Hour Clock
180	Attik _ NoiseFour screen saver
181	Attik _ NoiseFour screen saver
182	Spin _ Twenty-four Hours
183	Spin _ Twenty-four Hours
184	Foundation 33 _ Numerical Time Based Sound Composition
185	Foundation 33 _ Numerical Time Based Sound Composition
186	Cartlidge Levene _ Canal Building
187	Cartlidge Levene _ Canal Building
188	Sagmeister Inc. _ Timeline
189	Sagmeister Inc. _ Timeline
190	Mark Diaper/Tony Oursler _ The Influence Machine
191	Mark Diaper/Tony Oursler _ The Influence Machine
192	Damien Jaques/Quim Gil _ Ceci n'est pas un magazine
193	Damien Jaques/Quim Gil _ Ceci n'est pas un magazine
194	Nina Naegal and A. Kanna _ Time/Emotions
195	Nina Naegal and A. Kanna _ Time/Emotions
196	Jem Finer _ Longplayer
197	Jem Finer _ Longplayer
198	Imagination _ The Talk Zone
199	Imagination _ The Talk Zone
200	Studio Myerscough _ Coexistence exhibition
201	Studio Myerscough _ Coexistence exhibition
202	MetaUnion _ Deutschbritischamerikanische Freundschaft
203	MetaUnion _ Deutschbritischamerikanische Freundschaft
204	Studio Myerscough _ Web Wizards exhibition graphics
205	Studio Myerscough _ Web Wizards exhibition graphics
206	Chapter divider
207	Chapter divider
208	Acknowledgments/credits

04 Time and space

05 Acknowledgments

00_Introduction

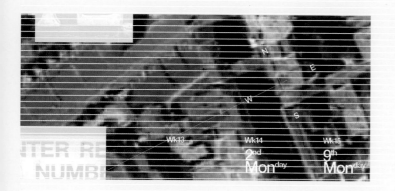

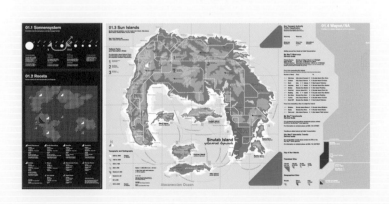

Beyond the horizon

Essay by William Owen

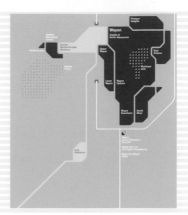

What is a map?
Maps inhabit the realm of fact, although not exclusively. They are figurative representations of dimensions, attributes and relations of things in the physical or logical world, reproduced at a scale smaller than life-size (usually, but not exclusively – sometimes their scale is 1:1 or, when mapping the microcosm, larger).

What can be mapped?
Anything can be mapped, and most things are: places, businesses, galaxies, histories, bodies, philosophies, devices and databases. The subject-matter of a map is measured, named and ordered (captured!) by the mapmaker who, armed with carefully verified data and a language of pictorial description, puts everything in its proper place with its proper name as he or she sees it.

Why make maps?
Maps give their makers the power to define the territory in their terms and write a singular vision onto the landscape. Princes, popes and governments have used maps to exert their rights, extend their trade, tax their subjects and know their enemies. Oil magnates use maps to locate and claim the earth. Newspapers use maps to tell stories of war and peace. Social scientists use maps to publicise social problems. A city resident sketches a map to bring a friend from the station by the shortest or most interesting route – the mapmaker decides.

Anything can be mapped, and most things are: places, businesses, galaxies, histories, bodies, philosophies, devices and databases.

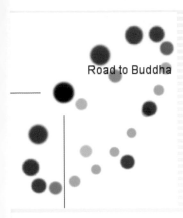

Road to Buddha

Why use maps?

Maps give their readers the simple and magical ability to see beyond the horizon. The enlightening and revelatory characteristic of a good map derives from its encompassing vision, contained within a single consistent pictorial model. The map provides a view that slides instantaneously between panorama and detail. A map embodies the work, knowledge and intelligence of others. We obtain a vision of a place that we may never have seen, or divine a previously unseen pattern in things we thought we knew intimately. So, we 'consult' a map as we would an adviser in order to locate, identify and decide, or to be enlightened. As a result we suffer, sometimes, a grand illusion of omnipotence by believing that the map contains everything necessary for understanding or controlling a domain. We forget that the mapmaker has an implicit or explicit agenda of his own, not necessarily aligned with ours. Maps are imperfect. They have missing layers and gaps within the layers ("London", said its 'biographer' Peter Ackroyd, "is so large, and so diverse, that a thousand different maps or topographies have been drawn up in order to describe it"). Paradoxically, much information can be gathered from the gaps left in maps, not least about the mapmaker's intentions. This is one of the beauties of maps.

Are maps true?

Maps are man-made things and so are neither arbitrary nor pure. They purport to be 'natural' and objective visual representations arising out of scientific observation, and yet the observations are selective and they must be translated and communicated through some graphic form: the scientist (or surveyor) relies on the cartographer's art to illustrate his findings.

What gives maps their power?

Maps are seen by their readers as neutral carriers of information, and thus have the power to persuade without appearing to do so "because the myths they contain are naturalised within a system of 'facts'."[1]

 This naturalness inhabits the language and conventions of maps, which comprises a value-laden semiological system. Maps contain clear hierarchies that influence how we see the world. For example, Ptolemy chose to orient north at the top of the map, and mapmakers have followed his precedent ever since. There is no good reason for this other than convention, but the effect is to create a hierarchy of the earth and the idea that a particular view is 'correct'. This is just one of a system of signs and therefore of values that constitute cartography. The language of cartography is so ingrained that it has become invisible. We do not question the connection between the blue line on the map and the idea of a 'river', or that roads should be anything other than two black parallel lines (of a width apart that almost never conforms to the actual scale of the map). We see the signifier and signified as equivalents, one deriving naturally out of the other. It is quite natural to us that north should always be at the top, a round world transformed into a flat plane, a particular thematic selection made, a certain scale chosen. The cartographer, therefore, has a heavy responsibility to be frank about his choices and their effect on the use and value of the map.

The language of cartography is so ingrained that it has become invisible. We do not question the connection between the blue line on the map and the idea of a 'river', or that roads should be anything other than two black parallel lines.

[1] Denis Wood,
'The Power of Maps',
The Guilford Press,
New York, 1992.

Beyond the horizon

Essay by William Owen
012/013

How do maps work?

Cartography has an arsenal of iconographic, geometric, linguistic and formal conventions with which to mediate source data into pictorial representation. Maps require geometric translations (of a 3D world onto a 2D plane) or transformations (scaling from 1:1 to 1: n), editorial selections (what is shown, what is ignored), and iconographic representation.

Two systems of signs are used predominantly to define attributes and dimensions: firstly icons, which normally define a general attribute or dimensional range (what order of object is this? a city, of between 50-100,000 inhabitants); and secondly text, to describe specific attributes (what name, who are the owners, how old is it, how big?).

There are four further sign systems – metapatterns that occur repeatedly in maps and which define spatial relations and dimensions: the matrix (also known as the chloropleth), which marks boundaries and divisions, where one area becomes another and what lies next to what; the network, which shows systems of flow, such as drainage, communication, navigation; the point, which marks the position of discrete objects within a space, such as settlements, landmarks or buildings; the nested layer, which reveals continuums of equality, as in contour lines marking equal height or isobars marking equal air pressure. Each of these sign systems exists within the context of a fifth, the axes or coordinates of the map, which frame the absolute relations of one point to another and define the limit of the map (and in extremes the edge of the known world).

How far can we stretch the meaning of 'map'?

The metapatterns – matrix, network, point and nest – are adaptable to an infinite range of non-geographic narratives. Activities that have a relation to physical space, such as social or commercial systems, usually adopt a geographical metaphor and are clearly accepted as maps by Western convention, mechanical, electronic or biological systems, such as the human body or electronic circuits, can be represented topologically or topographically. Mapping can be applied to ideas and information, to logical[1] systems of philosophy, religion, science and taxonomy, and even to allegorical or fictional accounts of social and political relations – Jonathan Swift's map of Gulliver's Travels is surely no less 'real' than Ortelius' atlas of the world, although one is merely mimicking the scientific language of the other. We tend, in Western culture, to restrict our definition of maps to faithfully scaled reproductions of linear spatial relations. Islamic and South Indian art pushes metapatterns much further, to create intuitive topological representations of human or physical relations independent of spatial dimensions. Such constructs are, potentially, a richly-layered, non-linear, multi-perspective communication model for the networked digital society, and they are no less maps.

[1] Logic in the Hegelian sense, as the fundamental science of thought and its categories including metaphysics or ontology.

Cartography has an arsenal of iconographic, geometric, linguistic and formal conventions with which to mediate source data into pictorial representation.

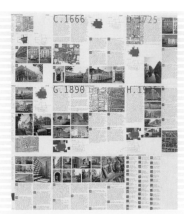

Lust
Kern DH map
138/139/140/141

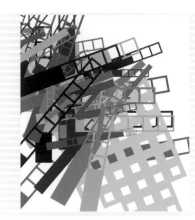

Nina Naegal
and A. Kanna
Time/Emotions
194/195

Where and when are maps?

Maps and fragments of maps are everywhere at any time. Maps now have no beginning or end, merging with networked devices within other traditionally discrete objects: the map, the key, the guidebook, the wallet, the phone, the camera – all one thing. In-car navigation systems speak your route. Global positioning systems plot your coordinates and altitude. Head-up displays throw the map onto your personal vision of the landscape. Third generation mobile phones know who you are, where you are, what's near you, who is near you, even what you want. The phone becomes the map. Digital maps have multiple scales for zooming to capture details, with multiple digital layers for different themes. You choose: transport? drainage? buildings? heritage? Geographical Information Systems define millions of objects as discrete data points each with their own logical address, to which any amount of data can be attached, and so the map merges with the database table and the table is interrogated through the map. Changing the database changes the map so that at last the map keeps pace with the landscape, released from the inertia and inefficiencies of print. The future of maps is to vanish into all of these things, and reappear in everything.

Maps now have no beginning or end, merging with networked devices within other traditionally discrete objects: the map, the key, the guidebook, the wallet, the phone, the camera – all one thing.

01 _ Representation and space

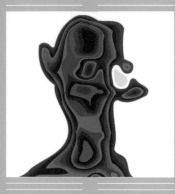
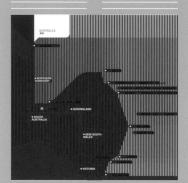

You are here . . .

Essay by William Owen
016/017

Inuit hunters carve three-dimensional charts of the coastlines around Greenland and Eastern Canada out of driftwood (and have done for over 300 years). These maps are highly functional and abstracted. The critical datum line provided by the land-sea boundary is represented by the flat edge of the carved wood – the chart is meant to be fingered on a dark night in a kayak out at sea – but the topography of islands and the features around coastal inlets are clearly represented in three dimensions in the curve and bulk of the wood. These maps fit easily in the hand and they are weatherproof and fumbleproof (if they are dropped overboard, they float). They also have no up or down, so orientation or hierarchy is not an issue, and neither are the problems of transformation from the real three-dimensional world to the flat land of maps[1]. These carved pieces are masterpieces of design.

Light-aircraft pilots – not a world away from the Inuit in their navigational preoccupations – use two-dimensional aviation charts that represent a bewilderingly complex three-dimensional land, sea and airscape. The design of these charts is in vivid contrast with the Inuit driftwood objects. Like most Western maps, aviation charts are, of course, printed on paper, with three dimensions flattened into two by projection. Linear thematic layers are stratified one atop another and read (not fingered, smelled or tasted) by the eye and the mind of a rational observer who is familiar with a myriad of signs. The family of signs – symbols, icons and indices – that comprise the language of maps, here signifies the perilous reality of civil aviation routes, airport exclusion zones, military airspace, microwave towers, radio navigation beacons and high ground on the landscape.

The aviation chart is an extreme example of the tortuous transformation from three dimensions to two because, in addition to the ground features that provide relational information, there are many different kinds of volumes of airspace to be negotiated, each with their own permissions, rules and other characteristics. The pilot flies through these or around them: not just over them, but also above, under and between them. In a busy and feature-laden airspace like that around southern England, the problem of spatial orientation and interpretation is acute; a highly refined sign-reading is critical to survival or the retention of one's flying licence. How a pilot must, sometimes, envy the intuitive instrument available to his kayaking counterpart.

The degree to which this chart is abstracted out of the reality of physical land, air and water is astounding – although in part this is merely because the abstraction is so evident. Many of the features indicated on the aviation chart, for example, have no physical reality. An airport exclusion zone is a man-made abstraction designed to control movement where there are no natural physical points of orientation (no traffic lights or curbstones in the sky!) although its existence is no less real in the pilot's mind. The zone is represented on the map by a combination of icons (signing airport and its position), index (boundary lines and coloured hatching indicating the extent and type of the exclusion zone) and symbols (text showing the name and altitude of the zone). This signification of abstract and physical entities applies to all maps to a greater or lesser degree and we have assimilated the language thoroughly into our consciousness. Having seen the name of a city represented on a map at scale, would we expect to see the same name printed in mile-wide text across the ground of the real world? Of course not, but why not? The language of maps that we have grown up with and that seems so natural and realistic has, nonetheless, a coded grammar and vocabulary that would be quite meaningless to an Inuit kayaker of 300 years ago.

The mediation that takes place during the transformation from the most objective survey data to readable map occurs at numerous levels and its result is an entirely subjective narrative.

Cartlidge Levene
Christmas card
030/031

Browns
0°
062/063

Lust
Lust Map
060/061

The mediation that takes place during the transformation from the most objective scientific survey data to readable map occurs at numerous levels and its result is an entirely subjective narrative. The most fundamental of these and the least visible are projection, orientation and scale. Projection gives a point of view, orientation creates a hierarchy, and scale provides an understanding of time and horizon – how far do we need to see and how far are we going. We don't need to be told that a 1:25,000 map is for walkers – anyone travelling faster needs a wider focus and less detail. It is telling that most single sheet maps contain within one view the distance a person can travel in half a day. 1:25,000 is 20-30 km across, being three to four hours walking at 6kph; 1: 50,000 is 40-60 km across, being three hours cycling at 20kph; 1: 300,000 is 150 km across, being three hours motoring at 50kph. A glance at the scale tells us the audience and purpose for the map.

The narrative is told by numerous factors that are extrinsic to the map itself. These are things that are not in the picture plane but inform it and establish context: the legend establishes a rhetorical style ('Classical Rome', 'Water: precious resource', 'pathfinder', 'streetwise'); unspoken but implicit themes are revealed by gaps in the mapped layers. (Think of the map of a seaside town that shows beaches but not sewage outfalls – the narrative is one of unsullied leisure without duty of care or acknowledging unpleasant reality.) There is also the utility of the map – why was it made and by whom, which might be revealed by some historical legacy such as the name Ordnance Survey (this map first served a military purpose) or the residue from a bygone age of travelling in the special signs for rural inns and public houses but none for contemporary urban coffee bars.

Other signs are intrinsic to the map itself – its icons and their correspondence to the objects they represent; its language, and how it elaborates on other signs; its tectonic codes and how they shape the space through projection, scale or indices; its temporal codes which are critical to the narrative form (most maps include only those classes of objects which are expected to remain static for a certain period of time – which could be a minute but is more likely to be a decade); its overall presentation, the style and tone of the imagery, which may be soft or loud, high or low contrast, luxurious or functional, whimsical or idealistic.

An example of the use of style and symbolic presentation in the subtle service of rhetoric is the GeoSphere project cited by Denis Wood[2]. Described by its publishers, National Geographic, as a 'global portrait' (i.e. photograph) this was a popular image of the earth created from satellite data by artist Tom Van Sant. The map presents itself as a photograph, a true image of the earth. It is nonetheless a map, comprised of indexical signs and therefore no more 'real' or 'natural' than any other map. In his deconstruction of the image, Wood notes that the 'Portrait' is first of all a flat picture of a round planet, with the world stretched and distorted to fit into a rectangle using the Robinson projection. The image is reproduced at scale, and its resolution is no greater than one pixel per square kilometre. The image caters to our perceptions of 'naturalness', its colours are false; there are no clouds visible whatsoever (the image is captioned 'a clear day' – one miraculously so), and – this is the clincher – there is no night: the entire surface of the globe is bathed in sunlight, and this last point is the least obvious to the casual observer when one asks what exactly is 'wrong' with this image.

[1] Victor Papanek, 'The Green Imperative: natural design for the real world', Thames and Hudson, 1995 (cited by George H. Brett, www.deadmedia.org).

[2] 'The Power of Maps', ibid.

Design Willi Kunz Associates
Project Programme information posters
Client Columbia University

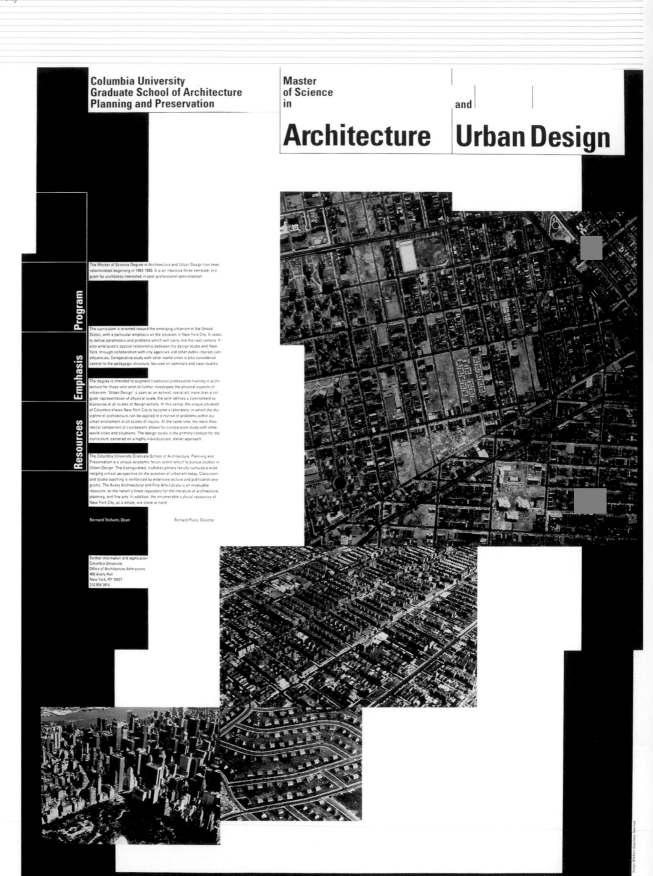

Two posters produced for Columbia University. The first poster announces a programme in architecture and urban design at the university. It incorporates a series of black and white images arranged in a stepped formation to suggest the gradual expansion from city to industrial environment. The strong grid lines in the aerial photography have a close relation to the cityscape photograph in the bottom left corner, helping to form a fluid link through the various images. The staggered layout of images is echoed in the thick irregular frame that contains the poster.

The second poster was designed to announce an undergraduate programme in architecture, urban planning, and historic preservation held in New York and Paris. The poster shows simplified maps of the two cities, placing the map of New York's Manhattan within a square which echoes the nature of the street plan, and placing Paris within a circle, again illustrating the more organic nature of that city's street plan. The overlapping of the two maps helps to create a dynamic tension between the two cities.

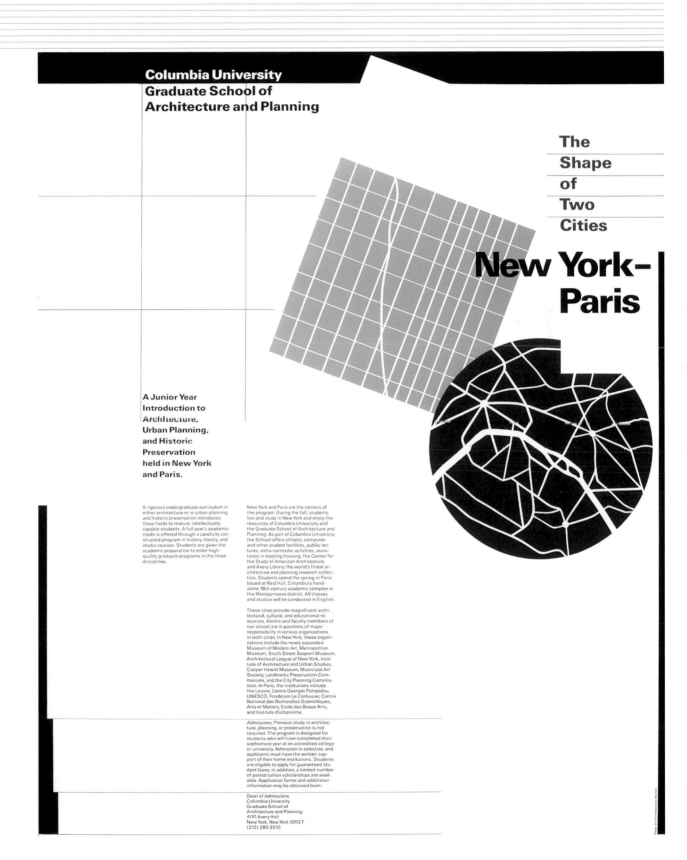

Columbia University
Graduate School of
Architecture and Planning

The
Shape
of
Two
Cities

New York–
Paris

A Junior Year
Introduction to
Architecture,
Urban Planning,
and Historic
Preservation
held in New York
and Paris.

A rigorous undergraduate curriculum in either architecture or in urban planning and historic preservation introduces these fields to mature, intellectually capable students. A full year's academic credit is offered through a carefully constructed program in history, theory, and studio courses. Students are given the academic preparation to enter high-quality graduate programs in the three disciplines.

New York and Paris are the centers of the program. During the fall, students live and study in New York and enjoy the resources of Columbia University and the Graduate School of Architecture and Planning. As part of Columbia University, the School offers athletic, computer, and other student facilities, public lectures, extra-curricular activities, assistance in locating housing, the Center for the Study of American Architecture, and Avery Library, the world's finest architecture and planning research collection. Students spend the spring in Paris based at Reid Hall, Columbia's handsome 18th century academic complex in the Montparnasse district. All classes and studios will be conducted in English.

These cities provide magnificent architectural, cultural, and educational resources. Alumni and faculty members of our school are in positions of major responsibility in various organizations in both cities. In New York, these organizations include the newly expanded Museum of Modern Art, Metropolitan Museum, South Street Seaport Museum, Architectural League of New York, Institute of Architecture and Urban Studies, Cooper Hewitt Museum, Landmarks Preservation Commission, and the City Planning Commission. In Paris, the institutions include the Louvre, Centre Georges Pompidou, UNESCO, Fondation Le Corbusier, Centre National des Recherches Scientifiques, Arts et Metiers, Ecole des Beaux Arts, and Institute d'urbanisme.

Admissions: Previous study in architecture, planning, or preservation is not required. The program is designed for students who will have completed their sophomore year at an accredited college or university. Admission is selective, and applicants must have the written support of their home institutions. Students are eligible to apply for guaranteed student loans; in addition, a limited number of partial tuition scholarships are available. Application forms and additional information may be obtained from:

Dean of Admissions
Columbia University
Graduate School of
Architecture and Planning
400 Avery Hall
New York, New York 10027
(212) 280 3510

Design Imagination
Project The Journey zone
Date 1999

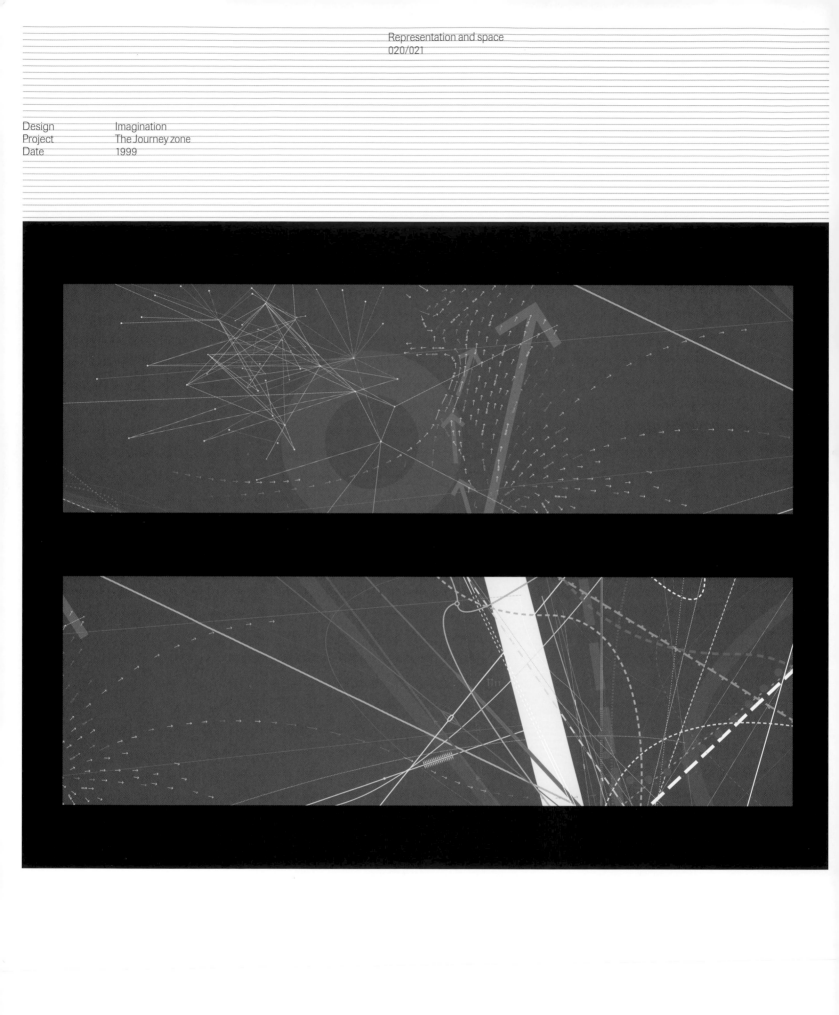

The Journey zone was the exhibition dealing with the subject of transportation at the UK's Millennium Dome, a network of exhibition pavilions designed to mark the new millennium. As the work of the multi-disciplinary design company Imagination, the building's architecture and the exhibition graphic were considered together, and the graphic design works to lead visitors around the exhibition, to create coherence throughout the building and to describe the nature of transportation and movement.

In the sample shown here, each panel graphically represents a different mode of travel/transport. By using and adapting the existing graphic language for each one, the viewer, with a little vision, can recognise the mode of transport being illustrated: motorways, flight paths, rail routes, footpaths and bridleways, and so on. Individually these graphic elements do not convey any precise information – they are purely stylistic illustrations derived from the language of mapping which, if nothing else, illustrate to the viewer the myriad ways that movement can be expressed using simple lines and arrows – but together they provide an innovative form of signage leading the visitor around a complex walk-though exhibition.

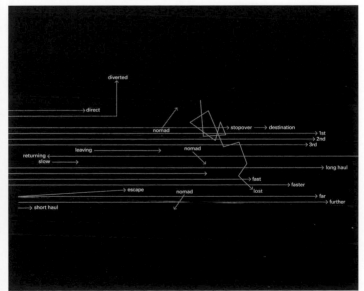

Design The Kitchen
Project USR Records' house bags
Date 2001

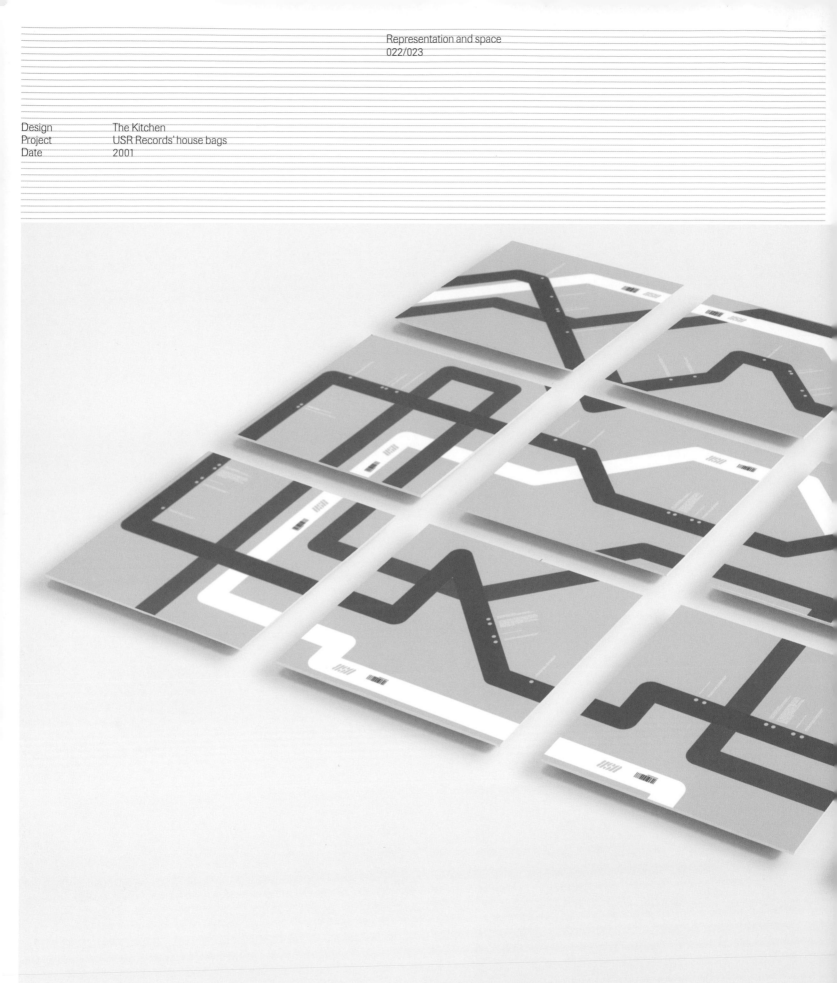

The language of mapping is appropriated for the sake of consistency in the output of record label USR, designed by The Kitchen. The design uses the graphic language of the underground/subway map, enlarging a small section of overlaying, interconnecting coloured lines. The backs of each sleeve form part of a larger map which has the potential to continue growing as more records are released. The fronts of the sleeves remain consistent to help consumer awareness and build instant recognition in the record store. The track listing, which appears on the back covers, again echoes the subway map, as each track appears like a stop on the line complete with a circular interchange point.

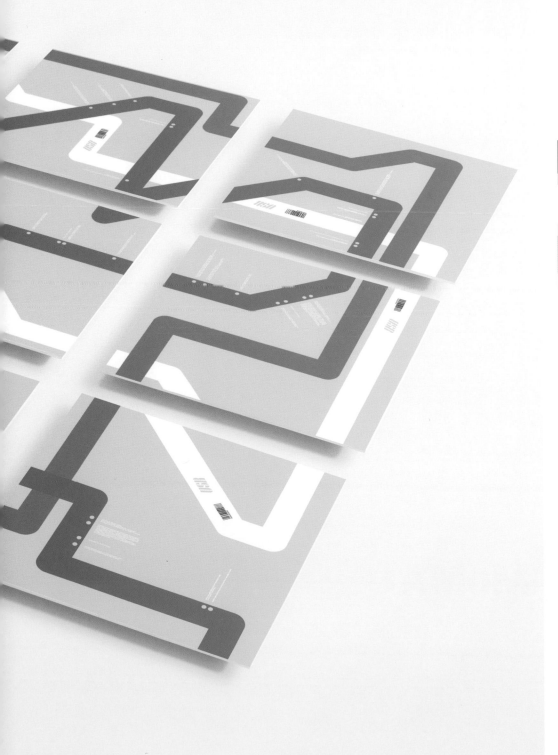

Design	Base
Project	MoMAQNS identity/signage
Date	2000

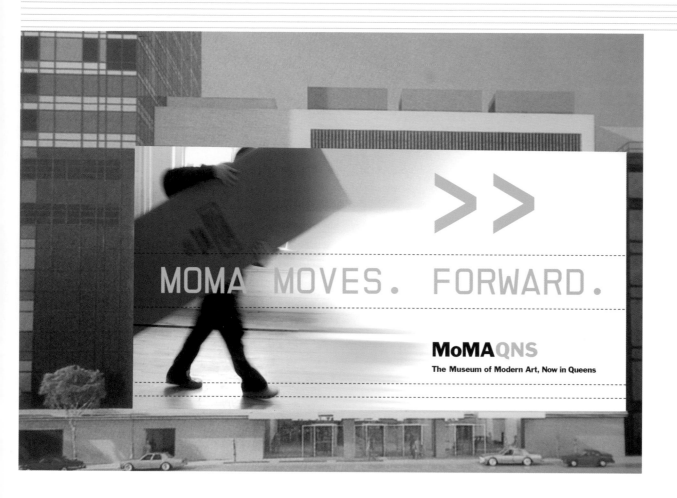

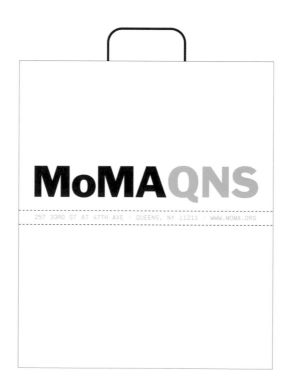

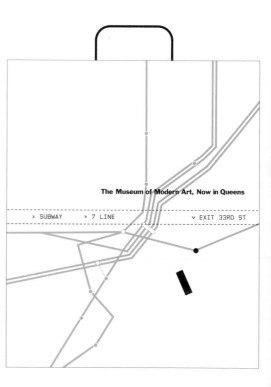

Designed by Base, an international design consultancy with offices in Belgium, New York and Barcelona, this visual identity for a new gallery of the Museum of Modern Art in New York used the New York subway map as an integral part of the identity. The gallery, which is located in Queens, off the standard gallery/museum circuit of Manhattan, represented a departure for MoMA, as its home is firmly fixed off 5th Avenue. The logo itself is in keeping with MoMA's existing identity, but with the addition of the letters QNS – an abbreviation of Queens in the style of airport name abbreviations (London Heathrow: LHR). Fragments of the New York subway map, stylised in accordance with identity guidelines, were then utilised in different applications ranging from carrier bags to vehicle liveries, bringing home the message to New Yorkers that while the new Gallery is a part of MoMA, they will have to look in a new area to find it.

MoMAQNS

>> NOW >> NOW >> NOW >> NOW >> NOW >> NOW >> NOW >> NOW >> N

>> MOMA MOVES. FORWARD. >> MOMA MOVES.

MANHATTAN >> QUEENS MANHATTAN >> QUEE

MOMA MOVES. FORWARD.

>> MOMA MOVES. FORWARD. >> MOMA MOVES. FORWARD. >>

MANHATTAN >> QUEENS MANHATTAN >> QUEENS MANHATTAN >> QUEENS

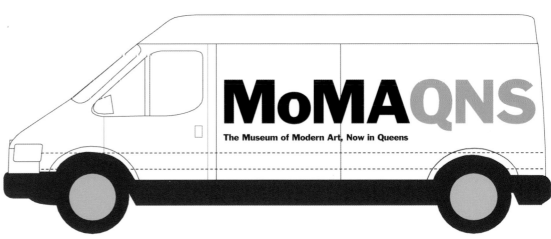

MoMAQNS
The Museum of Modern Art, Now in Queens

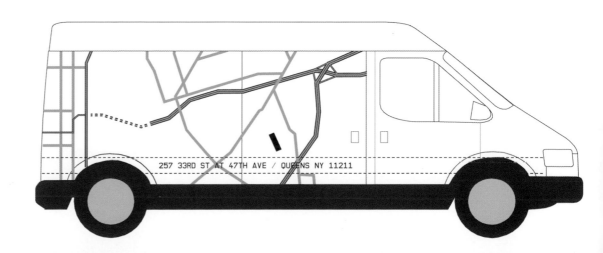

257 33RD ST AT 47TH AVE / QUEENS NY 11211

Artist	Simon Patterson		Artist	Simon Patterson
Title	'J.P.233 in C.S.O. Blue'		Title	'The Great Bear'
Dimensions	Variable		Dimensions	1092 x 1346mm
Date	1992		Date	1992
Photography	Matthias Hermann		Copyright	Simon Patterson and London Regional Transport
Image courtesy	The Lisson Gallery, London		Photography	John Riddy
			Image courtesy	The Lisson Gallery, London

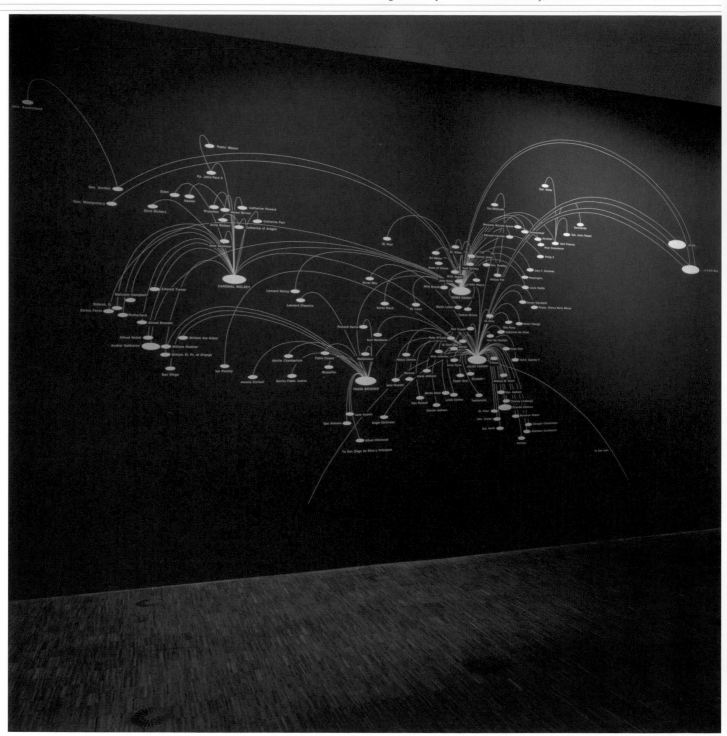

The artist Simon Patterson, a finalist for the Turner Prize, the UK's leading award for modern art, has worked extensively with the process of reinterpreting existing information systems. Shown here are two works by the artist which utilise maps and navigation/information systems.

'J.P.233 in C.S.O. Blue' is a large wall drawing which takes as its reference a global airline route map, using large sweeping arcs to represent the journeys between countries, which are implied by their relative positions rather than a delineation of boundaries. The destination names are replaced with seemingly unrelated famous people, from Julius Caesar, Elizabeth I, Pope John-Paul II and Mussolini to actors William Shatner, Helen Mirren, Leonard Nimoy and Peter Falk.

In 'The Great Bear', Patterson begins with a very famous reference point, the map of the London Underground, possibly the best-known and most copied subway map, which was itself first developed by Henry Beck in the 1930s. The London Underground map is most notable for the way it distorts and simplifies the physical spaces it represents, in order to provide the most effective presentation of the relationships between lines and stations, and aid the viewer with planning journeys on which there are few visible landmarks. In 'The Great Bear', Patterson remains faithful to the original London Underground map, but replaces all station names with a variety of famous names. Each line on the network plays host to a particular category of famous people – the Circle line stations take on the names of philosophers, for example, while the Northern line becomes a list of film actors. This replacement of names disorients the viewer: at first glance the map looks familiar – until, that is, one tries to find a particular tube stop, then it becomes increasingly difficult, because all the points of reference have been changed.

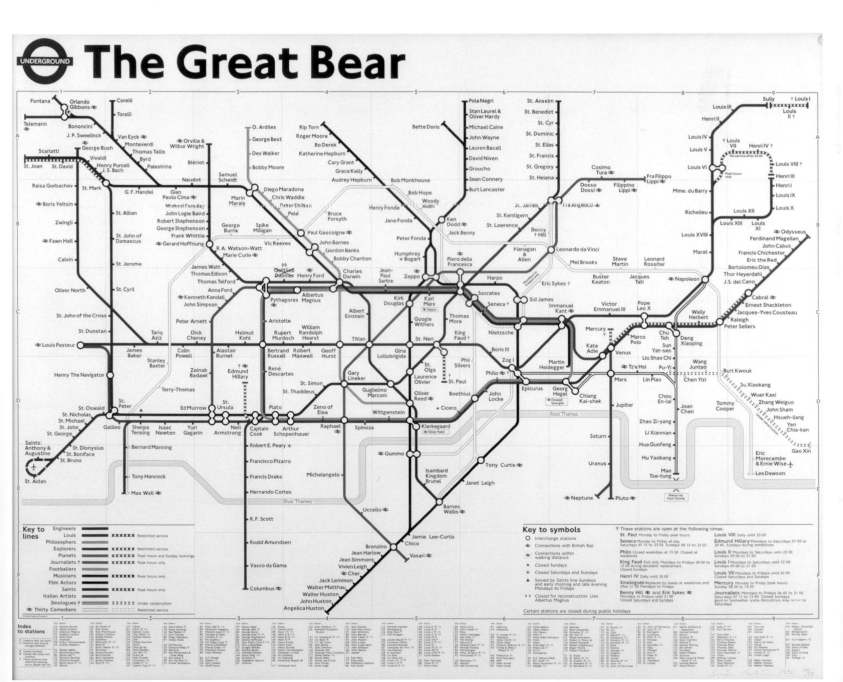

Artist	Simon Patterson	Artist	Simon Patterson
Title	'Untitled: 24 hrs'	Title	'Rhodes Reason'
Date	1996	Date	1995
Image courtesy	The Lisson Gallery, London	Image courtesy	The Lisson Gallery, London

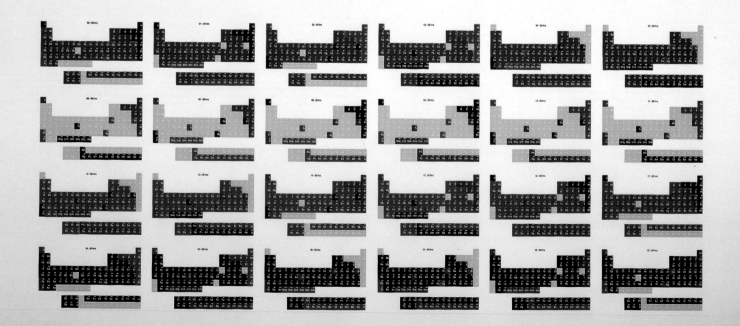

AP VII/X Simon Patterson 1996

Two further works by the artist Simon Patterson both refer to the Periodic Table, pinned up on the wall of every school chemistry lab. This typographic work of beauty is frequently plagiarised by other graphic designers, but here it is taken to a higher level. 'Untitled: 24hrs' reproduces the table 24 times. Each table is printed in four colours; the first row of tables are predominantly blue, the second row yellow, then red and finally black. The colours refer to a property of each substance: Black = Solid, Red = Gas, Blue = Liquid and Yellow = Synthetically Prepared. The same colour palette is also used in 'Rhodes Reason', which again features the odd film star, for example Kim Novak (Na 11) is Sodium, while Telly Savalas (As 33) is Arsenic. Rhodes Reason was also published as a book called Rex Reason.

Rhodes Reason

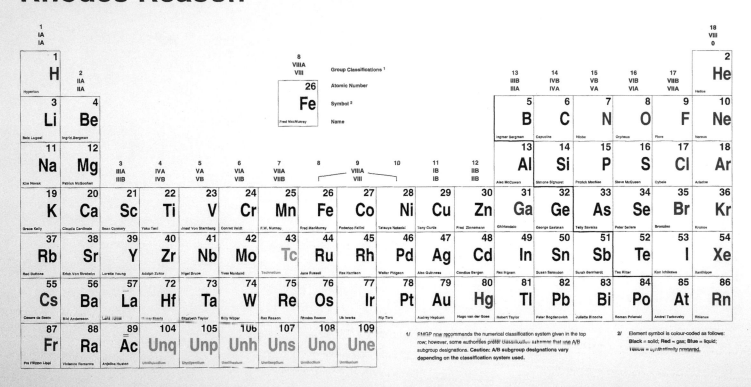

Design Cartlidge Levene
Project Christmas cards
Date 1995/1997/1998/1999

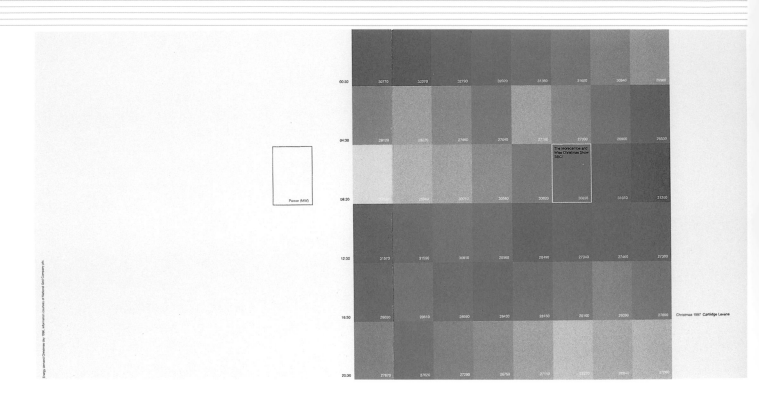

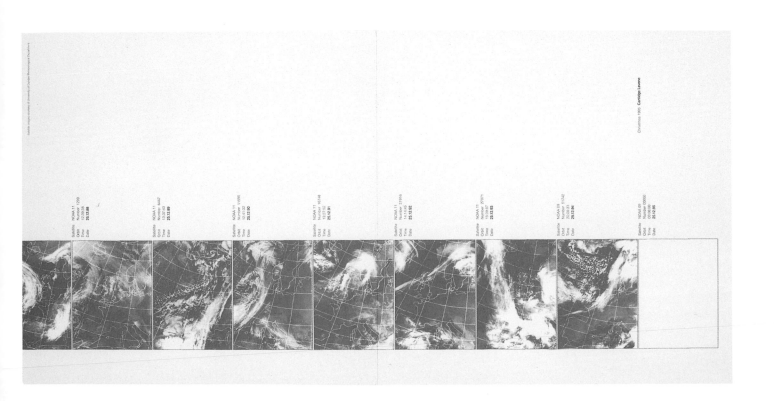

Each year the London-based graphic design consultancy Cartlidge Levene produces a Christmas card which pushes the connection to the festive period to its limits. As well as tidings of joy, the designers have often incorporated elements of mapping and location-finding in the cards. For Christmas 1995, the company used a collection of satellite images taken over its studio, one from each year since the company was founded, giving a snap-shot of the weather conditions on Christmas day throughout the period of the company's existence. For Christmas 1998, the card listed every area post code to which it would be sent. The A6 card was concertina-folded with the list running down the left edge. Each card was personalised to the recipient by the addition of a small hole punched next to their post code. The card designed for Christmas 1999 featured the addresses at which each individual at Cartlidge Levene had spent Christmas since their birth, thereby mapping a geographical Christmas history for the company's staff.

Design Fibre
Project Pages from Cre@teOnline
Date 2001

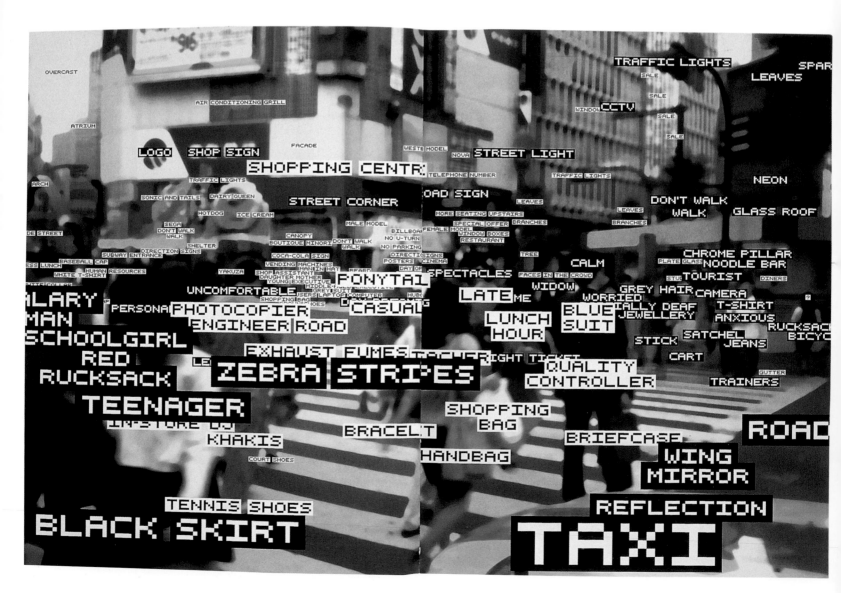

Commissioned by the digital media magazine Cre@teOnline to produce illustrations for a special issue about navigation, the London-based design consultancy Fibre produced two double-page spreads. The images taken in a busy street in Tokyo are blurred out, to the point where all details are lost. The images are then recoded with word byte captions printed in black and white in a bitmapped screen font. The captions identify every detail held on the page even down to a slightly buckled wheel on a sit-up-and-beg bicycle. The process of abstraction and re-translation turns a shot of reality into a computer game simulation, with multiple options.

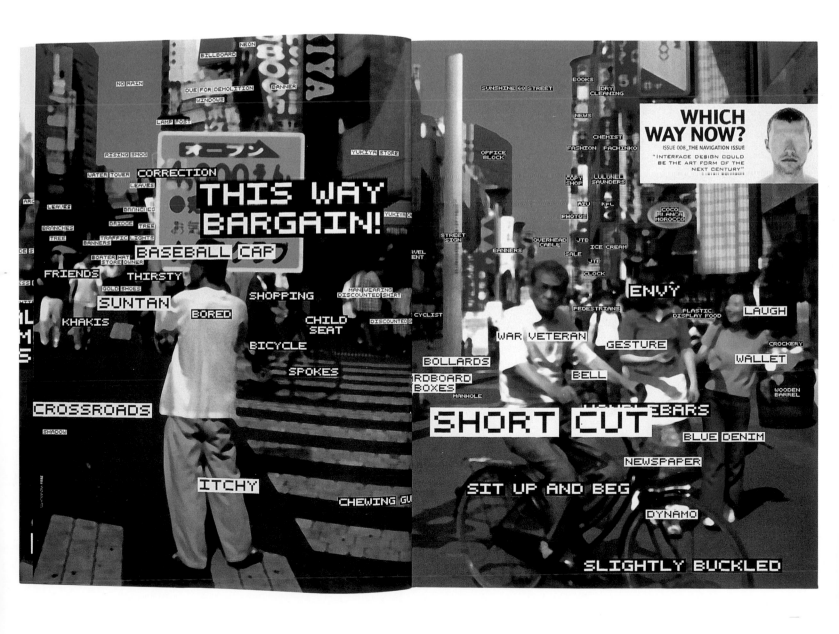

Design John Crawford
Project Parc de la Villette, typographic project
Date 1994

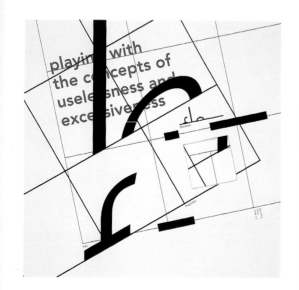

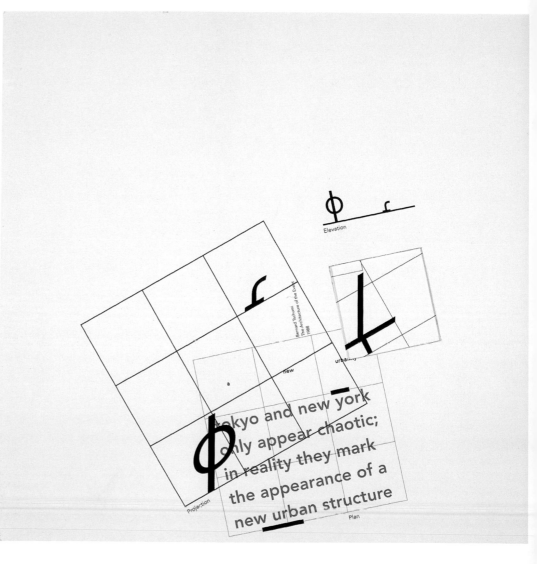

Produced as a loose leaf book or album of pages, this project by graphic designer John Crawford deconstructs an architectural grid system used in Parc de la Villette, the group of Parisian follies designed by the architect Bernard Tschumi, who wrote: "La Villette moves towards interpretative infinity, for the effect of refusing fixity is not insignificance, but semantic plurality. The park's three autonomous and superimposed systems and the endless combinatory possibilities of the follies gives way to a multiplicity of impressions. Each observer will project his own interpretation, resulting in an account that will again be interpreted."

John Crawford began to create typographic fragments or follies and placed these within the framework of the abstracted grid of the park. Each page is pierced by a 47-mm square hole, so when the pages are stacked one-on-top of another, a third dimension is created, allowing an interplay between the surfaces, revealing further fragments of typography and grid work.

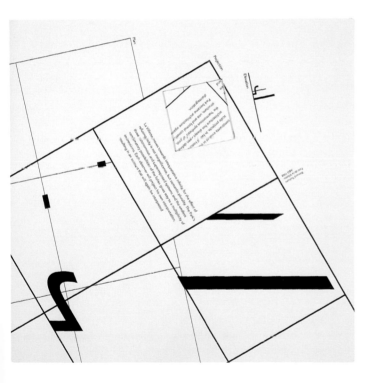

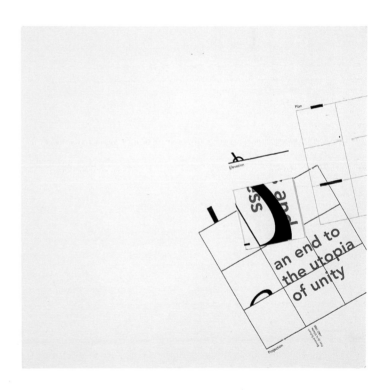

Design Cartlidge Levene
Project Eye magazine advertising
Date 1991

layout
layout
gepe 20 slide mounts layout barnett newman layout
 layout layout postcard c trace 90 layout
ntn bearings layout
 sony slv 474 operating instructions layout layout telephone
 sony acv 3u operating instructions layout
sony video cable layout

 morisawa type manual 3 graphic design in japan 90
 magnets air france ticket wallet
 cassette layout
 layout
 layout selected poems charles bukowski
m180 chisel point marker hot water music charles bukowski
 cheque book
 wallet

 vhs video mug

 black pilot razor point II
 vhs video tse
 black pilot razor point II

 AL

 design museum issue 5 keys receipt petty cash vouchers
 isle of wight rock orange felt tip pen wallet receipt
 receipt paper clip telephone 1989 2 pence piece
 rolodex black pilot razor point II receipt paper clip receipt
 black pilot razor point II paper
 rexel matador II stapler clip taxi receipt
 hotel du tribunal reciept
 post it pad 4h pencil

 ncr invoice copy swann morton bs 2982 receipt
 ncr invoice copy
 ncr invoice copy receipt
 guidex foolscap file 3ff11 receipt ncr invoice copy receipt
 guidex foolscap file 3ff11 ncr invoice copy
 guidex foolscap file 3ff11 ncr invoice copy settegiorni 1991
 guidex foolscap file 3ff11 ncr invoice copy 3 scalpel blades
 guidex foolscap file 3ff11 ncr invoice copy
 guidex foolscap file 3ff11 ncr invoice copy
 ncr invoice copy

 guidex foolscap file 3ff11
 guidex foolscap file 3ff11 bromide
 bromide
 guidex foolscap file 3ff11 bromide estates gazette
 eye magazine no 1 bromide
 proof
 correspondence
 telephone
 dutch art + architecture today layout
 layout daler 3406
 layout blue pilot razor point II
 layout
 japanese pan scrub touraine amboise 1989
 guidex foolscap file 3ff11 calculator sl807
tdk black pilot razor point II spectacles case
vhs video (lawrence of arabia) spectacles
 unique adjustable triangle 20cb facsimile facsimile wallet
 flip file facsimile
bromide ww39191 settegiorni 1991 facsimile

In the early days of Eye, the international review of graphic design, the London-based consultancy Cartlidge Levene designed self-promotional advertisements for issues two and four. Neither directly 'sells' the company, or even offers much direction as to what is being advertised. The 'red' ad forms a typographic map of Cartlidge Levene's studio at a given moment in time. The ad is composed of the contents of the desks of every designer in the company (who are identified only by their initials). The contents of the desks are given in words, which are repeated to signify multiples of the same object. The words are arranged on the sheet to reflect the actual position of the objects on the desk. The result is a clear picture of the state of each designer's desk, ranging from busy clutter to the austere minimalism of a single Black Pilot Razor Point II pen. Interestingly there appears to be a total absence of any computer equipment, a reflection of the times perhaps.

The second ad was produced as a collaboration with 4th Floor, a firm of hairstylists, who work on the floor above the Cartlidge Levene studio. The design maps out aerial close-up photographs of the various hairdressers' heads, working them into a gridded matrix.

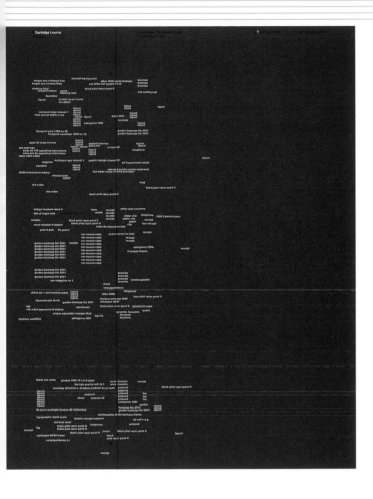

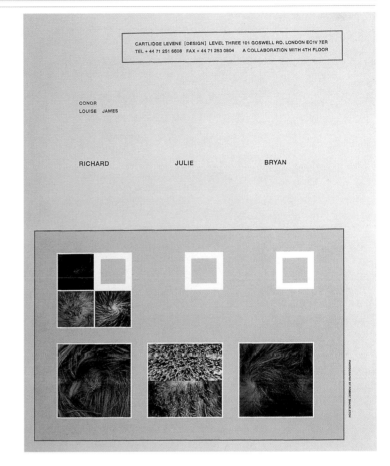

Design The Kitchen
Project Studio floorplan
Date 2000

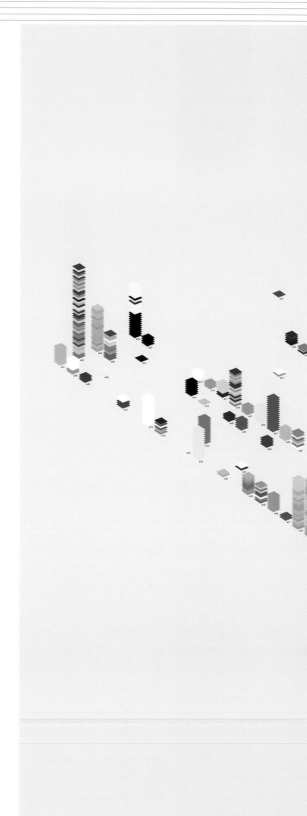

This floorplan of the studio occupied by London-based design consultancy The Kitchen works as a graphic snapshot of the space at one moment in time. Each item within the space has been carefully itemised and catalogued, and the map visually represents their locations within the studio. While the shapes of the objects are abstracted, a complex coding system is used, where each item is assessed and allocated a unique colour which is derived from the colour used most prominently in the object. The positions of the objects are further referenced – or cross-referenced – through a list of co-ordinates. The map of the studio contains none of the features one might expect to find in an interior plan – no suggestion of walls, windows, doors and so on – but the physical shape, business and working patterns of the studio are revealed by the relative densities and positions of the objects found in different parts of the map.

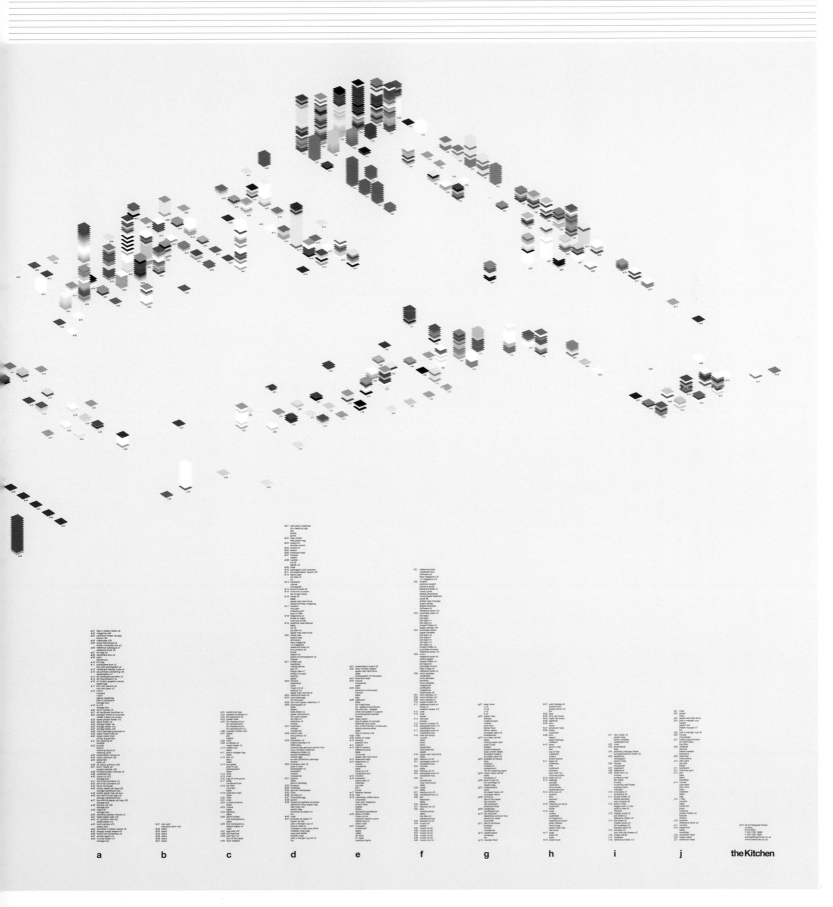

a b c d e f g h i j the Kitchen

Design Jeremy Johnson
Project A visual record of the entire contents of a typecase
Date 2001

Produced as a visual record of the entire contents of a type case at the Royal College of Art, London, over an 18-month period, this set of 12 425 x 1000-mm sheets was designed by Jeremy Johnson. The typographic inventories form clear maps showing the location of each character within the case and the quantity of each character. The work also highlights occasional mistakes on the part of those using the typecase, as the odd rogue letter crops up in the wrong location.

The first sheet acts as a 'road map' of the type case, showing all the streets, avenues and back alleys of the structure. The case is printed in silver, with each character location denoted by a single black character. The following sheets show a variety of fonts from Helvetica Light 12pt to Grotesque No. 9 in 60pt. One sheet, which is dedicated to 'miscellaneous stock blocks', shows an eclectic mix of logos, illustrations and dingbats. Another page shows all six font sheets overprinted: Helvetica Light, Gill Sans Italic, Baskerville Roman, Fashion Script, Grotesque No. 9 and Joanna Roman are overlaid to create a dense cityscape of the collection. Finally, a set of three pages shows the reverse side of the three formes used on the job, which represent the complex infrastructure of the work.

Design John Crawford
Project Open Week poster
Date 1994

The intention behind this large format poster (1185 x 820mm), produced as a promotional mailer and private view invitation for a degree show at Southampton Institute of Higher Education, was to show how easy it is to get to the college from any location in the United Kingdom and Northern Europe. Each alphabetically listed location is accompanied by a set of different modes of transport; road, rail and ferry (where appropriate), and each subhead is followed by a basic list of motorways, A-roads and rail connections.

design division open week

15 16 17 18 19 Feb

0703 229 281

Design	Mark Diaper
Artist	Michael Landy
Project	Breakdown
Client	Artangel
Date	2001

Over the course of two weeks in February 2001, the British artist Michael Landy took up residence in a former C&A clothing store in London's Oxford Street, and systematically destroyed all of his personal possessions, from his car to his passport and credit cards, in an industrial shredder. Prior to the event, the artist had made an inventory of his possessions – in effect, an inventory of his 37-year life. Over 5000 entries catalogued every piece of furniture, every record, every article of clothing, every letter from friends, every gadget, and every work of art – his own work and gifts from fellow artists such as Gary Hume – which were owned by the artist.

This inventory forms the basis of a book, designed by Mark Diaper, produced to document the project by Artangel, the agency which funded it. The possessions are categorised and given a prefix: A = Artworks, C = Clothing, E = Electrical, F = Furniture, K = Kitchen, L = Leisure, MV = MotorVehicle, P = Perishables, R = Reading Materials, S = Studio Materials. When the destruction of the objects took place, they were loaded onto a complex conveyor belt system which fed four work bays, each dedicated to the dismantling of certain items identified by these prefixes.

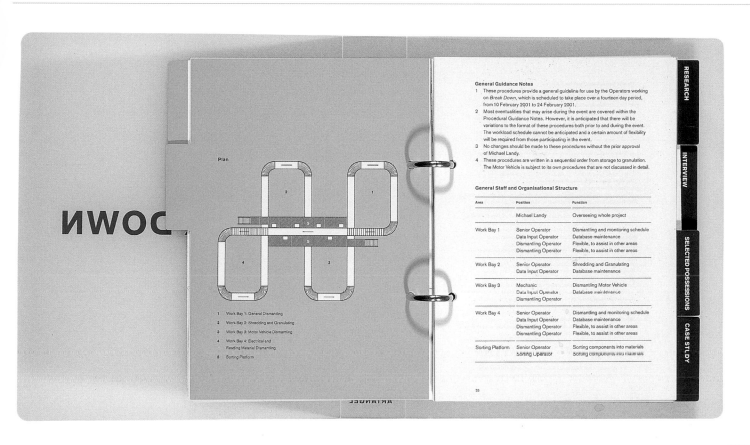

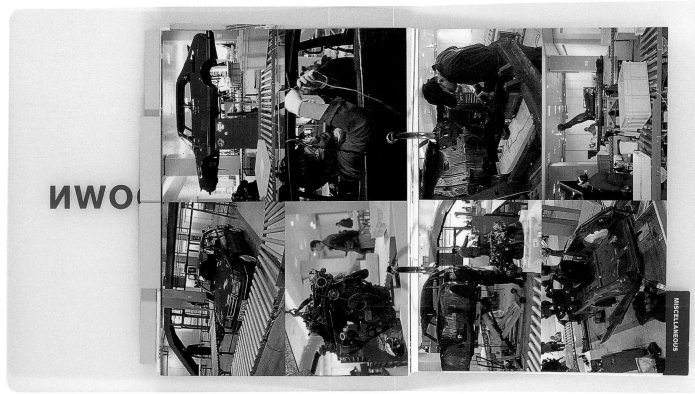

Design sans+baum
Map design Russell Bell
Project Facts of Life gallery guide
Date 2001

Hayward Gallery
on the South Bank · London

Facts of Life
Comtemporary Japanese art
Hayward Gallery
4 October – 9 December 2001

Facts of Life presents painting, photography, video, installation, sculpture, sound pieces and performance work – in the galleries, on the sculpture courts and outside – by 26 artists, all Japanese or working in Japan. It proposes links between established figures of an older generation and younger, emerging artists; all the work has been made in recent years, much of it especially for this exhibition.

The title – Facts of Life – points to a directness, an unmediated approach and a realism which unites all the work on show. The artists shown here, although their approaches differ widely, share an engagement with the real world: both with the minutiae of everyday experience and with the larger realities which govern our lives. This attitude – prevalent internationally – is in marked contrast to the academic and self-conscious postmodernism which characterised Japanese art in the 80s and 90s, and challenges the notion of Japan as a synthetic culture, an amalgam of virtual realities and wonderful fictions.

FACTS OF LIFE
for extended information on all the artists in Facts of Life log on to the special exhibition site at
www.haywardgallery.org.uk

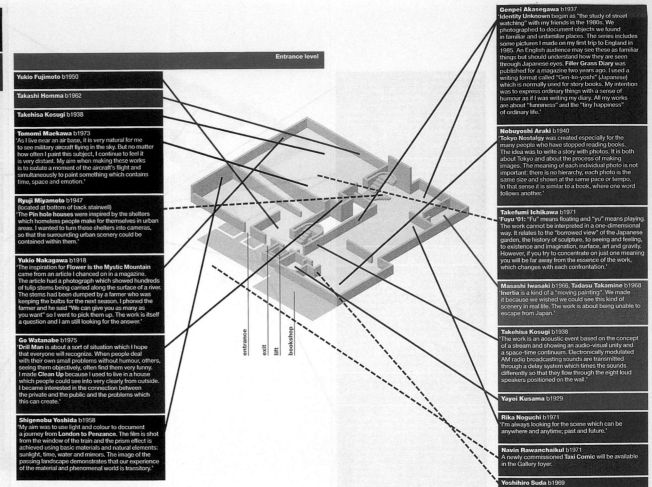

Entrance level

Yukio Fujimoto b1950

Takashi Homma b1962

Takehisa Kosugi b1938

Tomomi Maekawa b1973
'As I live near an air base, it is very natural for me to see military aircraft flying in the sky. But no matter how often I paint this subject, I continue to feel it is very distant. My aim when making these works is to isolate a moment of the aircraft's flight and simultaneously to paint something which contains time, space and emotion.'

Ryuji Miyamoto b1947
(located at bottom of back stairwell)
'The **Pin hole houses** were inspired by the shelters which homeless people make for themselves in urban areas. I wanted to turn these shelters into cameras, so that the surrounding urban scenery could be contained within them.'

Yukio Nakagawa b1918
'The inspiration for **Flower is the Mystic Mountain** came from an article I chanced on in a magazine. The article had a photograph which showed hundreds of tulip stems being carried along the surface of a river. The stems had been dumped by a farmer who was keeping the bulbs for the next season. I phoned the farmer and he said "We can give you as many as you want" so I went to pick them up. The work is itself a question and I am still looking for the answer.'

Go Watanabe b1975
'**Drill Man** is about a sort of situation which I hope that everyone will recognize. When people deal with their own small problems without humour, others, seeing them objectively, often find them very funny. I made **Clean Up** because I used to live in a house which people could see into very clearly from outside. I became interested in the connection between the private and the public and the problems which this can create.'

Shigenobu Yoshida b1958
'My aim was to use light and colour to document a journey from **London to Penzance**. The film is shot from the window of the train and the prism effect is achieved using basic materials and natural elements: sunlight, time, water and mirrors. The image of the passing landscape demonstrates that our experience of the material and phenomenal world is transitory.'

entrance
exit
lift
bookshop

Genpei Akasegawa b1937
'**Identity Unknown** began as "the study of street watching" with my friends in the 1980s. We photographed to document objects we found in familiar and unfamiliar places. The series includes some pictures I made on my first trip to England in 1985. An English audience may see these as familiar things but should understand how they are seen through Japanese eyes. **Filler Grass Diary** was published for a magazine two years ago. I used a writing format called "Gen-ko-yoshi" (Japanese) which is normally used for story books. My intention was to express ordinary things with a sense of humour as if I was writing my diary. All my works are about "funniness" and the "tiny happiness" of ordinary life.'

Nobuyoshi Araki b1940
'**Tokyo Nostalgy** was created especially for the many people who have stopped reading books. The idea was to write a story with photos. It is both about Tokyo and about the process of making images. The meaning of each individual photo is not important: there is no hierarchy, each photo is the same size and shown at the same pace or tempo. In that sense it is similar to a book, where one word follows another.'

Takefumi Ichikawa b1971
'**Fuyu '01**: "Fu" means floating and "yu" means playing. The work cannot be interpreted in a one-dimensional way. It relates to the "borrowed view" of the Japanese garden, the history of sculpture, to seeing and feeling, to existence and imagination, surface, art and gravity. However, if you try to concentrate on just one meaning you will be far away from the essence of the work, which changes with each confrontation.'

Masashi Iwasaki b1966, **Tadasu Takamine** b1968
'**Inertia** is a kind of a "moving painting". We made it because we wished we could see this kind of scenery in real life. The work is about being unable to escape from Japan.'

Takehisa Kosugi b1938
'The work is an acoustic event based on the concept of a stream and showing an audio-visual unity and a space-time continuum. Electronically modulated AM radio broadcasting sounds are transmitted through a delay system which times the sounds differently so that they flow through the eight loud speakers positioned on the wall.'

Yayoi Kusama b1929

Rika Noguchi b1971
'I'm always looking for the scene which can be anywhere and anytime; past and future.'

Navin Rawanchaikul b1971
A newly commissioned **Taxi Comic** will be available in the Gallery foyer.

Yoshihiro Suda b1969

Produced as a concertina-folded sheet of paper, this gallery guide for the exhibition Facts of Life at the Hayward Gallery in London was designed to help visitors navigate easily around a fairly complex set of exhibits, while providing information about the artists whose works they encountered along the way. The primary intention was to design an accessible guide which made the different gallery levels and spaces immediately clear. A colour-coding system was introduced to draw attention to the individuality of each exhibitor and their work. The isometric drawings of the two levels of the gallery are annotated by thick rules colour-coded to identify the presence of particular artists' works, while dotted lines are used to indicate a work which occupies a non-standard gallery space such as the basement area or the gallery's foyer, for example.

Public programmes
An extensive programme of events gives adults, students and families a range of opportunities to engage with the issues and ideas behind Facts of Life. Gallery Guides are regularly on hand to offer short, informal tours of the exhibition and to answer your questions. A series of informal gallery talks by artists and curators is open to all, as well as our regular student debates, this time with Goldsmiths' College and Kingston University. Two Hayward Forums, and two seminars with the Institute of Ideas, present visitors with a chance to participate in inter-disciplinary discussions around identity, transience, globalisation and the myths of orientalism and universalism.

Families are invited to make pin-hole cameras, comic books and much more over the opening weekend with Takefumi Ichikawa and Ryuji Miyamoto, alongside British artists Sally Barker and Milika Muritu. In addition, artists will be leading workshops over the half-term holiday.

Full listings of Hayward Gallery events are given in the exhibition leaflet available in the foyer, or visit our website at www.haywardgallery.org.uk

Facts of Life catalogue
A fully illustrated catalogue accompanies the exhibition. The book includes texts by Jonathan Watkins and Mami Kataoka. The catalogue is available from the Hayward Shop at a special price during the exhibition, and by mail order from Cornerhouse Publications
telephone
+44 (0)161 200 1503

Disability access
For information on disability, please ask at the Information Point in the Hayward Gallery Foyer or
telephone
+44 (0)20 7960 5226
or
minicom textphone
+44 (0)20 7921 0921

selected by
Jonathan Watkins
co-organised by
The Hayward Gallery/
The Japan Foundation
support in-kind
All Nippon Airways
architectural design
David Dernie Architects
lighting design
Lightwaves
guide design
sans+baum
guide diagrams
Russell Bell
guide texts
Artists' statements
copyright the artists
2001
guide print
Digital Brookdale

Co-organised with
国際交流基金
The Japan Foundation

Supported in kind by
ANA

Nobuyoshi Araki b1940
'I began photographing **Flowers** in the early 1970s at Jho-kan temple in Minowa where I grew up. Each year, during the weeks of the equinox, flowers were displayed in the temple. I would wait until these flowers started dying, then steal them and photograph them against a white background. For me, shooting fresh flowers is boring. I always wait until the flowers are dying because at that moment their eroticism and vitality is at its height. Flowers have become my abnormal love object.'

Yukio Fujimoto b1950
'**The Philosphical Toys** are simple objects made into musical boxes and designed to develop hearing ability and our relationship to simple things. **Cosmos (Black)** is about the balance of order and coincidence. The combination of spin and gravitation on the dice creates what seem like uneven sounds, but listen carefully, and you will realize that the sounds have a certain order. **Ears with Chair, Earpipes** were made at a time when my interest had changed from making sounds to listening to them.'

Tomoko Isoda b1976

Yayoi Kusama b1929
Narcissus Garden, was first made for the Venice Bienale in 1966. The 1,500 silver plastic spheres were placed in rows on a twenty metre square lawn in front of the Italian Pavilion. Kusama caused a sensation by selling the balls to passers-by for two dollars each, which at the time was seen as a radical gesture against the art market. In 1966 she said of the work, 'Artists should integrate themselves into economic life by making their work inexpensive and accessible enough to be bought like items in a supermarket'. For this showing the silver spheres are not for sale but the artist still maintains her stance: 'I will buy your narcissism for two dollars'.

Makoto Nomura b1968
2–9 November
Will be performing **Shogi** compositions in the Gallery.

Shimabuku b1969
'I took a living octopus that I had caught myself, to Tokyo. Then I brought it back, still alive, and returned it to the sea. This was probably the first octopus in history to go to Tsukiji, the big fish market in Tokyo, and come back alive. The octopus returned to the ocean in Akashi in good health. What does the octopus remember about this event? Is he talking to his fellow octopi at the bottom of the ocean about his trip to Tokyo? Or has he got inside an octopus trap with the idea that he might not be able to go to Tokyo again? In a way this was my Apollo project because taking an octopus to Tokyo is like taking humans to the moon.'

cafe
lift

Tatsuo Miyajima b1957
'I am currently interested in exploring ideas of time and space through direct communication with the audience. In **Floating Time** numbers between one and nine appear suspended in space (zero is not included because it means death). The numbers express the rhythm of time and the lives of individual human beings. When people step into the work they transform it. The space ceases to be abstract and becomes real, animated and alive. Without an audience this work can never be complete.'

Ryuji Miyamoto b1947
'I began the series **Inside Out, Upside Down** because I found it interesting that the images I made using the Pin hole houses appeared as they did. Images are received upside down on the retina of the human eye, which is itself a form of camera. Looking at the photos helps us to recognize that the world we are seeing is always "relative".'

Rogues' Gallery: Yasuhiko Hamachi b1970, **Yukihisa Nakase** b1971
The environment which we occupy on a daily basis is full of hidden elements, things we are not always conscious of. We are interested in extracting that which is not immediately apparent in our daily lives and converting it into real experience. **Residual Noise** encourages the audience to rediscover the phenomenon of sound.

Shimabuku b1969

Hiroshi Sugimoto b1948
'**Accelerated Buddha** began as 48 photographs of the 1,000 Buddha figures at the Hall of Thirty-Three Bays in Kyoto. One after the other, these individual images were photographed on video. The video of the 48 photographs of the 1,000 Buddhas was then looped 100 times so when you watch this video you are meeting 100,000 Buddhas in a mere five minutes. The lithographs on the wall, **In Praise of Shadows**, were made by photographing with the camera's aperture open for the time it took for a candle to burn. As the evening breeze fluttered the flame, my camera collected the trace of light and time on its film. Maybe it has to do with making the visible invisible.'

Atsuko Tanaka b1932

Yuji Watabe b1974
'I use my drawing to document and express my personal memories. I draw on the wall because it is permanent. I want to transfer the memories on to the wall as fast as possible. It is essential that the girls on the wall are my friends because with these drawings I want to keep the moments which I have shared with these girls. Through the work, I want to the audience to experience the invisible: time.'

Upper level

Design	Cartlidge Levene
Project	Selfridges Birmingham brochure
Date	2001
Architects	Future Systems

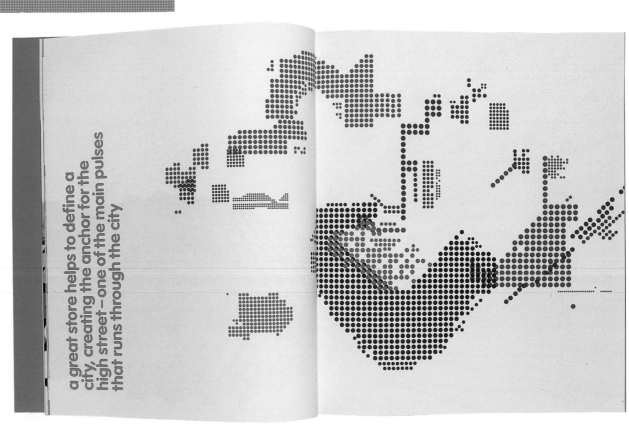

a great store helps to define a city, creating the anchor for the high street – one of the main pulses that runs through the city

Selfridges department stores and the architectural firm Future Systems requested the help of the London-based design consultancy Cartlidge Levene to design a promotional brochure for a new Selfridges store to be opened in Birmingham. Targeted at fashion brand owners, who might open branded concessions in the store, the aim of the brochure was to generate interest in the as yet unbuilt Birmingham Selfridges. The brochure includes models by Future Systems showing the proposed new building, whose organic form is covered with circular discs. The motif is used throughout the brochure as a graphic device. The publication includes a map showing the customer catchment area in and around the city of Birmingham, demonstrating the potential of the area to investors, and making a graphic feature of further abstractions of the map in different colours.

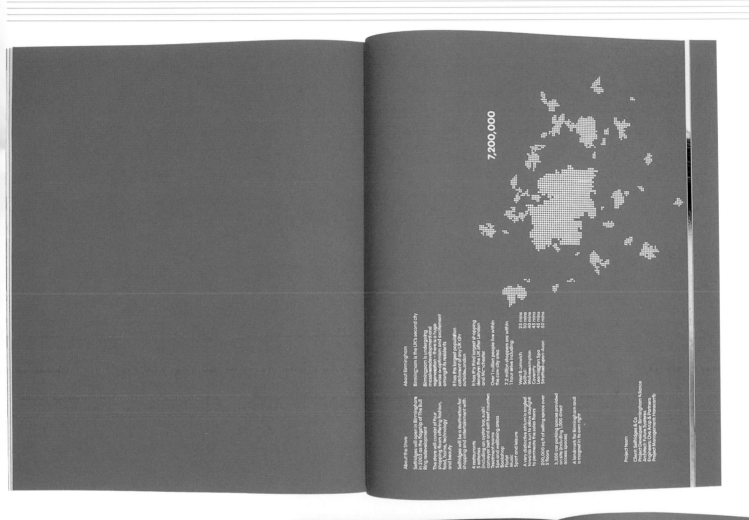

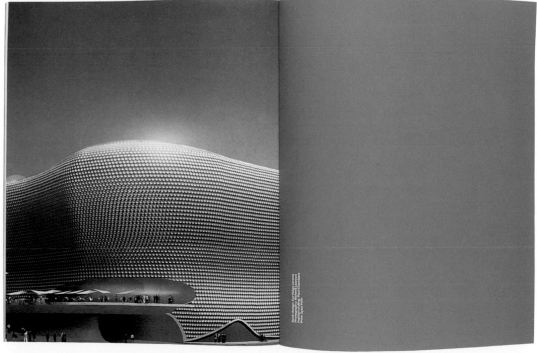

Design Build
Project 'TRVL'.
Date 2001

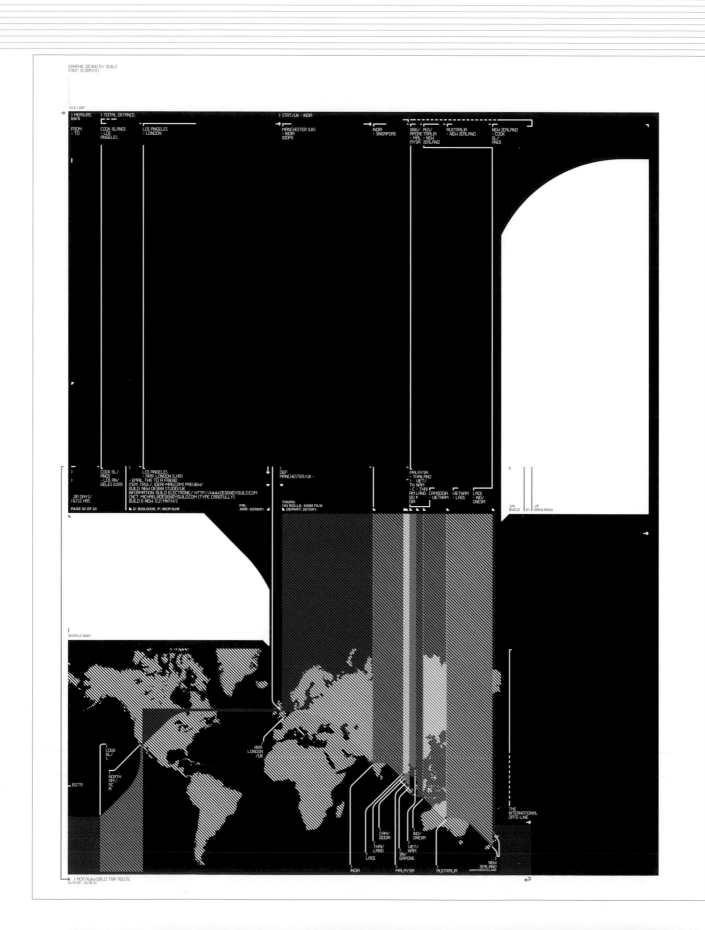

ild is a UK-based design consultancy established by
chael Place, who was previously employed at The
signers Republic. When he was commissioned by the
anese graphic design journal Idea to produce a piece
work, he chose to base it on the 281-day round-the-
rld trip he had taken between leaving The Designers
public and founding Build. The resulting piece is a
pplement/book which acts as a travelogue – a graphic
piction of the journey.

'TRVL', as it was titled, is a 24-page
French-folded publication featuring photographs taken
during the trip, which are supported by and cross-
referenced with location/map references and records of
times and distances travelled. Each page represents a
stage of the journey, identified by arrival and departure
times and related data.

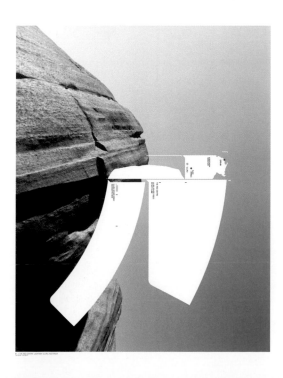

Design Nick Thornton-Jones/Warren Du Preez
Project Human mapping research project
Date 2001

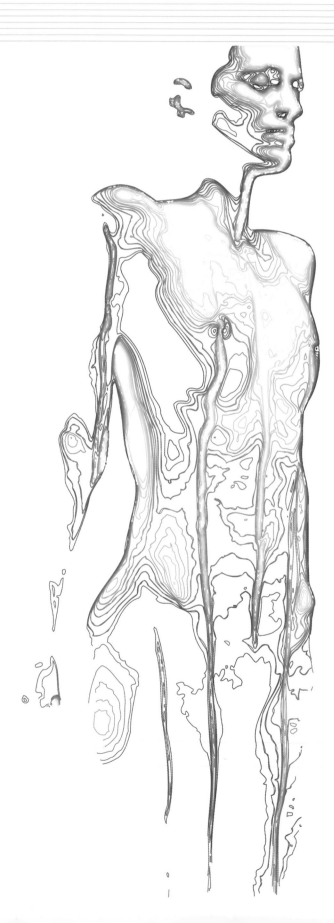
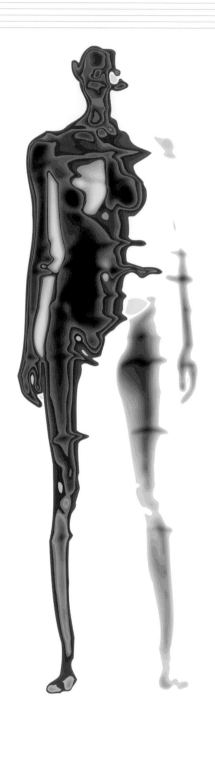

Nick Thornton-Jones and Warren Du Preez work together as image creators. With Du Preez coming from a fashion photography background and Thornton-Jones coming from graphic design and illustration, together they blur the boundaries between photography and digital illustration. The work shown here is part of an ongoing research project into the abstraction and reduction of the human form into light and contours, exploring surface, curvature, volume and perspective. They are interested in discovering a point at which a photograph becomes a graphic representation, and how far this representation can be pushed. By reducing images of the body to a series of tonal contour lines, the pair explore a level of information about shape and form that is not normally evident – or at least given prominence – in representations of the human figure.

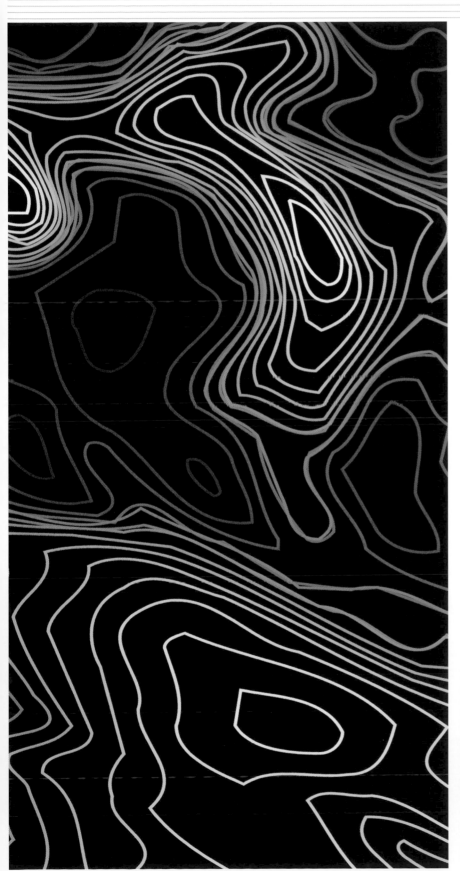

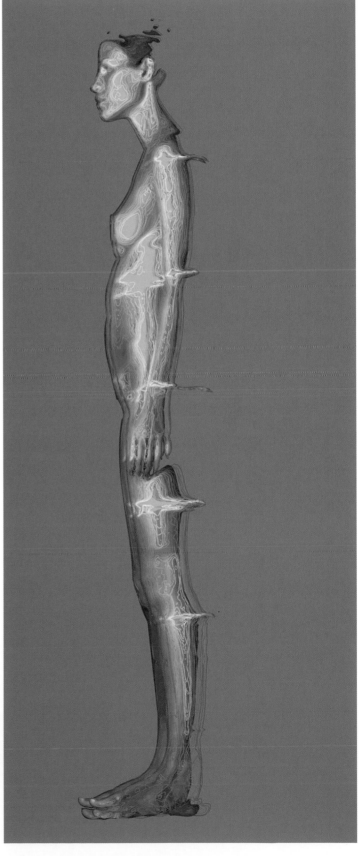

Studio Sinutype
Design Maik Stapelberg and Daniel Fritz
Project 'AM7/The Sun Years'
Date 2001

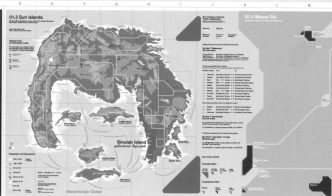

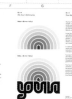

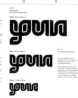

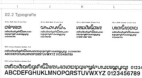

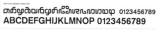

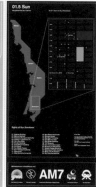

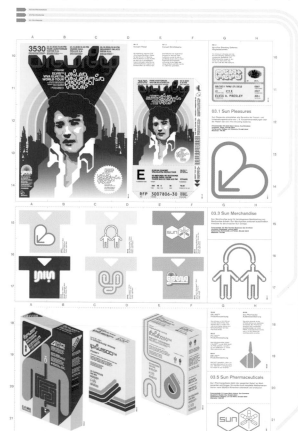

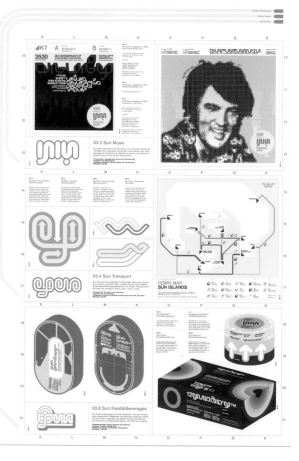

The 'Akademische Mitteilungen' (Academic Announcements) is a publication of the Academy of Arts and Design in Stuttgart, Germany. The magazine is published once a year by two graphic design students from the academy. The content of the magazine is always based around one main theme. The seventh issue of the magazine, designed by Daniel Fritz and Maik Stapelberg, was titled 'AM7'. The theme running throughout this issue was 'communication'.

The AM7 Sun Poster elaborates on an article written in the magazine called 'Sun Years', which is a fictional story about Elvis being kidnapped, after an alien race listened to his music which was on the golden record sent on a Voyager probe in 1977. The poster, which measures 1185 x 835mm, shows a series of very elaborate and stylistic maps for the fictional world 'Planet Roosta' whose continents bear a striking resemblance to a portrait of the King himself.

The poster forms a total graphic manual for Planet Roosta, showing everything from corporate colour palette and typeface to pharmaceutical and food packaging, and maps the entire infrastructure of the civiliasation. It includes a revised map of the solar system, a world map, a map of Sun Islands focusing on their roads, waterways and cities, a map of Wayon, the capital of North Alacarecca, a map of Sun, the capital of Sun Islands with a zoom-in Sun Downtown (streetmap) and also a ferry map for Sun Island (shown below).

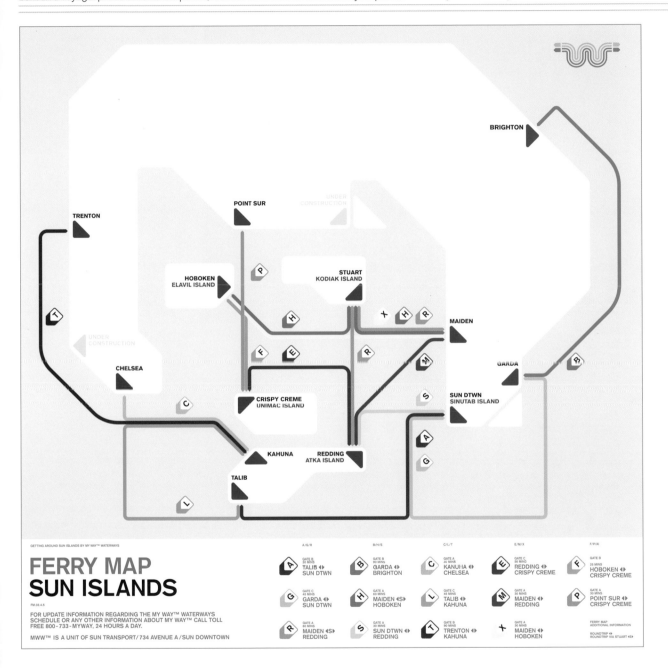

Studio	Sinutype
Design	Maik Stapelberg and Daniel Fritz
Project	'AM7/The Sun Years'
Date	2001

01.1 Sonnensystem

Illustration des Sonnensystems und des Voyager Vorfalls

The inner solar system

The solar system consists of the Sun, the 10 planets, midnight satellites of the planets, a large number of small bodies and the interplanetary medium.

The inner solar system contains the Sun, Mercury, Venus, Earth and Mars.

01.1.1 Planet Earth
08.01.1977
The Voyager probe started from Kennedy Space-Center Cape-Canaveral/USA.
16.08.1977
Kidnapping of Elvis Presley by Tourist crew members.

01.1.2 Planet Roosta
22.04.1977
Alacareccian spaceship Tourist Cyrall Stain, Setisch Harlay and Vew Chuchut.
16.08.1977
Kidnapping of Elvis Presley and preteens of his death.

The outer solar system

The planets which are located in the outer solar system are Jupiter, Roosta, Saturn, Uranus, Neptune and Pluto.

01.2 Roosta

Roosta-Karte mit allen Kontinenten und Ozeanen

North Alacarecca
Surface: 5.599.063 qkm
Inhabitant: 184.987.206 ± 35 per qkm
Capital: Wayon
Bookish Language: Alacareccian and English
Gross National Product: 24.740 FN per Inhabitant

South Alacarecca
Surface: 3.321.037 qkm
Inhabitant: 103.073.164 ± 32 per qkm
Capital: Aksan
Bookish Language: Alacareccian, Alsanian and English
Gross National Product: 2.980 FN per Inhabitant

Bracillia
Surface: 10.663.000 qkm
Inhabitant: 245.250.190 ± 23 per qkm
Capital: Cillia
Bookish Language: Brazilian
Gross National Product: 2.900 FN per Inhabitant

Surinemo
Surface: 7.240.025 qkm
Inhabitant: 188.240.650 ± 26 per qkm
Capital: Goljaba
Bookish Language: Surinemi
Gross National Product: 12.350 FN per Inhabitant

Ostralia
Surface: 6.230.050 qkm
Inhabitant: 155.501.250 ± 25 per qkm
Capital: Ramos
Bookish Language: Ostralian and English
Gross National Product: 3.340 FN per Inhabitant

Wayon
Surface: 141.080 qkm
Inhabitant: 17.635.000 ± 125 per qkm
Center: Downtown

Alacareccian Ocean
Surface: 106.220.050 qkm
Average Depth: 3.936 m
Deepest Point: 11.456 m

Blender Ocean
Surface: 185.334.024 qkm
Average Depth: 3.584 m
Deepest Point: 12.456 m

Sun Islands
Surface: 55.080 qkm
Inhabitant: 1.266.840 ± 23 per qkm
Capital: Sun

Algol Ocean
Surface: 240.220.050 qkm
Average Depth: 4.986 m
Deepest Point: 9.435 m

Additional Information:

For information about the Roosta Map or any other information concerning Roosta call toll free 800-733-ROOSTA, 24 hours a day.

Copyright:
Ares 3527 Sun Information
Visuals:
Felton, Jarvis & Associates, Tampa

01.3 Sun Islands

Die Sun Islands bestehen aus den Inseln: Sun Island, Atka Island, Elavil Island, Kodiak Island, Unimac Island.

Map of Sun Islands with cities, roads and ferry connections

National Parks and Recreation Areas

For information about National Parks and Recreation Areas please contact the respective Parkland Organization.

1 Klondike Mountains National Park
2 Muir Woods National Park Recreation Area
3 Def Woods Recreation Area

N

Topography and Hydrography

	Heights in meters
2000 to 3000	
1000 to 2000	
500 to 1000	
200 to 500	
Sealevel to 200	
Sealevel to 50	
50 to 200	
200 to 2000	Depths in meters

Scale 1:1.000.000 (1cm = 10 km)
A Sun Cyan grid unit indicates a 45 km square.

09–02–3527
This map may not be sold or offered for sale without written permission from the Sun Transport Authority.

Copyright
Ares 3527 Sun Transport Authority
Visuals
Felton, Jarvis & Associates, Tampa

Elavil Island

Kodiak Island

Unimac Island

Sinutab Island

Atka Island

Madeline Island

Alacareccian Ocean

Shown here in more detail are: a revised map of the solar system, a world map, a map of Sun Islands focusing on its roads, waterways and cities, a map of Wayon, the capital of North Alacarecca, a map of Sun, and the capital of Sun Islands with a zoom-in Sun Downtown (streetmap).

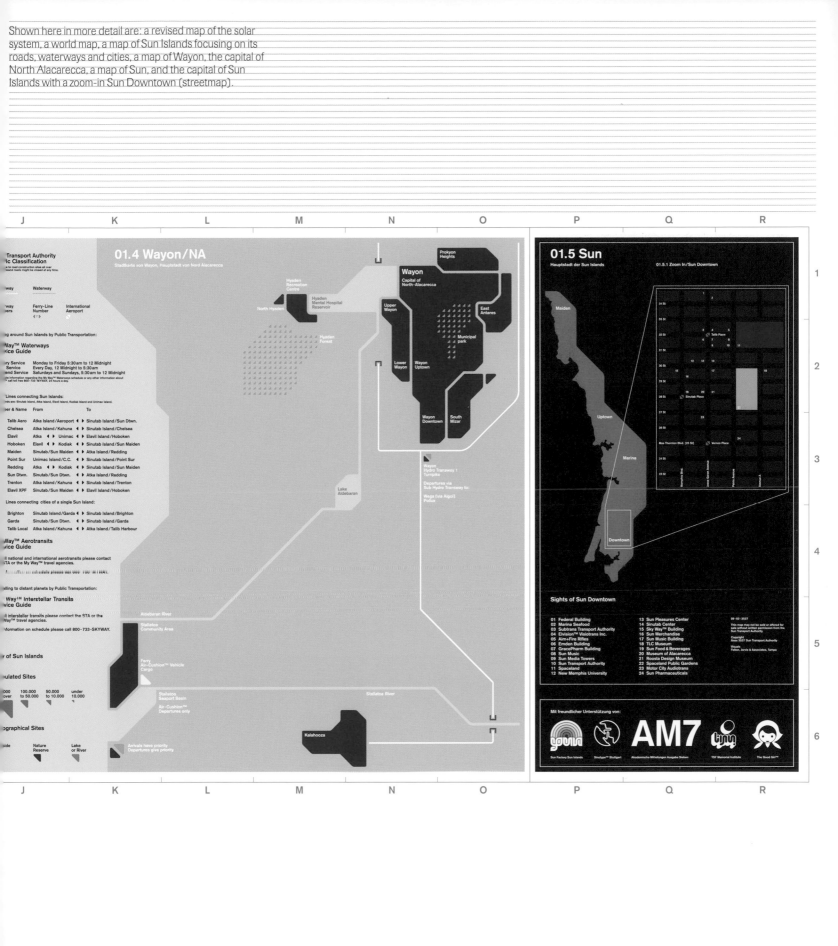

Studio Sinutype
Design Maik Stapelberg and Daniel Fritz
Project AM7/File Exchange
Date 2001

participants 01
joergbauerdesign, eboy, designklinik, vectorama,
extra design, augenbluten, sweden graphics

participants 02
norm, lahm, linientreu, michael waterfield,
jasper goodall, phunkstudio, laurent fétis

file exchange

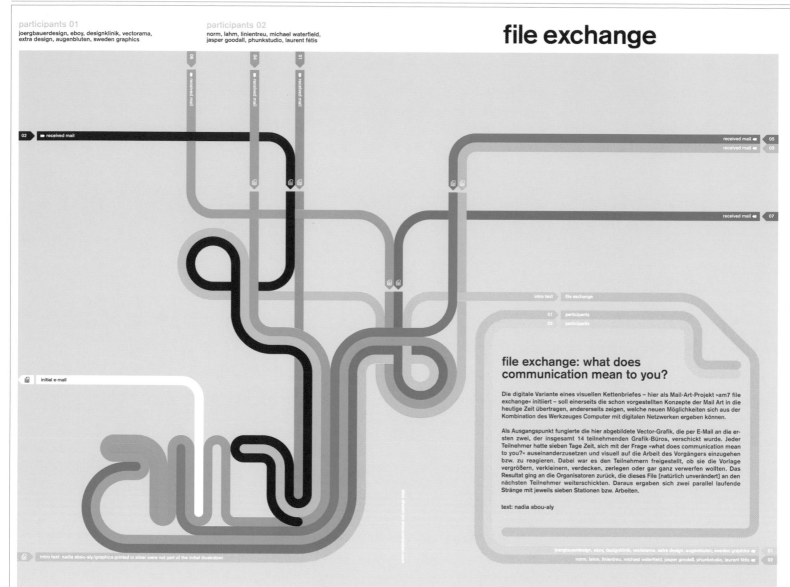

file exchange: what does communication mean to you?

Die digitale Variante eines visuellen Kettenbriefes – hier als Mail-Art-Projekt »am7 file exchange« initiiert – soll einerseits die schon vorgestellten Konzepte der Mail Art in die heutige Zeit übertragen, andererseits zeigen, welche neuen Möglichkeiten sich aus der Kombination des Werkzeuges Computer mit digitalen Netzwerken ergeben können.

Als Ausgangspunkt fungierte die hier abgebildete Vector-Grafik, die per E-Mail an die ersten zwei, der insgesamt 14 teilnehmenden Grafik-Büros, verschickt wurde. Jeder Teilnehmer hatte sieben Tage Zeit, sich mit der Frage »what does communication mean to you?« auseinanderzusetzen und visuell auf die Arbeit des Vorgängers einzugehen bzw. zu reagieren. Dabei war es den Teilnehmern freigestellt, ob sie die Vorlage vergrößern, verkleinern, verdecken, zerlegen oder gar ganz verwerfen wollten. Das Resultat ging an die Organisatoren zurück, die dieses File [natürlich unverändert] an den nächsten Teilnehmer weiterschickten. Daraus ergaben sich zwei parallel laufende Stränge mit jeweils sieben Stationen bzw. Arbeiten.

text: nadia abou-aly

With the File Exchange, another project for AM7, Fritz and Stapelberg wanted to create a spontaneous, communicative event paying tribute to the concepts of mail-art. They built a network of 14 graphic design groups from different countries and cities using mass media (Internet), to interact/collaborate on a given subject (what does communication mean to you?), thereby creating a collective-visual work in a unpredictable way which – in the final viewing – is as surprising to the participants as it is to the viewer. Contributors to the File Exchange project included Norm, Lahm, joergbauerdesign and Peter Stemmler (eboy).

01.1
joergbauerdesign: jan maier
stuttgart, germany

01.2
eboy: peter stemmler
new york, usa

02.1
norm: dimitri bruni, manuel krebs
zurich, switzerland

02.2
lahm: lutz eberle, andreas jung, marcus wichmann
stuttgart, germany

Design Lust
Project Lust Map
Date 1995

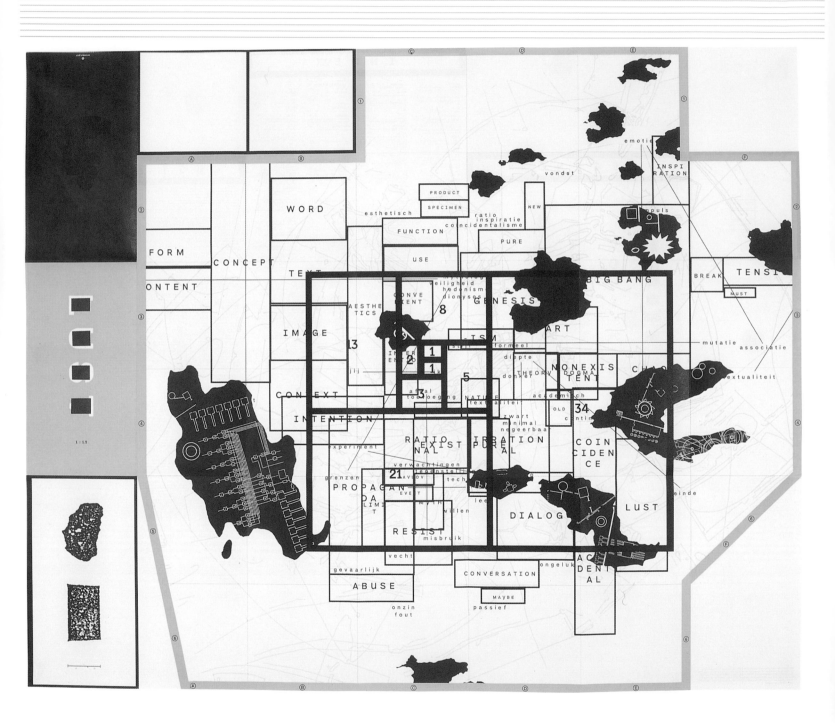

This map functions as a conceptual guide to the inner workings of the studio that designed it, Lust. It was created as a map to accompany two separate design projects, one being a study of the role of coincidence and association in graphic design, and the other being the implementation of these concepts in relation to architecture and urban structures. According to the designers, the key elements of the map which directly relate to the Lust design philosophy and methodology include an associative collection of words, a ratio of magnification, a virtual legend, a relative scale, an index of self-defined words and images, coincidental spaces, architectural and urban structures, the Golden Section, Fibonacci numbers, an intentionally broken piece of glass, a black square, and a pin-up girl.

Design Browns
Project '0°'
Date 1999
Photography John Wildgoose

duced in time for the Millennium celebrations at the end
1999, '0°' is a beautifully produced book showing the
rk of the photographer John Wildgoose. The book
ows the Greenwich Meridian as it passes through
gland, from Peacehaven in the south to Tunstall in the
rth. The line, which represents the Prime Meridian of the
orld – 0° longitude – dictates that every place on earth is
easured in terms of its distance east or west of it. From
ing chalk hills to flatlands, the images are held together
that invisible man-made thread which circles the world.
ages were taken directly north or south along the 0° line.
othing was chosen for its particular beauty or ugliness,
d nothing was shot for political reasons. The only arbiter
s the line.

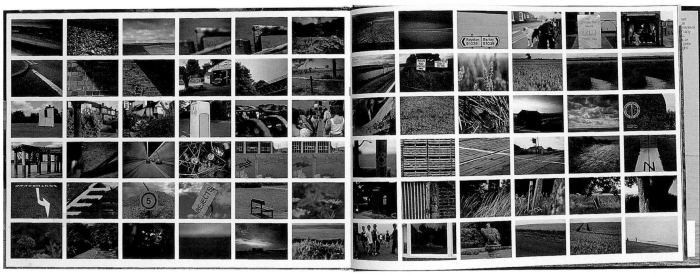

duced in time for the Millennium celebrations at the end
1999, '0°' is a beautifully produced book showing the
rk of the photographer John Wildgoose. The book
ows the Greenwich Meridian as it passes through
gland, from Peacehaven in the south to Tunstall in the
rth. The line, which represents the Prime Meridian of the
orld – 0° longitude – dictates that every place on earth is
easured in terms of its distance east or west of it. From
ing chalk hills to flatlands, the images are held together
that invisible man-made thread which circles the world.
ages were taken directly north or south along the 0° line.
othing was chosen for its particular beauty or ugliness,
d nothing was shot for political reasons. The only arbiter
s the line.

02 _ Inhabitable space

Café/Bar
Gardens Café Bar

The inhabitable map

Essay by William Owen + Fenella Collingridge
066/067

The dividing line between the map, the landscape and the narratives scored onto it by man can be very slim. Subject and object have a tendency to intersect and fuse, each influencing the other. Before humans made maps they incised them on the landscape – both small signs and megamaps marking out territory or homestead, naming places and objects and providing orientation. The handheld map, whether made of stone, papyrus or paper, comes much later.

Man-made marks on the landscape have large ambitions: they tell narratives of life and death and attempt to control and moderate nature. There are numerous examples of these megamappings at huge scale still in existence. The Egyptian necropolis plots the path to the underworld; the giant neolithic chalk figures in southern England proclaim fertility and virility; the intaglio geoglyphs (incised pictures) in Blythe, California, are barely visible from the ground but vast when seen from the air. Another example would be the extraordinary Nazca lines in Peru which are believed to be a model at a huge scale of the drainage from the Andes mountains into the Nazca desert, with ceremonial walkways travelled by the map's makers to encourage the water down.

We have our modern equivalents in art, architecture and engineering of people's attempts to feel as large as the landscape they inhabit. The artist Christo wrapped in fabric (and remade) whole coastlines and photographed them from the air. In the United States the National Survey and Land Acts have recreated the literal appearance of a map on the surface of the western states, marked out in the chequerboard landscape of 1-mile squares created by fields and roads that religiously follow the survey lines. This repetitious, hyper-rationalist grid deviates only to pass insurmountable natural obstacles such as rivers, canyons or mountain ranges. Here is a case of the mapmakers not merely recording the landscape, but subjugating it, however imperfectly.

The modern city, too, is subtly and not so subtly marked in many hundreds of ways by objects, signs and symbols that exist only to map it and help us read the way. We insert small clues throughout the built environment to enable identification and orientation in cultural and geographical matters. Church spires and skyscrapers over-reach sight lines and provide orientation and locus; textured curbstones mark the boundary between road and walkway; signs identify buildings and their purpose or ownership; brass studs set into the pavement delineate property boundaries; viewpoints along major routes relate goal to starting point; and different districts are identified by their unique building types. These visual and textural cues are like a trail left by a pathfinder, clues to help us in our quest of navigation and exploration. We only register their importance where a city or suburb is visually homogenous, perhaps because – like Tokyo, for example – there are only one or two discernible historical layers, or because we are unfamiliar with the cultural signs of difference. The result is disorientation.

Every city and every district contains key modes of outlet or entry, often subway stations or rail termini, portals at which orientation is a critical issue and which establish the city's rhythm. Rational signage systems are built around these points, providing the text and directional markers that complete the inhabitable map.

Signage is a complex subset of information design that combines architectural, graphic and industrial design skills with a cartographer's understanding of theme. One signage system cannot serve every user. Some users may be visitors, with little knowledge of the city; others may be residents, familiar with the overall pattern but not the detail of certain districts. Some users will want to stay; others only want to leave. Some users may be travelling rapidly by car or bicycle, others by foot. Some users will be interested only in tourist sites, others in utilities like hospitals or transport. There are, clearly, only a limited number of themes, modes of

Knowledge of a navigator's identity, location and intention is the holy grail of signage designers but something that in reality they can make only crude assumptions about.

Intégral Ruedi Baur
et Associés
Parc et Musée
Archéologique de
Kalkriese
092/093

Peter Anderson
Poles of Influence
096/097

Lust
Open Ateliers
2000
084/085

passage and user goals that can be served by a single signage system before it overloads and collapses under its own weight.

Knowledge of a navigator's identity, location and intention is the holy grail of signage designers but something that in reality they can make only crude assumptions about. If we were to make the ideal sign or map, we would know these things. And likewise, we would reintegrate the inhabitable three-dimensional landscape with the two-dimensional map so that they became one thing.

Digital technology brings us much nearer to the reintegration of sign, map and landscape, in the form of the mobile phone. Third generation mobile technology is not only capable of downloading video and cartographic data, but it is also location-sensitive, knows the identity of the user, and may through customisation or personalisation know or infer specific intentions at any one point in time.

Geographic Information Systems offer the potential to enable mobile phone users to interrogate objects, buildings – even people – or any selected thematic layer within the landscape (each will carry attribute data located at a specific logical address in the digital space that parallels its real address in the physical landscape), to push or pull information about events, services, times or offers at the user as well, of course, as acting as a traditional pictorial map.

Digital production, reproduction and distribution has exciting (and dreadful) implications for the way we make and use maps, and for the effect on the landscape maps survey.

First of all, we may no longer be using shared maps – as are the thousands of identical multiple-run printed maps – but ones that are unique to ourselves, with levels of access to information and control over the space of the city that varies according to all sorts of factors such as our personal selection, our credit card status, our phone company

or our technical ability. Individuals may develop radically different viewpoints on the same location.

Secondly, the digital map may also map its user (the map knows its own location) and so there is the obvious possibility that a map of map-readers can be created, shifting constantly in real time as the readers move about. Feedback effects can result, as the world that is mapped changes according to the action of individuals responding to the map. This happens in printed maps too, but more slowly (the guide book recommends a restaurant, which as a result becomes overcrowded and therefore undesirable).

These feedback effects might create interesting and bizarre situations in a world in which we can survey, reproduce and distribute maps of the landscape instantaneously (mapping in real time). The flocking effect of in-car navigation systems, whereby the more cars that use the system and take similar congestion avoidance action, the more quickly alternative centres of congestion are created, is a prototypical example.

Real time mapping (using the appropriate sensors) enables us to map many new classes of object including those (like map readers) that are impermanent and highly localised: goods for sale, in storage or transit, for example; vehicles on the road; events; discarded items; pollution; weather. Knowledge of these things will affect their properties and relationships with each other and us. One can envisage that the overall effect could be a massive acceleration of change and a huge concentration of power and therefore value in the map. It is worth remembering, then, that in the Renaissance a map cost the equivalent of many thousands of times what it does today. The real time, location-aware, identity-aware, intention-aware maps of tomorrow may be equally valuable to their users.

Man-made marks on the landscape have large ambitions: they attempt to control and moderate nature.

Design	Projekttriangle
Project	Krypthästhesie
Date	2000

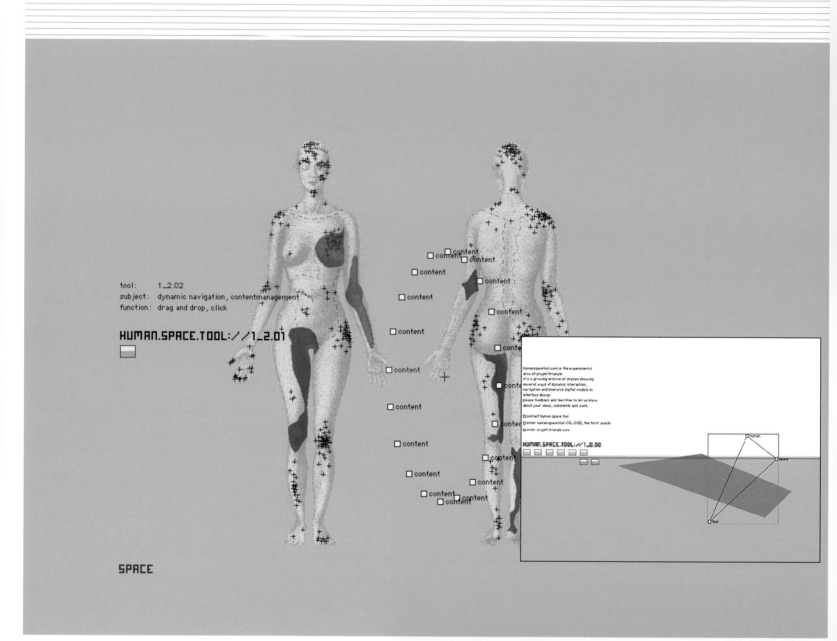

tool: 1_2.02
subject: dynamic navigation, contentmanagement
function: drag and drop, click

HUMAN.SPACE.TOOL://1_2.01

SPACE

The mapping system Krypthästhesie was developed from German design company Projekttriangle's researches into a new and more effective way of finding and presenting information concealed in the multiplicity of data. "Our study is years ahead of the technology needed to implement it," says Martin Grothmaak of Projekttriangle. "We don't wait with our designs for the engineering to be available to put them into practice. What interests us is not the media themselves but intermedia relationships, in particular the inter-relationships between man and medium. Human beings are always at the centre of our interface design."

This research tool looks for information in big databases or on the Internet, evaluates it and displays it geometrically. The dynamic model illustrates both the content-based relationships between search criteria and the generation of search results. The results appear not as a list but as data clouds in the form of points in a circle around the central search word. If you search for information about 'Japan', for example, all the available information on that country appears as points distributed in a circle. A dynamic data map is created on the surface which permits a geographical orientation. The points closest to the search word contain a lot of information about Japan and the more distant ones less. If a second word – 'museums' – is entered at the edge of the circle the points rearrange themselves dynamically. They move towards the word to which they are most closely related. The user can now look at a point in more detail that is close to the word 'museums' but relatively far from 'Japan'. The information revealed when one clicks on the point turns out to be a museum of ethnology with Japanese exhibits.

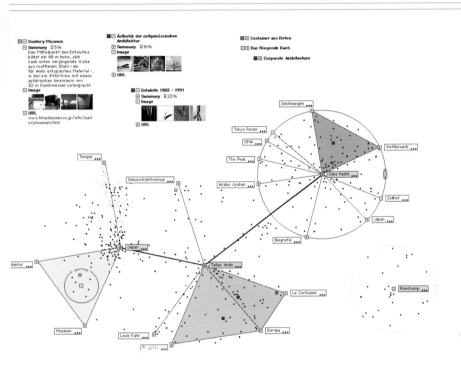

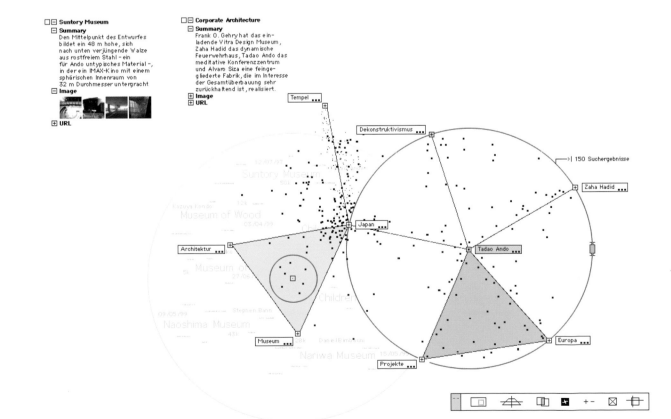

Design	Lust
Project	Atelier HSL web site
Date	2001

ATELIER HSL

WAT IS ATELIER HSL

N S
P U UR-
D DE A
O SN. H. D.
IJ Z

EEN KUNST- EN
URPR
GRAM A RO D
DE
HO HEID.
SLIJN-ZUID

EE KUNST-
EN CULTUUR-
PR GRAMMA
RO D DE
HO ESNELHEID
SLI N-ZUID

DE SN

ATELIER HSL IS EEN LABORATORIUM EN KATALYSATOR VOOR CULTURELE PROJECTEN ROND DE HSL. IN DIT LABORATORIUM

VINDT ONDERZOEK PLAATS NAAR DE CULTURELE EN MAATSCHAPPELIJKE BETEKENIS

VAN DE HOGESNELHEIDSLIJN EN HET TOEKOMSTIGE GEBRUIK ERVAN.

Dit gebeurt door middel van het geven van opdrachten aan kunstenaars, het organiseren van tentoonstellingen en symposia en het publiceren van uitgaven. Maar Atelier HSL staat ook open voor ideeën en concepten van anderen. Atelier HSL ontwikkelt activiteiten voor een

publiek: (toekomstige) reizigers, geïnteresseerden, en omwonenden langs het tracé van de hogesnelheidslijn, professionals en liefhebbers uit de wereld van kunst en cultuur.nenden langs het tracé van de hogesnelheidslijn, professionals en liefhebbers uit de wereld van kunst en cultuur.

WAT IS DE CULTURELE IMPACT VAN DE HSL LIJN

De HSL-Zuid verbindt Nederland in 2006 met het Europese net van hogesnelheidslijnen. De lijn doorsnijdt en transformeert het door mensenhanden aangelegde polderlandschap en beïnvloedt het stedelijke landschap. De HSL levert een bijdrage aan

Het bijna 100 kilometer lange tracé loopt dwars door Nederland en telt tal van 'kunstwerken'. Bruggen, viaducten en tunnels vormen een aaneenschakeling van monumenten van moderne techno

Evenzo omvangrijk en indrukwekkend is de ingreep die in de ruimtelijke, maatschappelijk en logistieke omgeving van de lijn plaatsvindt.

BEKIJK EEN INTERACTIEVE VERBEELDING

DE HOGESNEL
H. NEN
V RME
S RARS T
F SIE N
C
INTERNET VAN
EUROPA.

SITE

sla over

Atelier HSL is an arts and cultural programme based around the Dutch High Speed Rail Line. Its web site functions as a medium where activities surrounding HSL are presented on-line. The concept for the interface is a matrix of points that symbolises points on a map and the distance between them. Since the arrival of the HSL, time and distance have become relative because of speed. Cities are drawn closer together: to a traveller, Amsterdam will be 'nearer' to Paris than to a southern Dutch city such as Maastricht. By the expansion and contraction of the points of the matrix, areas are created for the content of the site. This expansion and contraction relates back to the idea of the relativity of time and distance.

LABORA-
TORIUM

SKOR

HSL-Zuid

Werkplan 7 Thema's Scenario **Atelier HSL** **En route**

Nieuws

Design	Cartlidge Levene
Project	Process type movie
Date	2001

With no brief, apart from that the design company wished
to be represented by an on-screen piece of work in an
exhibition organised by the International Society of
Typographic Designers held in London, Cartlidge Levene
created the design shown here. The content of the seven-
minute on-screen loop was created directly from dialogue
around the subject of what the piece may become – a
representation of conversation, over time, using
typography and sound. The animated typography
highlights structures and links though the repetition of
words. Letters are repeated, removed and distorted during
the loop.

— one thing I ▮▮▮▮▮ be bad
to ▮▮▮▮▮, so it's not — I can just imagine. things?
just ▮▮▮▮▮, but,

Design	Tomato Interactive
Project	Sony Vaio interface
Date	2001

Developed as an interface for the Sony Vaio system,
Tomato Interactive produced this on-screen navigational
world, in which the viewer can click on a morphic blob and
be transferred to another location and culture. Despite
containing a huge wealth of information, the system is
straightforward and simple to interact with.

"A monk visited eight sacred places for Buddhist, and writes up about the travel. Included here are
topics about Buddha, Gandhi, and Taj Mahal."

Road to Buddha

WORLD HERITAGE

Taj Mahal/Agra Fort (India)

Taj Mahal/Agra Fort (India)

WORLD HERITAGE

Chronological explanation about the events in ancient China enables you to grasp rather easily.

Chronicles Ancient Chronicles

WORLD HERITAGE

Design Fibre
Project Diesel StyleLab
Date 2001

Diesel's cutting edge clothing range, StyleLab,
commissioned London-based graphic design consultancy
Fibre to produce a CD-Rom as a directional tool for the
company's ethos. The interface is based loosely on a
molecular structure, which moves and morphs shape as
the mouse is moved around the area. By clicking on a blue
circle a key word appears together with a close-up macro
photographic detail of a garment. By using the plus and
minus icons the viewer can travel deeper into the system.

Design	Fibre
Project	cc2000
Date	2000

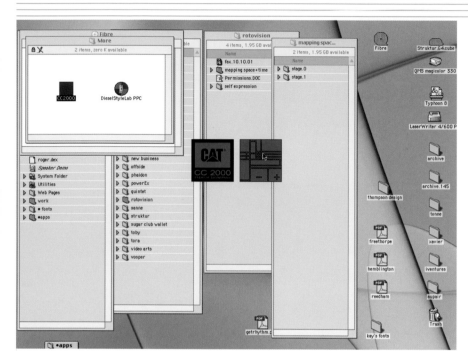

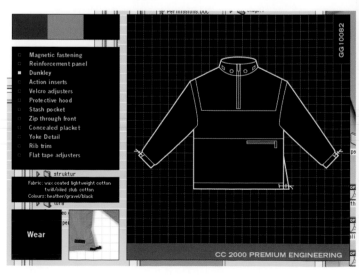

Produced to promote Cat's (Caterpillar Clothing)
collection, Fibre produced a CD-Rom-based interface. The
programme runs just in the central area of the screen,
leaving all the other desktop windows visible, visually
suggesting that the cc2000 interface floats over the 'urban'
landscape of the user's computer. The interface is broken
down into several sections such as Wear, Experience,
Image, Signs and Watch, and the content of these modules
varies widely, from narrated stories and an exhibition
events guide, to showing the actual clothing. The
navigational system works by using the mouse to scroll
over a moving grid matrix; the section names pop up as
you scroll, and the section is entered by clicking on the
section name as it floats over the navigation box.

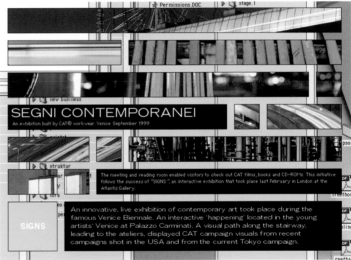

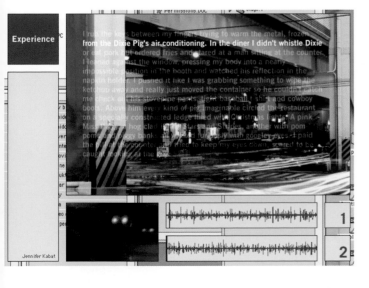

Design	Spin
Project	Tourist
Date	2002

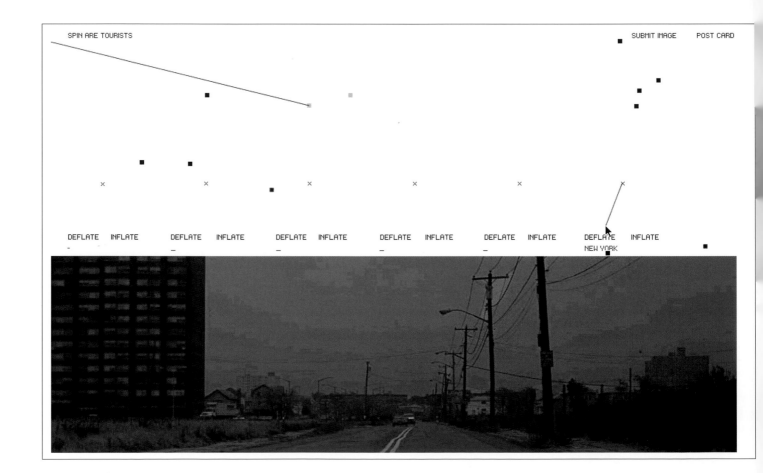

SPIN ARE TOURISTS SUBMIT IMAGE POST CARD

DEFLATE INFLATE DEFLATE INFLATE DEFLATE INFLATE DEFLATE INFLATE DEFLATE INFLATE DEFLATE INFLATE
– – – – – – – – – – NEW YORK

Every year the design consultancy Spin sends its designers to unknown destinations to encourage them to develop their own responses to what they find. Tourist is a self-initiated project inspired by this activity. Tourist is divided into five layers, consisting of ten items (black squares). The layers are navigated by moving the mouse close to the black crosses. Linear connections can be formed using the mouse. These activities reveal various snapshots taken at different Spin holiday locations such as Blackpool, the Isle of Wight and New York.

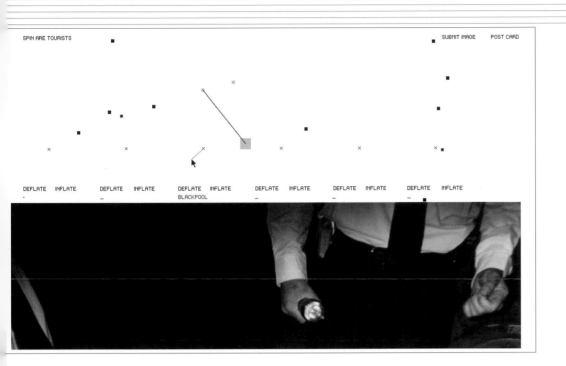

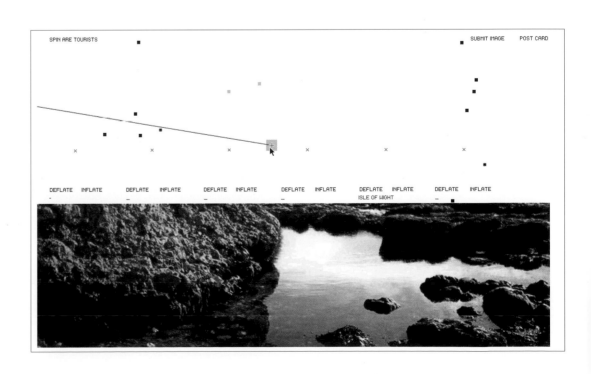

Design sans+baum
Project Future Map exhibition graphics
Date 1999

Future Map celebrates the best work of graduates from the London Institute, the umbrella body containing many of London's best-known art and design schools, and is held each year in the London Institute's gallery space near Bond Street. To emphasise the individual nature of the work, each student's contact details were printed on a series of 'jotter pads' throughout the exhibition. Sheets could be torn off and collected into a bag which was provided to visitors as they arrived. These bags were also sent out, shrink-wrapped, as private view invitations. A series of essays on larger pads were also available for collection. There was no need for any graphics on the walls or a catalogue. The jotter pad dimensions acted as a module on which all of the exhibition design was based so that graphics and build became totally integrated.

Design Lust
Project Open Ateliers 2000
Date 2000

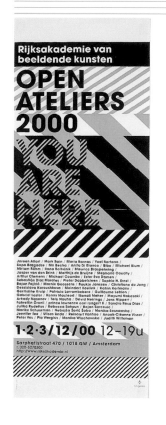

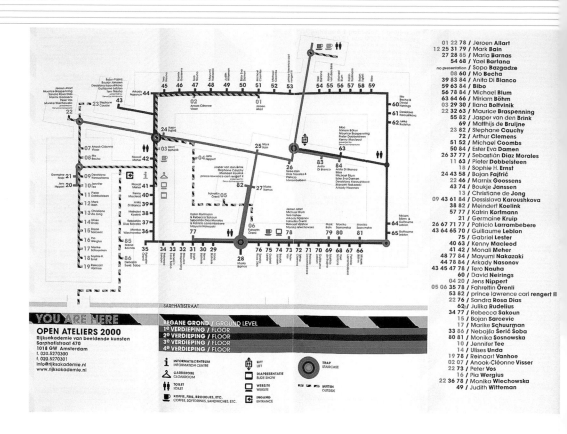

01 22 78 / Jeroen Allart
12 25 31 79 / Mark Bain
27 28 85 / Maria Barnas
54 68 / Yael Bartana
no presentation / Sopo Bazgadze
06 60 / Mo Becha
39 83 84 / Anita Di Bianco
59 63 84 / Bibo
56 78 84 / Michael Blum
63 64 66 / Miriam Böhm
03 29 30 / Ilana Boltvinik
22 32 63 / Maurice Braspenning
55 82 / Jasper van den Brink
69 / Matthijs de Bruijne
23 82 / Stephane Cauchy
72 / Arthur Clemens
51 52 / Michael Coombs
50 84 / Ester Eva Damen
26 37 77 / Sebastián Diaz Morales
11 63 / Pieter Dobbelsteen
18 / Sophie H. Ernst
24 43 58 / Bojan Fajtríc
22 46 / Marnix Goossens
43 74 / Boukje Janssen
13 / Christiane de Jong
09 43 61 84 / Dessislava Karoushkova
38 82 / Meindert Koelink
57 77 / Katrin Korfmann
21 / Germaine Kruip
26 67 71 77 / Patricio Larrambebere
43 64 65 70 / Guillaume Leblon
75 / Gabriel Lester
40 63 / Kenny Macleod
41 42 / Monali Meher
48 77 84 / Mayumi Nakazaki
44 78 84 / Arkady Nasonov
43 45 47 78 / Tero Nauha
60 / David Neirings
04 20 / Jens Nippert
05 06 35 78 / Fahrettin Örenli
53 82 / prince lawrence carl rengert II
22 76 / Sandra Rosa Dias
62 / Julika Rudelius
34 77 / Rebecca Sakoun
15 / Bojan Sarcevic
17 / Marike Schuurman
33 86 / Nebojša Šerić Šoba
80 81 / Monika Sosnowska
10 / Jennifer Tee
14 / Ulises Unda
19 78 / Reinaart Vanhoe
02 07 / Anook-Cléonne Visser
22 73 / Peter Vos
16 / Pia Wergius
22 36 78 / Monika Wiechowska
49 / Judith Witteman

The Rijksakademie, Amsterdam, holds an event called
Open Ateliers when the public can visit the studios of the
artists attending the school. Because of the complex
nature of the building, a major complaint in previous years
was that no-one could find their way to all of the studios.
The decision to use a metro-like map with floor markings,
as used in institutions such as hospitals, led to the main
graphic element of the print work – floor-tape. A map was
therefore designed which led the public around the
building directly to the studio of choice: no-one got lost.

Design	Frost Design
Project	Give & Take exhibition graphics
Date	2001

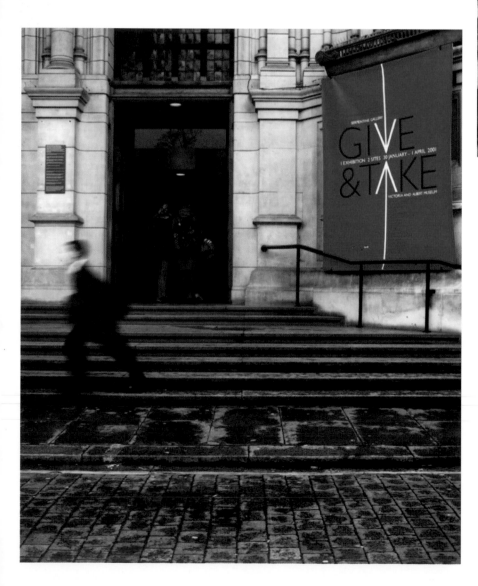

Faced with the task of producing graphics for an exhibition at the Victoria & Albert Museum (V&A) in London, Frost Design created a concept that embodied both a logo and a navigational system that ran through the entire space.

The exhibition juxtaposed permanent display artefacts with contemporary art, and the works were not confined to just one or two rooms, but ran throughout the entire museum. A strong navigational system to help guide the viewer through the labyrinth of exhibition rooms and corridors was therefore crucial.

The designers' solution was to run a red stripe along the floors (a system frequently used in hospitals to guide patients to the appropriate ward). The red line also becomes a recurring motif, appearing in the exhibition logo and graphics, the 'V' of 'give' and the 'A' of 'take' becoming arrowheads.

Design	Lust
Project	Risk Perception carpet for InfoArcadia
Date	2000

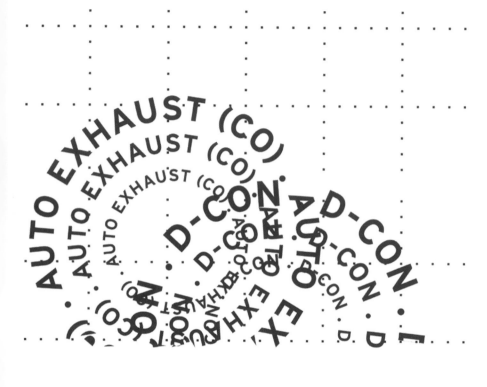

InfoArcadia is an exhibition about data, information and the manner in which they are visualised. Information graphics, instruction manuals, information landscapes, data clusters are included, but so too are more personal ideas – like mapping one's life by marking events on food tin lids. The Dutch design company Lust was asked to make a piece which interpreted the data Paul Slovic gathered through surveys on people's perception of risks in 1988. Lust selected 81 'risks' from Slovic's collection of more than 40,000 answers. A way was needed to visualise the 'x-y matrix' on which the 'risks' were mapped. The commissioner wanted a visualisation of three results of the research: factors such as 'controllable vs. uncontrollable' and 'known risk vs. unknown risk'; the desire of people for strict regulation of certain risks; and the importance of certain risks as signals to society. Lust decided that the visitor would form the third axis (z). The carpet measures 3 x 3 metres.

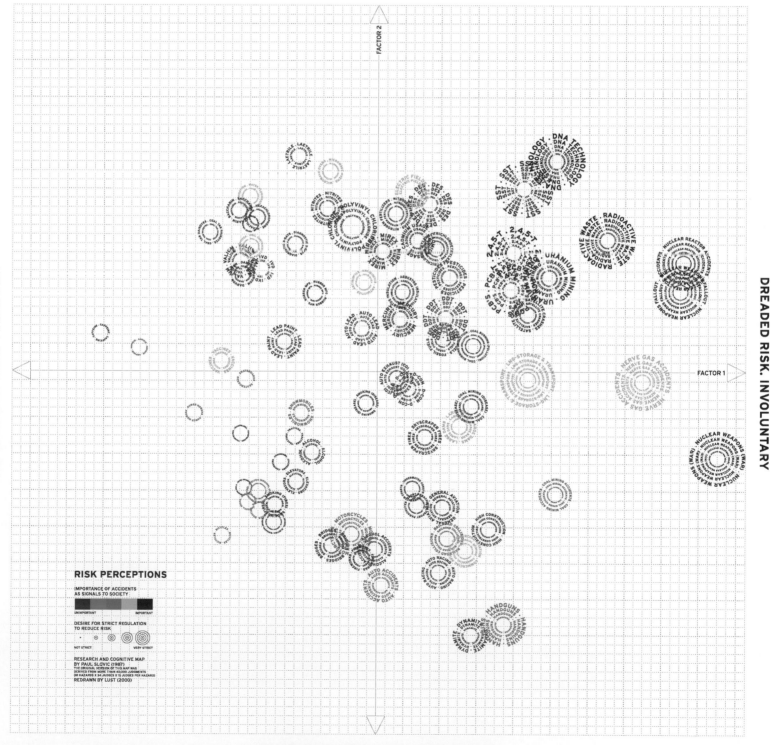

UNKNOWN RISK. NEW. DELAYED EFFECT

NOT DREADED RISK. VOLUNTARY

DREADED RISK. INVOLUNTARY

FACTOR 2

FACTOR 1

KNOWN RISK. OLD. IMMEDIATE EFFECT

RISK PERCEPTIONS

IMPORTANCE OF ACCIDENTS
AS SIGNALS TO SOCIETY

UNIMPORTANT IMPORTANT

DESIRE FOR STRICT REGULATION
TO REDUCE RISK:

NOT STRICT VERY STRICT

RESEARCH AND COGNITIVE MAP
BY PAUL SLOVIC (1987)
THE ORIGINAL VERSION OF THIS MAP WAS
DERIVED FROM MORE THAN 40,000 JUDGMENTS
(81 HAZARDS X 34 JUDGES X 15 JUDGES PER HAZARD)
REDRAWN BY LUST (2000)

Design Peter Anderson
Project Cayenne interior
Date 2000

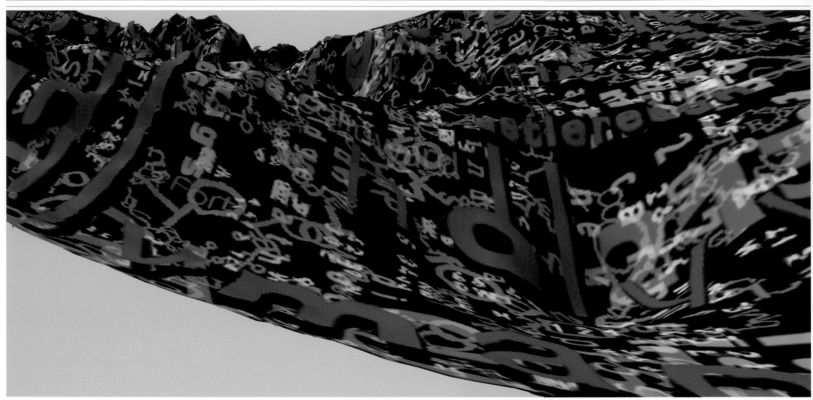

When Peter Anderson was commissioned to produce graphics for a stylish restaurant in Belfast, Northern Ireland called Cayenne, the resulting material became more art installation than just menu cover design. For a piece recessed into one wall of the restaurant (below), Anderson took as a starting point every surname in the Belfast telephone directory, then began to work this mass of typographic data into an abstraction of the Belfast street map. This random placement of names created some interesting instances of wordplay, and in a divided city where one can often tell the area where someone lives by their surname, the appearance of some names next to others created a talking point – or thinking point – for some more observant diners. Other elements of Anderson's design included a lenticular wall piece, mounted above the bar, called 'Mountain People' (left). Made up of map reference points for high points in the mountains around Belfast as well as grid references for cities around the world, the piece asks the question 'are mountain people curious? Do they always want to see what is on the other side?'

Design	Intégral Ruedi Baur et Associés
Project	Parc et Musée Archéologique de Kalkriese
Date	1999–2002
Photography	Eva Kubinyi

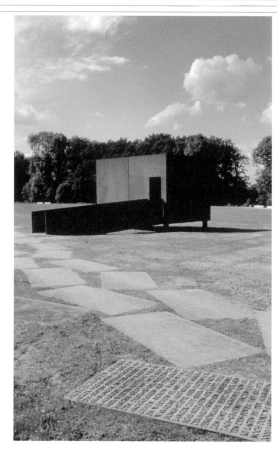

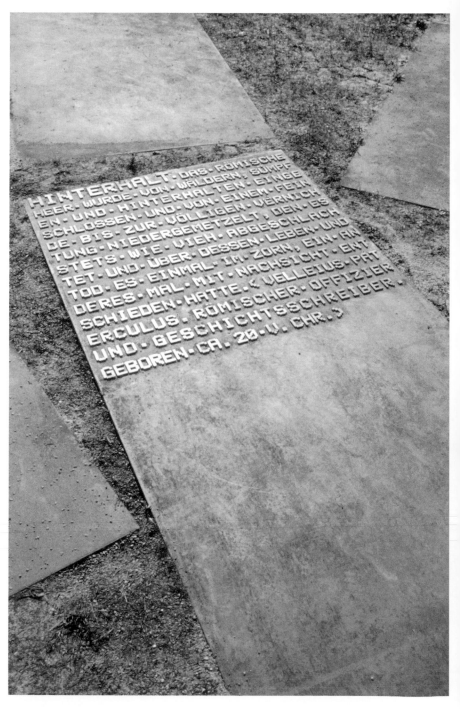

This archeological museum is located at a site where the 'Germans' beat the Romans. It tries to retrace the battle using large iron plates installed in the ground on which inscriptions in Latin and German explain the course of events. Three pavilions, constructed from corrugated iron, connect this event to the contemporary world through the expression of sensations such as seeing, hearing and understanding. The large iron slabs work as both a pathway and a directional signage system, leading the visitor through the different parts of the museum. The typography on the slabs is raised and set in a bitmapped font, all in upper case, working as a counterbalance to the history of the museum. As the iron is untreated, the surface is gradually eroded by the elements, allowing the panels to work in harmony with the surrounding nature.

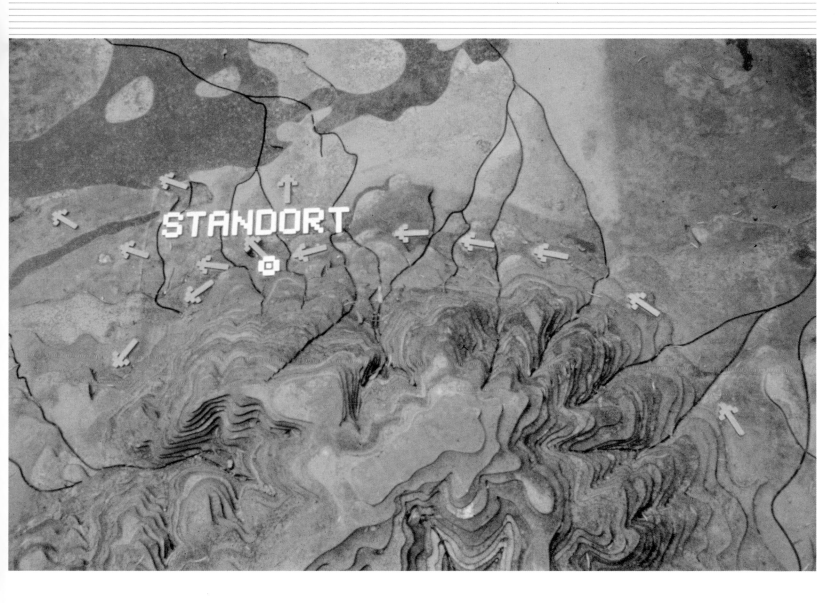

Design	Intégral Ruedi Baur et Associés
Project	Centre Pompidou, Paris
Date	1997–2001
Photography	Blaise Adilon

The signage system developed by Ruedi Bauer for the Centre Georges Pompidou, Paris, is based on the idea of 'spatial explosion' of information usually contained in a single signage panel. Signage, in this case, equals scenography. Concentrations of words appearing in different languages express the interdisciplinarity and multi-culturalism present at the Centre Pompidou.

The signage system works on various surfaces and non-surfaces, including freely suspended neon typographic elements, and large format banners overprinted in numerous colours with the same word in various languages. The overall effect of the system is one of energy and immediacy. The interaction between surfaces and the open spaces all helps to build on the graphic intensity.

Design Peter Anderson
Project Poles of Influence
Date 1998

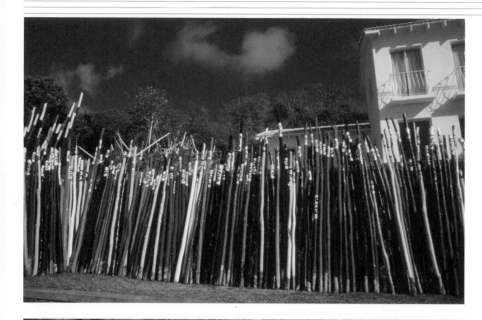

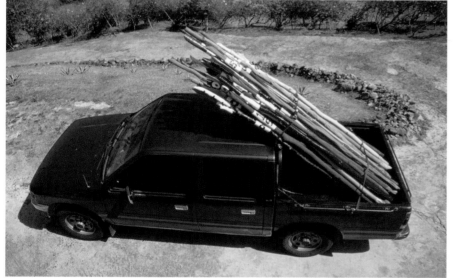

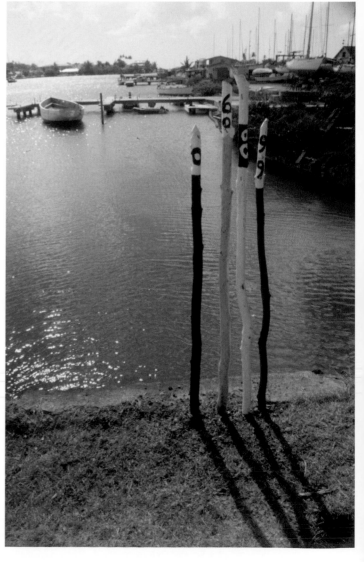

London-based graphic designer and artist Peter Anderson was commissioned to produce a work of art for the opening exhibition of the St. Lucia Museum of Contemporary Art, but on arriving on the Caribbean island, he discovered that the museum was not yet finished. This gave him some time to familiarise himself with the island and its culture. He discovered that tall, thin wooden poles were everywhere, their uses ranging from acting as props for banana trees and washing lines to building houses. As he was keen to produce a work of art that responded to its environment, he decided to use these wooden poles as an art installation which would extend across the entire island. He painted the sticks using a colour coding system and gave each stick a specific number, which ranged from his car registration number to an ex-girlfriend's phone number. These poles were then planted across the island in groups following a specific matrix, thereby creating a new set of co-ordinates for the island, and allowing islanders and tourists to weave their own stories around these strange interventions in the landscape.

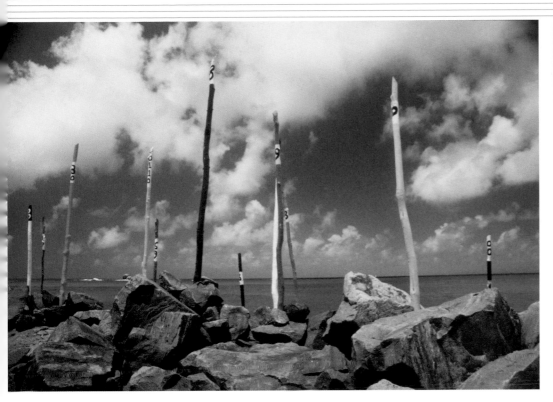

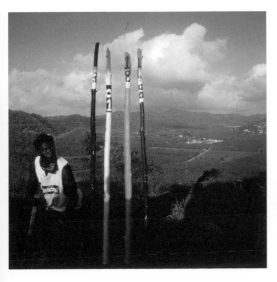

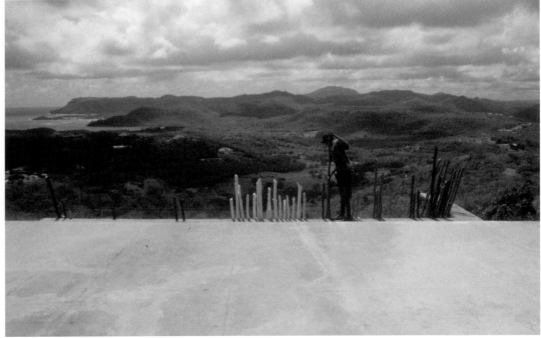

Design	The Kitchen
Project	Ocean club signage system
Date	2001

How do you create a navigation system for people who cannot see? That was the question facing graphic design consultancy The Kitchen when it was commissioned to create a signage system as part of its identity for Ocean. Ocean is one of the largest music venues in London with a capacity of 3000, and boasting three auditoriums over four levels.

The Kitchen attempted to devise a system that was as restrained as possible, working all the signs into a square format produced in enamelled metal panels. White backgrounds were applied to all the signs with a second colour chosen for each of the auditoriums.

All panels are split in half along a horizontal axis, with the text and icons shown in white out of the area colour at the top, braille text also reads across the foot of each panel. A further element of braille was applied to the sign, but this information was printed, not embossed, thereby becoming purely a surface effect, and adding a little humour to the otherwise austere signs (the text contains the titles of famous songs which are relevant to the area or information the sign depicts; the toilet sign reads 'Boys and Girls' by Blur, a sign showing the way upstairs reads 'Stairway to Heaven' by Led Zeppelin, and so on.) This aspect of the signage has proved to be

successful among the partially sighted, who are able to read printed text as well as braille.

The system has proved to be highly successful, with a number of the panels being 'liberated' in the weeks after the new venue opened.

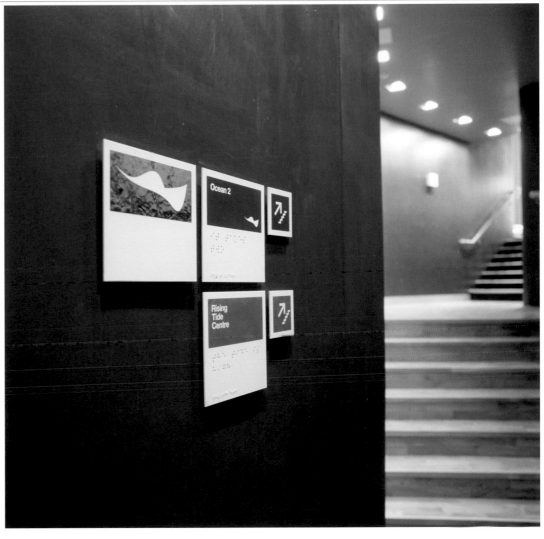

Design MetaDesign, London
Project Bristol City street signage
Date 2001

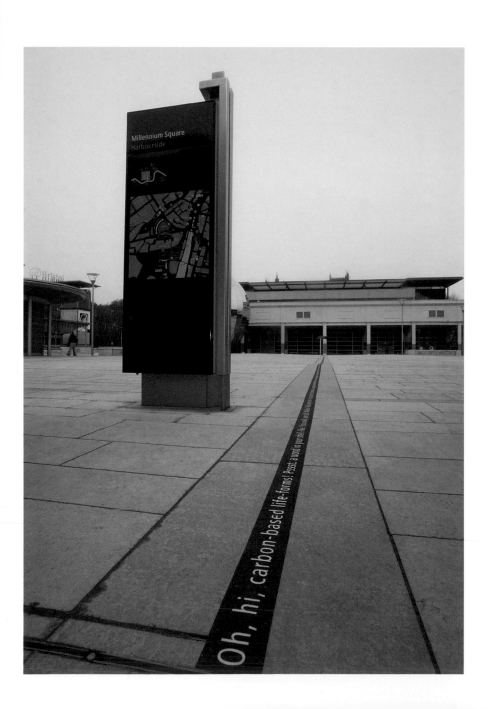

The UK city of Bristol has always proved to be a
navigational nightmare for pedestrians and motorists alike.
MetaDesign, London, was asked to solve the problem by
introducing a complete signage and navigational system
for the entire city centre. One of the most radical and yet
obvious ideas behind the system was to angle the street
information panels towards the desired destination from
the viewer's perspective, making the orientation
immediately clear.

Design North
Project Selfridges interior signage
Date 2000

Department stores generate a very noisy visual environment to work in, with numerous in-store concessions shouting for attention with a multitude of different graphic styles and tactics. Graphic design consultancy North was asked to devise a navigational signage system for Selfridges on Oxford Street in London, one of the oldest and largest independent department stores in the city. North's approach was one of reduction. Instead of trying to shout louder than the others, the designers adopted a totem pole device, which measures a mere 150 x 80mm but extends upwards to three metres. The posts are predominantly white, which helps to make them more noticeable against the background colour and noise.

A strong hierarchical system was developed to allow certain poles to contain very minimal levels of information, with pictograms on one plane and the descriptive word on the following plane. The basic colour palette was used sparingly; the level the shopper is on is highlighted in yellow whilst the other levels remain white.

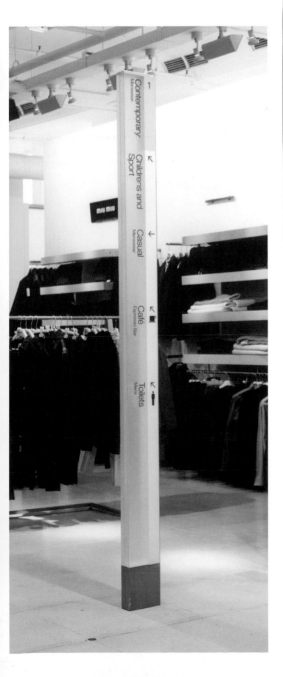

Design Pentagram
Project Canary Wharf signage
Date 1995

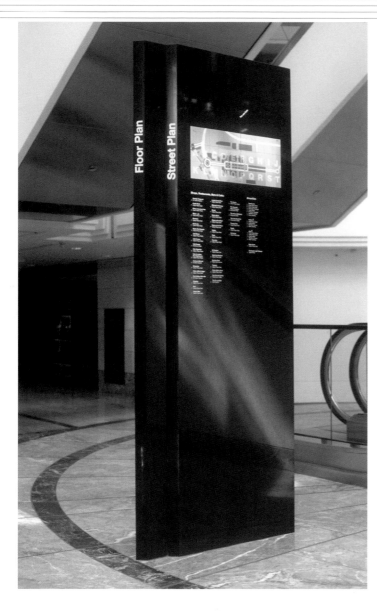

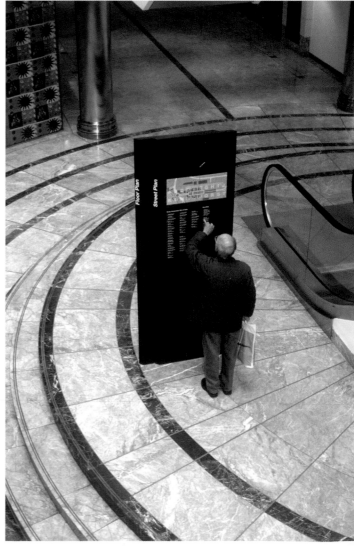

Design consultancy Pentagram was commissioned to undertake a review of the existing interior and exterior signage in use at the prestigious Canary Wharf development in London. The client's brief dictated a solution that would solve the problems of scale and flexibility. The exterior signage creates a natural arrow device by the intersection of two planes set at an angle to each other. This construction is both simple and striking.

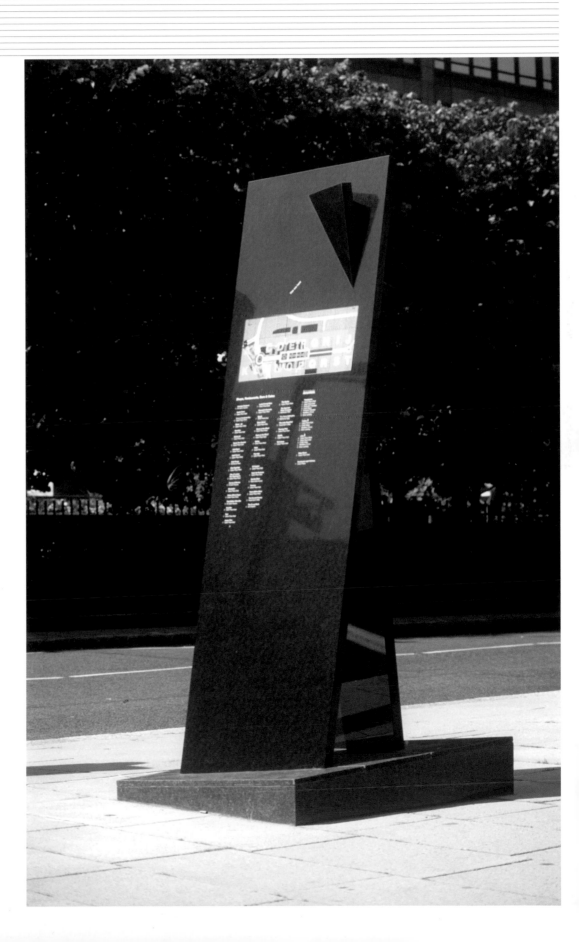

Design Pentagram
Project Croydon signage
Date 1992–1993

Croydon Council commissioned Pentagram to design signage for a new arts complex containing a museum, library, cinema and art gallery. The brief called for public, 'front of house' signs and non-public signage for staff 'behind the scenes'. Attached to the Town Hall, the complex was in the process of being built by architects Tibols, Karsky, Williams and Monroe.

 The behind the scenes signage was deliberately discreet and low key. By contrast the public signs were large and high profile. Giant arrows gave directions, while monolithic numerals indicated floor levels. Signs with boldly applied graphics were used to identify particular locations within the complex, such as the David Lean Cinema, the Riesco Gallery and the shops.

 Secondary signage, designed as easily understood pictograms, indicated amenities and facilities such as cloakrooms, reception and toilets.

Design Pentagram
Project Stansted Airport signage
Date 1990–1991

Stansted, London's third international airport, was designed by the architect Sir Norman Foster, who commissioned the design consultancy Pentagram to produce a signage system which would complement the distinctive architecture. The solution includes large-scale graphic symbols which can be seen at a distance across the open space of the interior. These guide and reassure the traveller by pinpointing toilets, food services, the currency exchange and other essential facilities.

The location and information signs are back-lit letters set in the monochromatic walls and dividing panels of offices, the check-in counters, customs barriers and so on. The directional signs, largely confined to the huge tree-like columns that support the building and make natural information points, are modified versions of the yellow British Airport Authority sign system.

Unfortunately the rot has set in: visitors to Stansted today will find this beautiful system still in place, but the visual noise and pollution of shops and advertising has destroyed the original purity. The world of cut-price, budget airlines has graphically bombarded the space, while the original elegance of the Pentagram-designed BAA signage system, set in a clean sans serif, has been replaced by a clumsy bold serif, which has no relationship to the purity of the supergraphics.

Design Base
Project PASS – Scientific Adventure Park

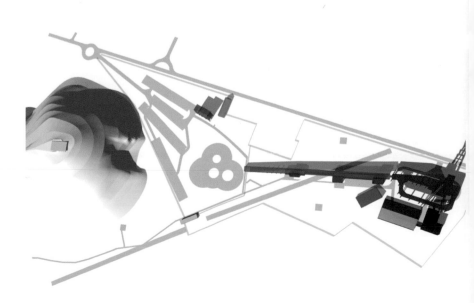

The graphic identity for this Scientific Adventure Park in Belgium was designed by Base, who were involved in every aspect of the graphic project from web site to building graphics. The interiors have the quality of a raw industrial plant, space station or bunker, and untreated structural materials such as concrete and steel are visible throughout the building. The signage and navigational system works with these raw materials: large panels are painted in bright colours, which relate to an on-screen virtual navigation map of the park. Large typography, applied directly to the surface, indicates zones or levels, while huge icons are applied to walls and floors marking lift shafts and ticket halls.

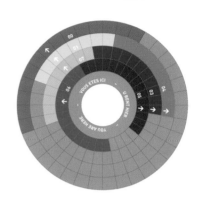

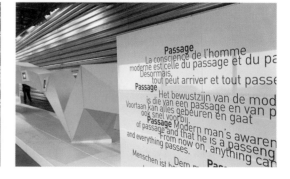

Design Farrow Design
Project Making the Modern World
Date 2001

Farrow Design was asked to design the permanent exhibition 'Making the Modern World' at the Science Museum in London.

At the entrance to the gallery is a large black stone obelisk which contains a lightbox with orientation graphics of the gallery. One of the most striking features of the gallery is 'Carhenge', a stack of six cars which extends right up to the roof. The plinth at the base of this tower contains a flush-mounted graphic panel housing information on each car. Smaller items are housed in floor-standing boxes with back-lit panels on the top plane showing information about the object and an LCD monitor which shows footage of the object in action.

Design
Diversity –
Minimal
Motoring
1950–1965

03 _ Information and space

Measuring the dataspace

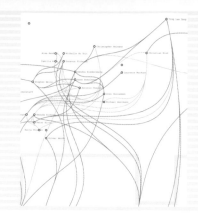

Essay by William Owen
116/117

By teaching the simple facts of the shape, size and position of a country relative to all the others, the political map of the world has become intrinsic to our sense of national identity. When I was growing up, in Britain in the mid-1960s, our school maps portrayed the British Isles (we just called it 'England') sitting comfortably and naturally at the exact longitudinal centre of a flat world, north at the top and south at the bottom, the country subtly and significantly exaggerated in size by the Mercator projection and coloured prettily in pink. We learnt from the beginning that this was the natural way of things.

A lot of the rest of the world was pink, too: these were the twilight years of the British Empire. The map was probably 20 years old by then and its representation of demi-global dominion in superabundant pinkness had already been made obsolete by national liberation movements across Africa, the Mediterranean, Arabia, India, East Asia and the Caribbean. But it wasn't easy for a school geography department to keep up with the winds of change and so we clung to the fiction of empire.

The real use of this map, like most maps, was "to possess and to claim, to legitimate and to name" [1], in this case the assertion by the British state of sovereignty over itself and a large portion of the world, and the expression of the singular point of view that England lay at the centre of everything.

In the 35 years since I was at junior school ideas about possession and sovereignty have altered, possibly faster than maps have. The political map of the world has been redrawn, of course, with the creation within the former Soviet and Yugoslav Republics of nineteen new nation states and the destruction of one (the GDR). These are the kinds of absolute changes that conventional maps excel at: the transformation of political boundaries – lines on the ground - or of names, or of regimes. Rights were being reasserted in eastern Europe and Russia, but elsewhere national boundaries were becoming confused. The more interesting and subtle changes – for society and for cartography – have been those arising out of the integration of world trade, communications, politics, culture and population, and the diminishing importance of national political boundaries.

The inexorable progress of globalisation is a challenge to mapmakers. How do we define, in cartographic terms, contemporary political relations, or ideas about nearness and remoteness, relative size and wealth in a world where political alignment is multi-layered and distance is measured in air miles and bits per second. Harder still, how do we represent within a figurative geographical construct what it is to be British, Japanese, Nigerian or Turkish and how each nation fits within the world, when we each live, either in a literal or metaphorical sense, everywhere?

The inadequacy of the one-dimensional identity and the singular point of view described by a national boundary (and national colour, flag, anthem, bird…) should be self-evident, although like a school geography department we cling to old truths. Western topographical conventions are fixated on physical space, not just for the needs of navigation but also because they are rooted in asserting property relations – rights of ownership – and therefore the accurate description and allocation of territories (private or state) is paramount. Space, however, is increasingly distorted by the wealth or continuity of communications or by cultural influence and integration (who needs to be in California when Starbucks is round every corner?). Also, the assertion of absolute rights of ownership has relatively less meaning than access to goods and services (or to certain rights and privileges that in the modern world supersede citizenship: those accruing from educational qualifications, wealth or trading block membership). The possession of physical space and the representation of 'real' physical distance (and even navigation across it) has relatively less meaning than newer, more complex equations of proximity or privilege.

How do we define, in cartographaphic terms, ideas about nearness and remoteness, relative size and wealth in a world where distance is measured in air miles and bits per second?

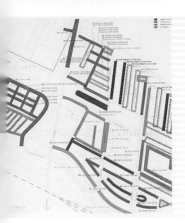

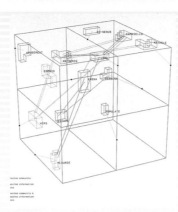

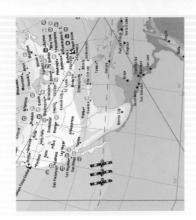

Take Britain as an example of a vague, ambiguous and unresolved political state. There is a ghostly fragment of Empire in the Commonwealth and in dominion over Northern Ireland and diminutive offshore redoubts like the Turks and Caicos islands. There is a degree of internal fragmentation expressed in its one 'parliament' – British – and three 'assemblies' – Scottish, Welsh and Northern Irish. Britain's principal legal and economic policies are subject to those of the European Union, of which it is a leading member. However Britain remains outside the common currency Eurozone, and is semi-detached from the Schengen Agreement that defines border controls and police cooperation within the EU, dictating the all-important policy of who to let in and who to shut out. Other aspects of national sovereignty are influenced by membership of bodies such as Nato (defence policy) and the World Trade Organisation, (which defines tight parameters within which the economic and trade policies of its member states can flex).

Now take into account Britain's eclectic ethnic, cultural or linguistic traditions, or its central position within the global networked sub-economy in which a substantial minority of its citizens participate, in highly mobile supranational industries such as finance, media, software, oil and professional consulting. In the light of these multiple layers (and multiple maps?) what constitutes 'Britain' and 'Britishness' evidently still matters but has lost its old crispness.

Remapping a world in which global and national space/time co-exist requires a radical new approach, that allows topographical and topological representations to co-exist. Showing the 'true' proximity of one place to another in a jet-turbined, video-conferenced and Internet-enabled world requires a similarly multi-dimensional understanding of space and time, logical and physical. For example, if we measured distance by the duration, availability and price of air travel between two locations, rather than miles or kilometres, London would be very much 'nearer' to New York than to, say, Athens; or we could measure connectivity not by roads, railways or shipping lanes – as my mid-1960s atlas did – but by the number of Internet users and ISPs, or the price of voice telephony, the number of mobile users per population, the connection speed and miles of optical fibre, the number of television stations.

Such a map of proximity and connectivity would reveal a chain of massively connected global cities girdling the earth: in Europe – London, Paris and Frankfurt; in the Middle East – Dubai; in the Far East – Kuala Lumpur, Singapore, Hong Kong, Shanghai, Tokyo, Sydney; in the Americas – Sao Paolo, San Francisco, New York. Huge swathes of the world – predominantly but not exclusively in Africa and Asia – would be seen to be almost entirely disconnected from this hyper-concentration of activities and resources.

"The new networked sub-economy of the global city occupies a strategic geography that is partly deterritorialised, cuts across borders, and connects a variety of points on the globe. It occupies only a fraction of its local setting, its boundaries are not those of the city where it is partly located, nor those of the 'neighbourhood'."[2]

Where are the boundaries located, in a world in which the power of a non-government organisation (say Greenpeace), a media network (CNN) and a global corporation (Shell) are as significant in shaping environmental policy as a national government?

The boundaries lie in multiple dimensions, and not merely along national borders. They cross the routes of cross-border migration and encircle linguistic concentrations; they plot the activities of global corporations and their influence on our food, entertainment and health; they pinpoint the hotspots of international crime; they lie around trade zones and regions (or philosophies) of political alignment; they follow the contour lines of equal wealth, education, skills or connectivity; they are intersected and overlaid by specialised human activities (such as finance or media) or key nodal points of physical or digital exchange (Heathrow Airport, Wall Street, Dubai Internet City, the golf course at Palm Springs).

Our sense of place and position, and our understanding of the relations between things, their dimensions and attributes (true or false), is forged and reinforced by their representation on the map. By making these new facts visible, and revealing the coincidence of logical and physical objects or the rapid oscillation and contradiction between global and local points of view, then we should have a better map.

[1] 'The Power of Maps', ibid.

[2] 'Obbis Terrarum, Ways of Worldmaking, cartography and Contemporary Art', ed. King and Brayer, Ludion Press, Ghent/Amsterdam 2000

Design Lust
Project 'Stad in Vorm'
Date 2001

INHOUDSOPGAVE

0.00 Ten geleide
A.00 Projectoverzicht

A.01 Bouwen in bestaande omgeving

B.01 Stedelijke vernieuwing

C.01 Hoogbouw

D.01 Wonen

E.01 Werken

F.01 Onderwijs

G.01 Cultuur

H.01 Verdichting

I.01 Uitbreiding

J.01 Openbare ruimte

1.00 Appendix

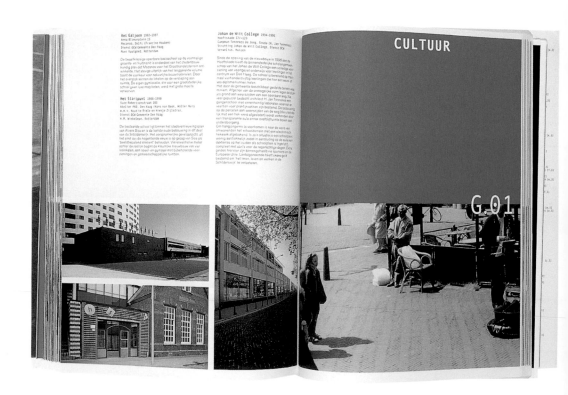

CULTUUR

G.01

This book documenting the architectural projects of the last 15 years in The Hague was designed by Dutch design consultancy Lust. The photography, by Guus Rijven, is careful to show not only the facades and spaces of the buildings, but also the architecture in context – peopled by those who live and work in the buildings.

The design of the book is based on a classification system which helps to guide the reader through several layers of information throughout the book. The ten chapters, each covering a different genre of architectural planning, are represented by specific colours. These colours are combined with an alphabetic 'numbering' system, which runs from A to J. Therefore, each building is given a distinctive 'serial number' comprised of the section letter and colour. On the inside of the dust jacket, several maps of The Hague are presented, showing only the areas mentioned in the text. Thus a cluster of green numbers on the map reveals, in an intuitive way, that that part of the city is mainly residential.

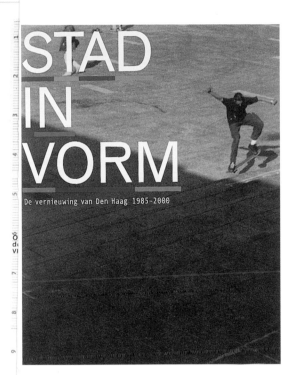

Design Lust
Project Fietstocht door Vinex-locaties Den Haag
Date 2001

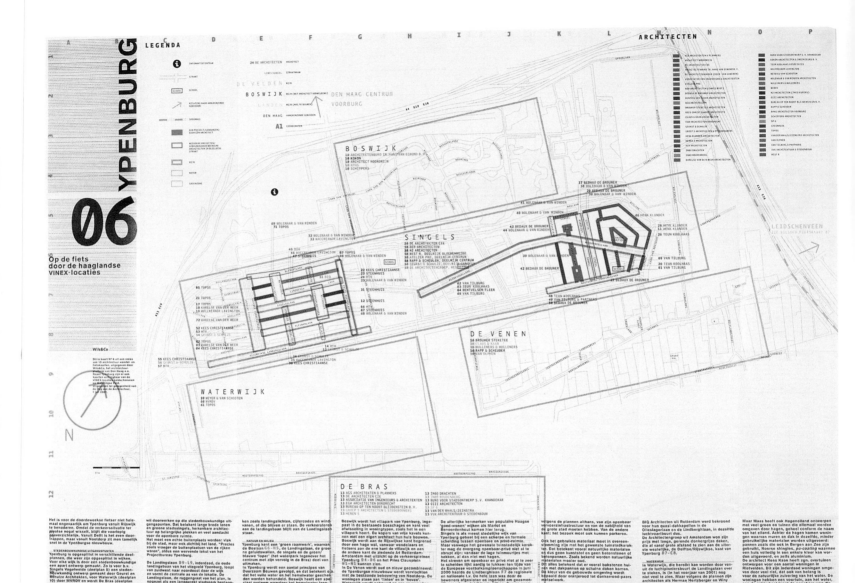

07

Op de fiets door de haaglandse VINEX-locaties

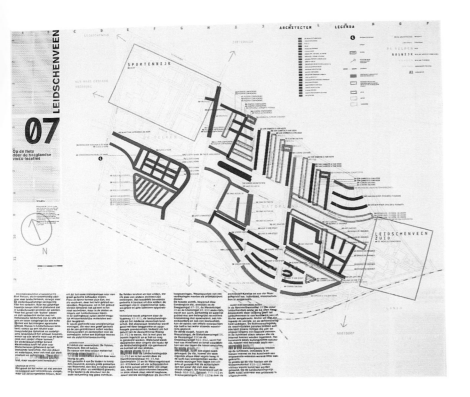

SPORTENWIJK

DE VELDEN

LEIDSCHENVEEN ZUID

N

ARCHITECTEN LEGENDA

STRATEN · ARCHITECTEN

Op de fiets, door de haaglandse VINEX-lokaties

Design Sandra Niedersberg
Project London Connections –
 Who got to know whom, where, when and how?
Date 2000

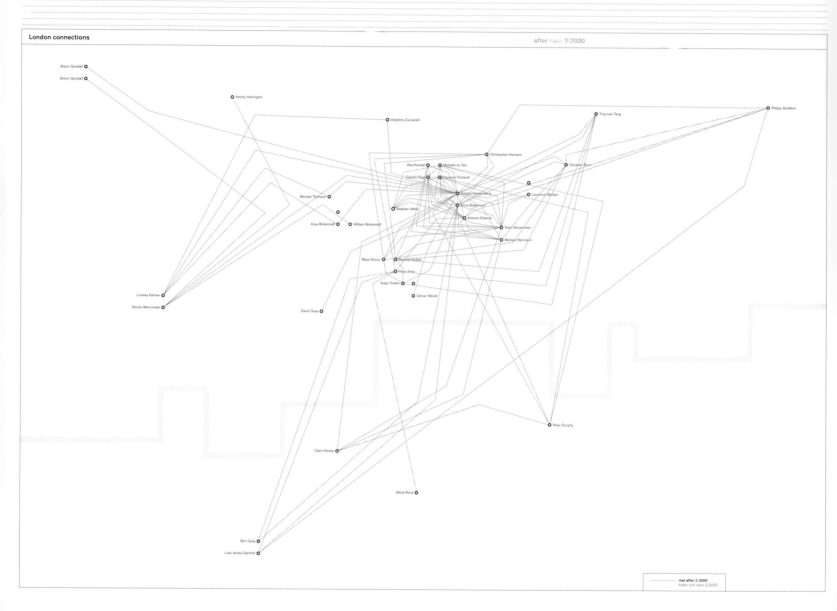

London connections after nach 2|2000

met after 2|2000
trafen sich nach 2|2000

The 'six degrees of separation' theory claims that any two people are connected to each other through a maximum of six friends or associates – assuming that everyone knows a hundred people and those hundred people each know another hundred. In this way six connections are enough for the six billion people living on the earth.

Using this information as an inspiration, Sandra Niedersberg mapped and analysed the way she made friends and acquaintances over a five-month period after moving from Germany to London. The research was extended to include interviews with each contact which formed a book. With the information amassed she also created a series of A2 maps printed onto translucent paper allowing the different levels to be over-laid to show further associations.

Each map uses the geography of London as its framework, reduced to a symbolic representation of the River Thames. Each person is represented by a dot and their name, the position of which corresponds to where they live. All the co-ordinate dots appear on every map, but a person's name only appears if they have a connection on that particular map. Each map shows different statistics for different situations, such as living, home, work, institutions, school, meeting points and so on, with colour coding used to reveal further levels of information.

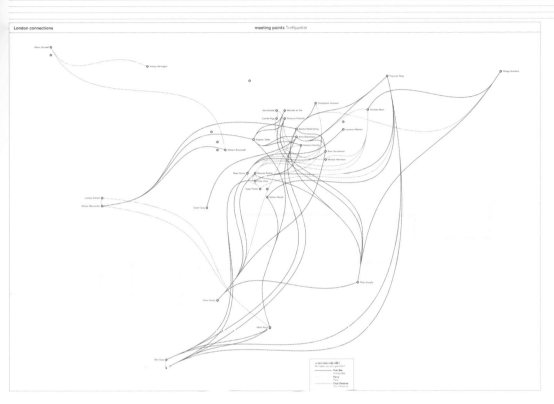

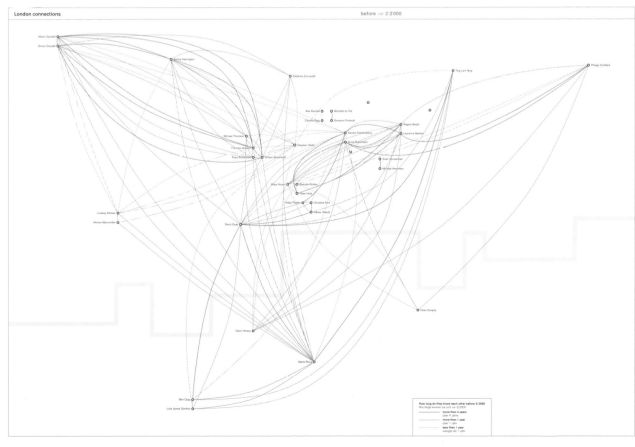

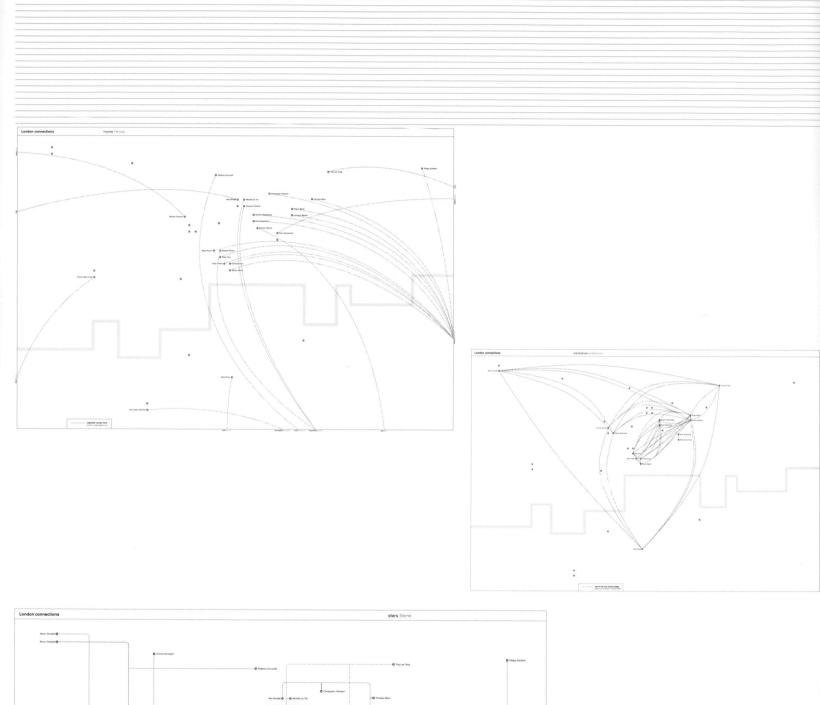

London connections — home Heimat

London connections — institutions

London connections — stars Sterne

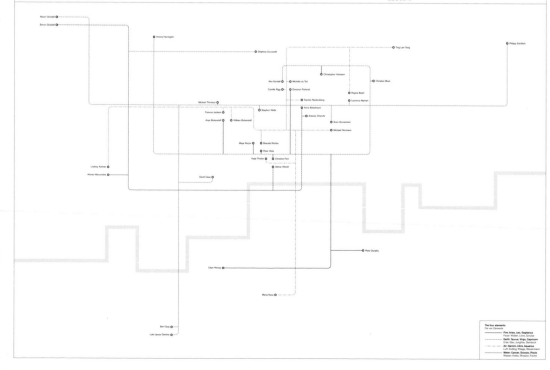

The four elements
Die vier Elemente

Fire: Aries, Leo, Sagittarius
Feuer: Widder, Löwe, Schütze
Earth: Taurus, Virgo, Capricorn
Erde: Stier, Jungfrau, Steinbock
Air: Gemini, Libra, Aquarius
Luft: Zwilling, Waage, Wassermann
Water: Cancer, Scorpio, Pisces
Wasser: Krebs, Skorpion, Fische

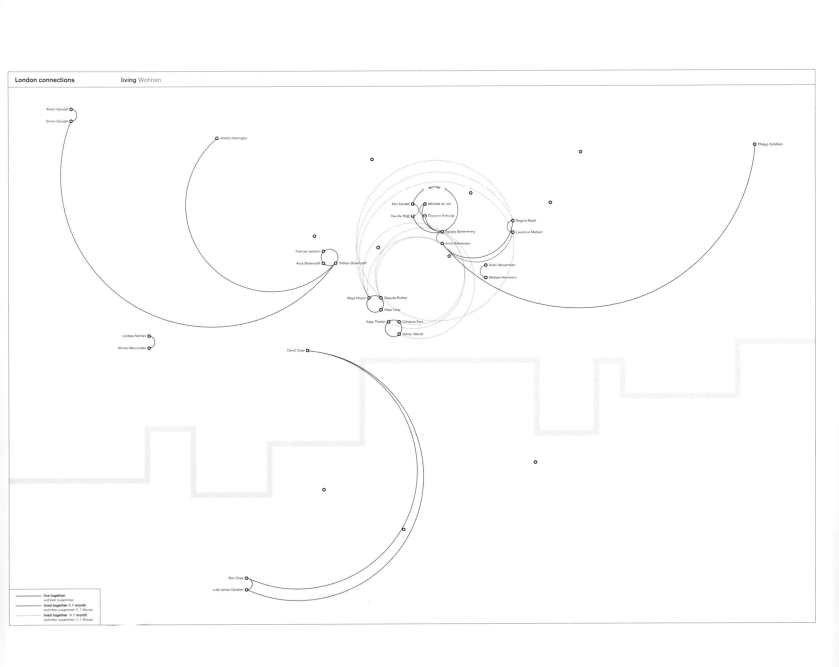

London connections **living** Wohnen

Alison Goodall
Simon Goodall

Attöfly Harrington

Philipp Schifferli

Alex Kendall
Michelle du lod

Cecilia Rigg
Ortmann Eckardt

Regina Beyhl

Sandra Niedersberg
Laurence Markart

Anne Bökelmann

Frances Jackson
Sven Vercammen

Anya Bickerstaff William Bickerstaff
Michael Herrmann

Maya Noçon Beaudé Richter

Peter Hirte

Katja Thielen Christine Fent

Lindsey Kelman
Gilmar Wendt

Afonso Marcondes

David Quay

Ben Quay
Luke James Gardner

live together
wohnen zusammen
lived together < 1 month
wohnten zusammen < 1 Monat
lived together > 1 month
wohnten zusammen > 1 Monat

Design Lust
Project I³ Map
Date 1999

I³: FROM SCIENCE FICTION

I^3 is a design programme of the European Union involved in research into intelligent information interfaces. As a contribution to the design publication IF/THEN, design company Lust designed a map which showed the relationships between the projects of the 71 institutions involved with I^3. It was important to show which project was associated with which other project, whether geographically or conceptually. To map the spatial relationships between the institutions, a cube representing the world was used which was then deconstructed to reveal the existing and virtual connections of the corresponding projects. The map, although certainly informative in nature, also reveals the 'virtual' or 'experimental' aspect of each project. As well as hinting at the name of the programme, the choice of the cube was also a conceptual necessity since it afforded multiple geometries in which to visualise the connections. This map was designed by Lust for the Werkplaats Typografie, Arnhem, Holland.

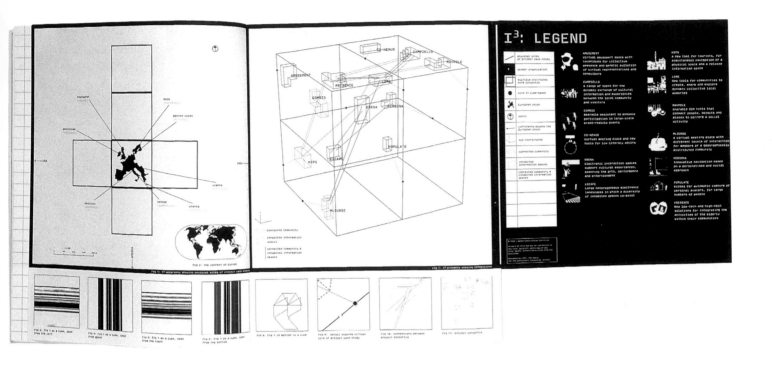

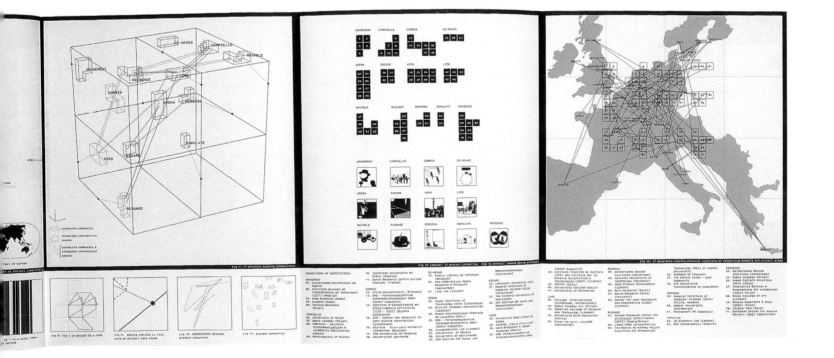

Design UNA (London) designers
Project 'Lost and Found' exhibit
Date 1999

Nick Bell, art director of Eye magazine and principal of UNA (London) designers was invited by the British Council to create a piece of work for an exhibition entitled 'Lost and Found', held in Belgium in 1999. He designed a map in the form of a tablecloth which uses typography to show the wettest and driest parts of England and Wales, and simultaneously explores the influence of invaders and immigrants on the language. Screenprinted onto paper damask banqueting roll is a list of nearly all the rivers that drain off Britain to the north, south, east and west. When the work was exhibited, pots of crayons were placed on the tablecloths (covering tables in the gallery refrectory) inviting vistors to comment on what they had seen. The list of French, Celtic, Norse, Roman, Flemish and Dutch river names all found in England and Wales, are testament to a rich and varied history. The map, the designer suggests, makes the point that "despite being an island race, with an occasionally isolationist stance, the history of the country seems always to have been multi-cultural."

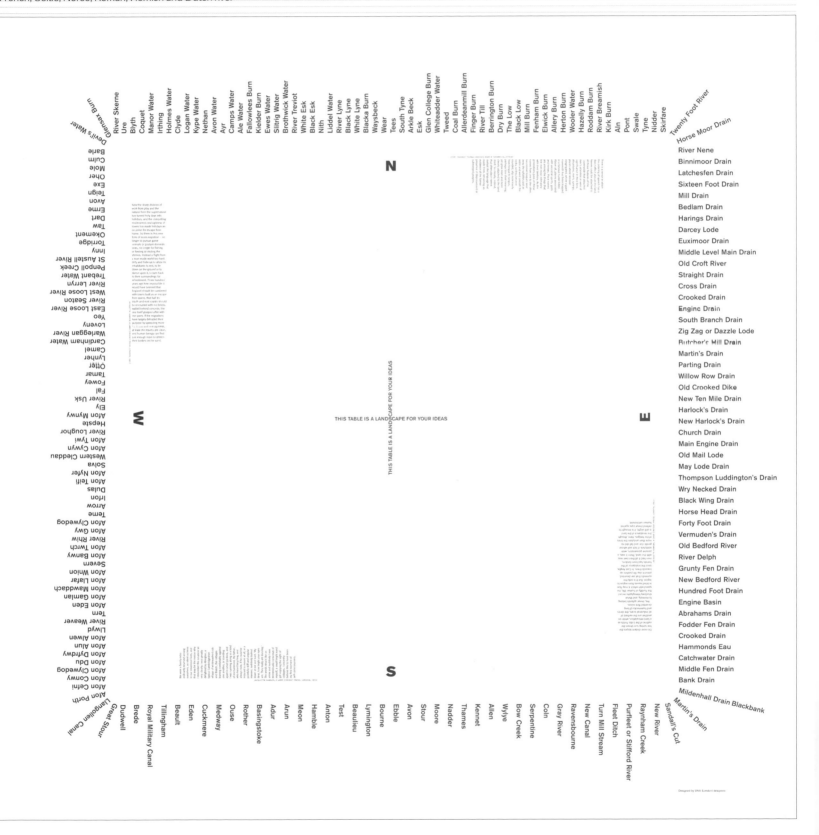

Design	Lust
Project	HotelOscarEchoKiloVictorAlphaNovemberHotelOscarLimaLimaAlphaNovemberDelta
Date	2001

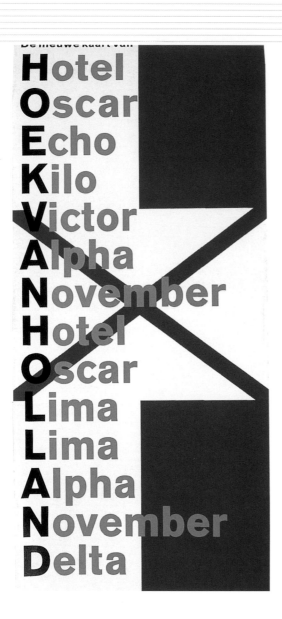

To highlight Hoek van Holland (Hook of Holland) as the 'beach & water recreation area' of Rotterdam during 2001, the year the city was European cultural capital, a map was published which revealed the many facets of Hoek van Holland: historical, economic, industrial, residential, maritime, recreational, and so on. A two-metre-long sheet was needed to cover the broad range of information presented in the map. To keep the map convenient and easy to use despite its size, a useful folding system was devised that eliminated the trouble of having to continually fold and re-fold the map to see the necessary information. As a result, the map can actually be used as four maps, each giving a greater level of detail than the one that

follows it: Hoek van Holland, the North Sea, Europe and the world. Each folded variant shows information pertaining to that specific area, as well as showing the relation to the bigger area around it. A special projection of the world was also designed that placed Hoek van Holland in the middle of the map. On the other side of the map, the tidal and lunar information of Hoek van Holland is given for a complete year. Full moon is represented by a solid blue, while the new moon is represented by a ten per cent shading of the same blue. The stages of the moon inbetween are shown by increasing the percentage of blue. Seen as a whole, the function system symbolises the ebb and flow of the tides.

The map also records the position of site-specific art installations created for Hoek van Holland, providing another point of contact between the user of the map and the area.

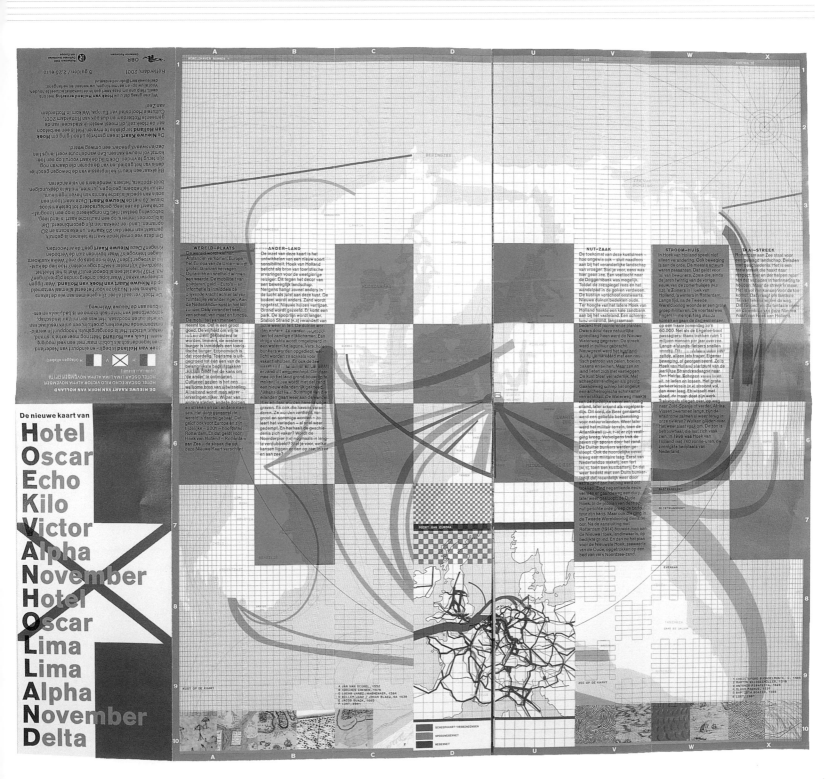

Design Lust
Project HotelOscarEchoKiloVictorAlphaNovemberHotelOscarLimaLimaAlphaNovemberDelta
Date 2001

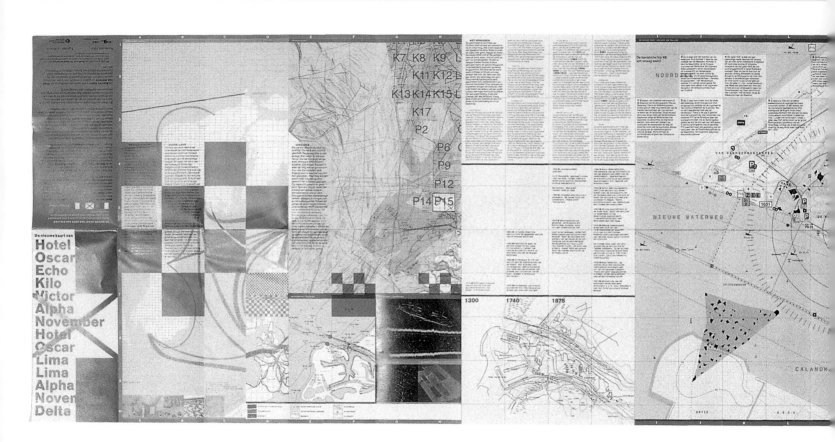

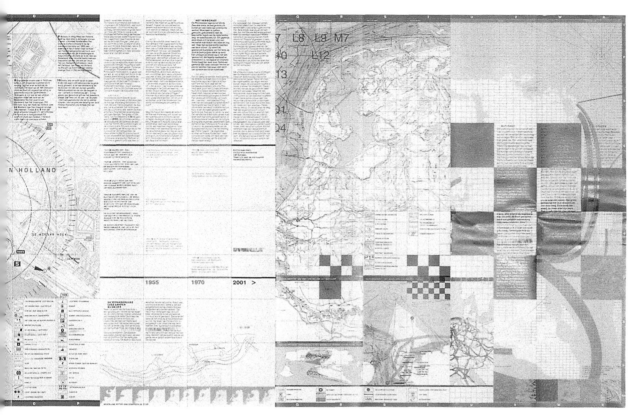

1955 1970 2001 >

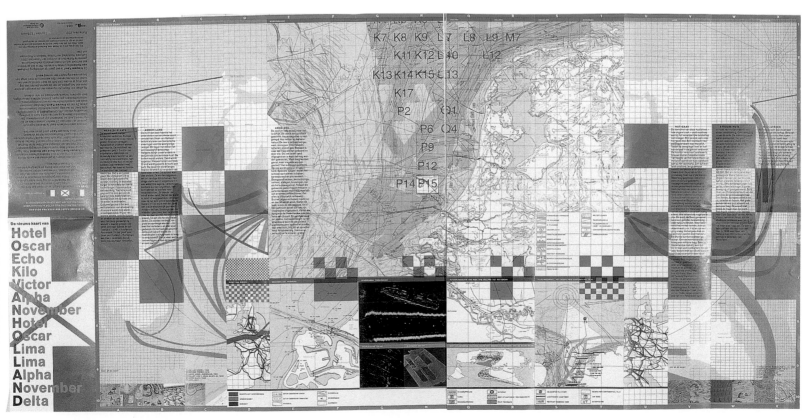

De nieuwe kaart van

Hotel
Oscar
Echo
Kilo
Victor
Alpha
November
Hotel
Oscar
Lima
Lima
Alpha
November
Delta

K7 K8 K9 L7 L8 L9 M7
K11 K12 L10 L12
K13 K14 K15 L13
K17
P2 Q1
P6 Q4
P9
P12
P14 P15

Design	Damian Jaques
Project	The MetaMap
Date	2001

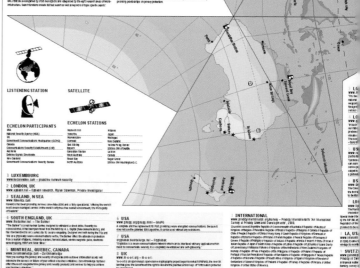

THE METAMAP
surveillance and privacy

DYMAXION DREAMS

RESEARCH

LISTENING STATION SATELLITE

ECHELON PARTICIPANTS ECHELON STATIONS

TOOLS, PRODUCTS AND SERVICES

STATE

MEAN LOW TEMPERATURE

REVERSING THE TRANSFORMATION

This large format map of the world uses the Fuller Projection – Dymaxion. Originally devised by the mathematician, designer and engineer Buckminster Fuller, this system allows the map to be cut-out and folded to form a three-dimensional globe. The MetaMap was developed by Mute magazine and is concerned with global surveillance and privacy. Various colour coded information zones are set up around the edge of the map. These include: Research, State, Hacking, Security, Tech DIY Education, Privacy and Free Speech Campaigning,

Publishers, Independent Media and Open Infrastructures. Each zone has a numbered list of locations with URLs for relevant web sites and brief descriptions of each site. The number and colour of each entry is also reproduced on the map to show the global position. The map also contains information about radar listening stations and satellites.

ART PROJECTS

1 ITALY
www.0101011011011101.org – 0101011101011101.org

2 BLEILEFELD, WEST GERMANY

3 TORONTO, CANADA

4 TORONTO, CANADA

5 NEW YORK, USA AND BRISTOL, UK

6 PITTSBURGH, USA
www.applesandoranges.com – Institute for Applied Autonomy (IAA)

7 CHICAGO, USA

8 UK / INTERNATIONAL

9 USA

10 GERMANY

11 SHEFFIELD, UK

12 IRELAND

13 MANCHESTER, UK

14 DENMARK

PRIVACY AND FREE SPEECH CAMPAIGNING

1 CAMBRIDGE, MA, USA

2 LONDON, UK

3 SEOUL, KOREA

4 WASHINGTON, DC, USA

5 ITALY

6 NETHERLANDS

7 WASHINGTON, USA

8 UK

9 JAPAN

10 CA, USA

11 SAN FRANCISCO, USA
www.eff.org – Electronic Frontier Foundation

12 AUSTRALIA

13 CANADA

14 USA

15 UK

16 HONG KONG

17 VIENNA, AUSTRIA

HACKING, SECURITY, TECH DIY EDUCATION

1 LAS VEGAS, NEVADA, USA

2 ENCHEDE, TWENTE, NETHERLANDS

3 ST. PAUL, MN, USA

4 SAN DIEGO, CA, USA

5 NASHVILLE, TN, USA

6 NYC, NY, USA

7 GERMANY

8 INTERNATIONAL

9 BRISTOL & LONDON, UK

10 HULL, UK

INDEPENDENT MEDIA CENTRES (IMC@), INTERNATIONAL

3 INDEPENDENT MEDIA CENTRES (IMC@), INTERNATIONAL

2 TORONTO, CANADA

3 ROME, ITALY

4 GERMANY

5 NEW YORK, USA

6 FRANCE

7 WOLVERHAMPTON, UK

8 FRANCE

9 NEW YORK, USA

10 POLAND

11 ROME, ITALY

12 USA

13 BERKLEY, CALIFORNIA, USA

14 AMSTERDAM, NETHERLANDS

15 LONDON, UK

16 LONDON, UK

17 DELHI, INDIA

18 BERLIN, GERMANY

19 AMSTERDAM, NETHERLANDS

20 MUNICH, GERMANY AND LONDON, UK

PUBLISHERS, INDEPENDENT MEDIA AND OPEN INFRASTRUCTURES

FULLER PROJECTION
Dymaxion™ Air-Ocean World

Design Lust
Project kern DH map
Date 2000

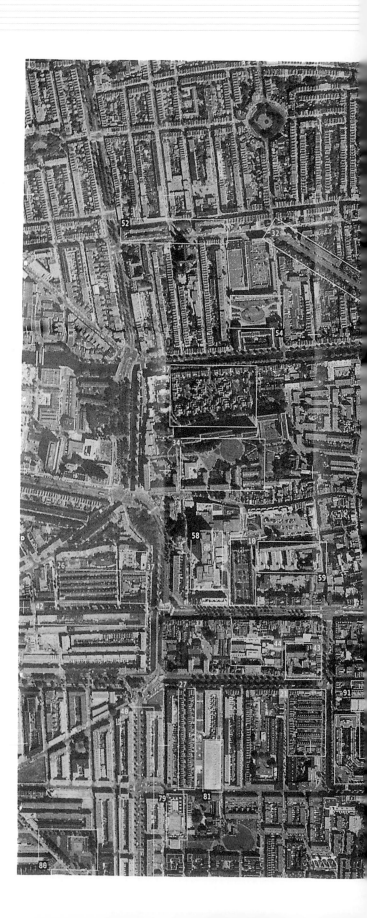

This map, designed to commemorate the 'Week of Architecture 2000', shows a number of 'year rings' that represent the periods of important growth and development of the city of The Hague. It features a giant satellite photograph of the downtown area. The map includes an extended index, showing the growth in 'structure' and 'mass' of every period, and covers in text and images the most interesting architectural projects and urban development. A colour scheme was designed which assisted in the mapping of these architectural projects in terms of location, the period of their development, and their relationship to the growth in structure and mass.

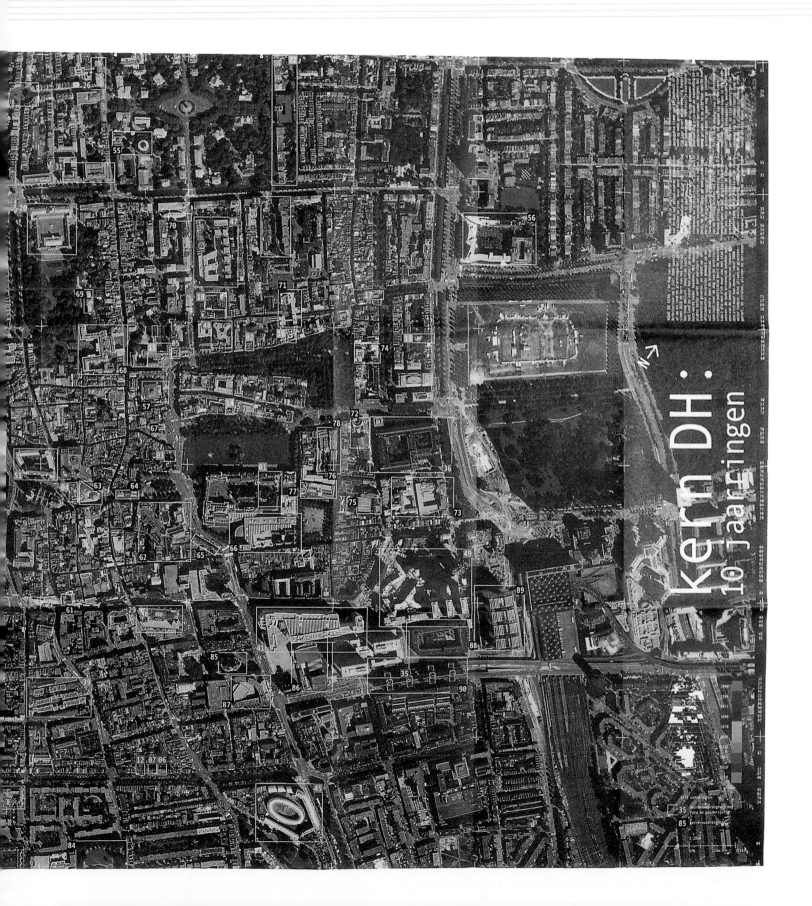

Design	Lust
Project	kern DH map
Date	2000

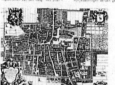

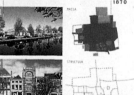
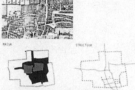

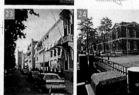
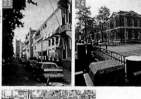

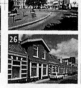

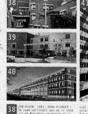
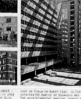

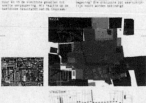
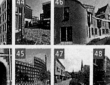

A. HOF & DORP A.1250
B. ORGANISCHE GROEI & AANLEG GRACHTENSTELSEL B.1616
C. UITBREIDING BINNEN GRACHTEN C.1666
E. BEBOUWING VAN BINNENTERREINEN E.1850
F. EERSTE UITBREIDINGEN BUITEN SINGELS F.1870
G. UITBREIDING VAN DE STAD OP SLOTENPATROON G.1890
I. CITYVORMING I.1960
J. STADSVERNIEUWING J.2000
KERNPLAN

Studio	Sinutype
Design	Maik Stapelberg and Daniel Fritz
Project	AM7/Die Deutsche Flugsicherung Frankfurst/Langen
Date	2001

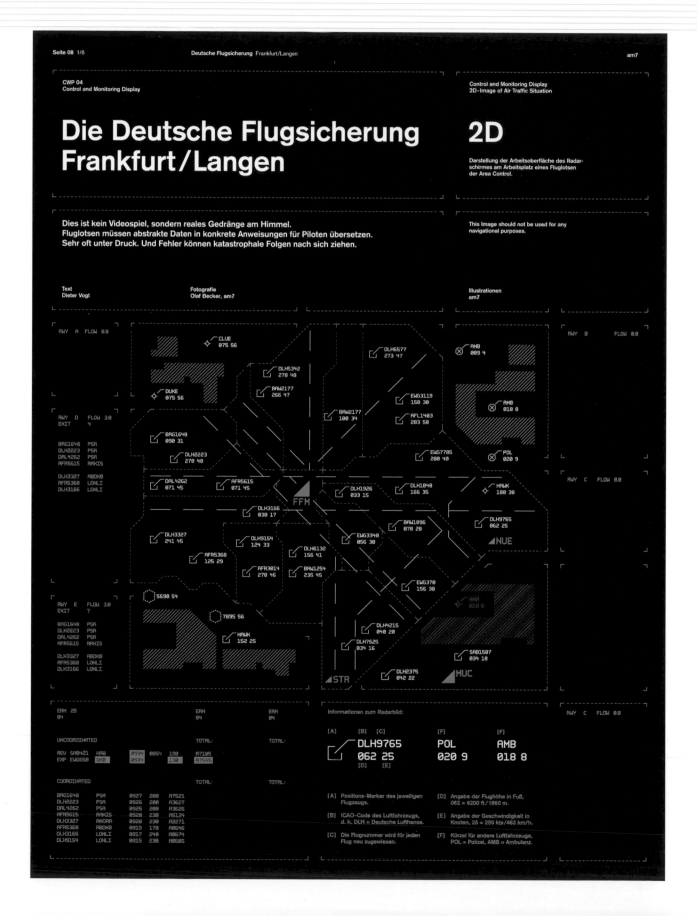

The 'Akademische Mitteilungen' (Academic Announcements) is a publication of the Academy of Arts and Design Stuttgart, Germany. Issue seven, edited by Daniel Fritz and Maik Stapelberg, two students from the academy, was based around the theme of communication.
This article is about the German air traffic control network, based in Frankfurt/Langen, Germany. The diagram on the left shows the given information from the radar monitor of an air traffic controller which appears only as two-dimensional data. The diagram on the right shows a three-dimensional version of the same data. This view, of course, is left to the imagination of the air traffic controller. The three dimentional version is instantly more approachable, visually representing as it does the altitudes of the various aircraft.

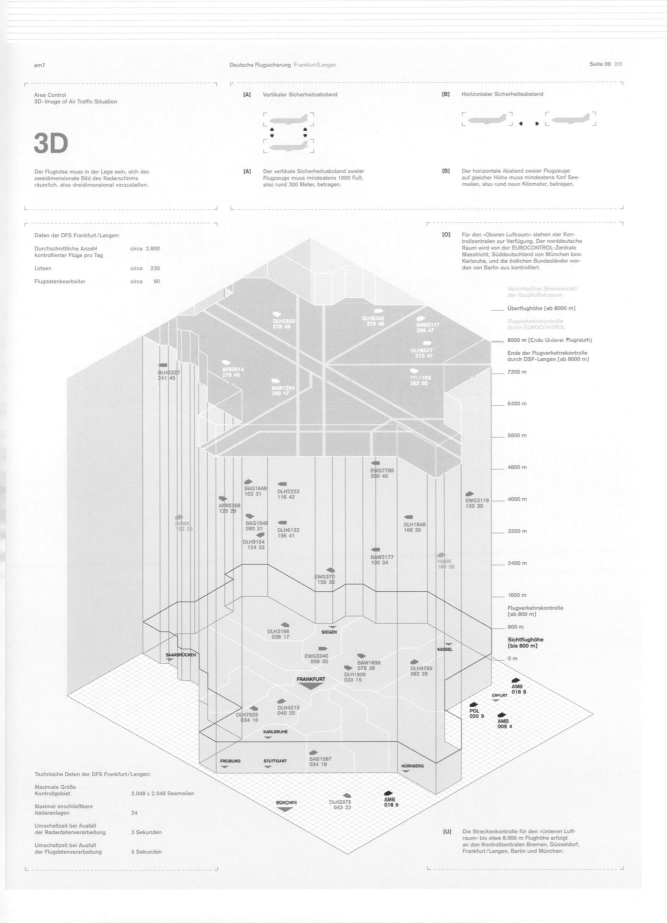

Area Control
3D-Image of Air Traffic Situation

3D

Der Fluglotse muss in der Lage sein, sich das zweidimensionale Bild des Radarschirms räumlich, also dreidimensional vorzustellen.

[A] Vertikaler Sicherheitsabstand

[B] Horizontaler Sicherheitsabstand

[A] Der vertikale Sicherheitsabstand zweier Flugzeuge muss mindestens 1000 Fuß, also rund 300 Meter, betragen.

[B] Der horizontale Abstand zweier Flugzeuge auf gleicher Höhe muss mindestens fünf Seemeilen, also rund neun Kilometer, betragen.

Daten der DFS Frankfurt/Langen:

Durchschnittliche Anzahl kontrollierter Flüge pro Tag	circa	2.800
Lotsen	circa	230
Flugdatenbearbeiter	circa	90

[O] Für den »Oberen Luftraum« stehen vier Kontrollzentralen zur Verfügung. Der norddeutsche Raum wird von der EUROCONTROL-Zentrale Maastricht, Süddeutschland von München bzw. Karlsruhe, und die östlichen Bundesländer werden von Berlin aus kontrolliert.

Vereinfachtes Streckennetz der Hauptluftstrassen

Überflughöhe [ab 8000 m]

Flugverkehrskontrolle durch EUROCONTROL

8000 m [Ende Unterer Flugraum]

Ende der Flugverkehrskontrolle durch DSF-Langen [ab 8000 m]

7200 m

6400 m

5600 m

4800 m

4000 m

3200 m

2400 m

1600 m

Flugverkehrskontrolle [ab 800 m]

800 m

Sichtflughöhe [bis 800 m]

0 m

Technische Daten der DFS Frankfurt/Langen:

Maximale Größe Kontrollgebiet	2.048 x 2.048 Seemeilen
Maximal anschließbare Radaranlagen	24
Umschaltzeit bei Ausfall der Radardatenverarbeitung	3 Sekunden
Umschaltzeit bei Ausfall der Flugdatenverarbeitung	5 Sekunden

[U] Die Streckenkontrolle für den »Unteren Luftraum« bis etwa 8.000 m Flughöhe erfolgt an den Kontrollzentralen Bremen, Düsseldorf, Frankfurt/Langen, Berlin und München.

Design	Jeremy Johnson
Project	Colours
Date	2002

Produced as a self-initiated project, this B1 poster contains
the CMYK breakdown for every Pantone colour, with a
graphic representation of each colour shown purely as a
set of four lines (cyan, magenta, yellow and black). The
length of each line is determined by the volume of colour
used in each Pantone equivalent. The mapping of this
information helps the viewer to understand the quantities
and frequencies of process colours used within special
Pantone inks.

Design Hochschule für Gestaltung Schwäbisch Gmünd
 Student project
Project 'Arbeitssuche im netz'
Date 2001

Produced as a project by students at the Hochschule für Gestaltung Schwäbisch Gmünd in Germany, 'Arbeitssuche im netz' is a system to aid job-hunting on-line. The site is aimed at people whose knowledge and skills do not fit in with the traditional criteria set out on many such sites. The site visually illustrates skills-matching and uses a complex indexing system to direct the prospective candidate to the correct area.

Design	Hochschule für Gestaltung Schwäbisch Gmünd
	Student project
Project	'f.i.n.d.x.'
Date	2001

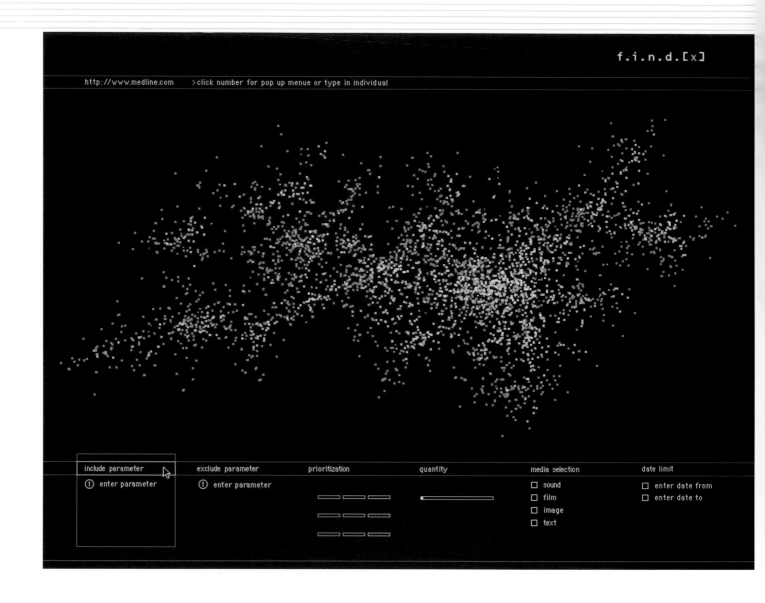

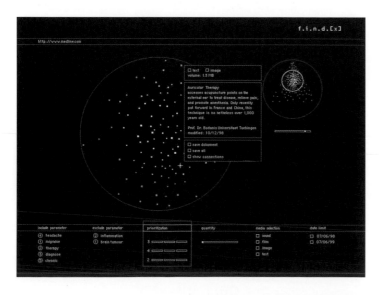

Produced as a project by students at the Hochschule für Gestaltung Schwäbisch Gmünd in Germany, 'f.i.n.d.x.' is a visually-aided investigation instrument for the medical industry. The web site uses as its starting point the chaos of fragmented information that is the Internet, illustrated using hundreds of small green floating squares which form an organic galaxy of information. The user can select areas and zoom in to focus on specific areas of research and information.

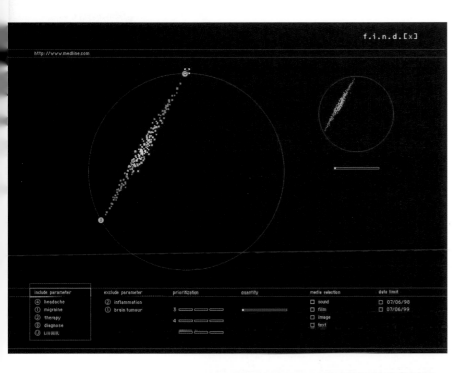

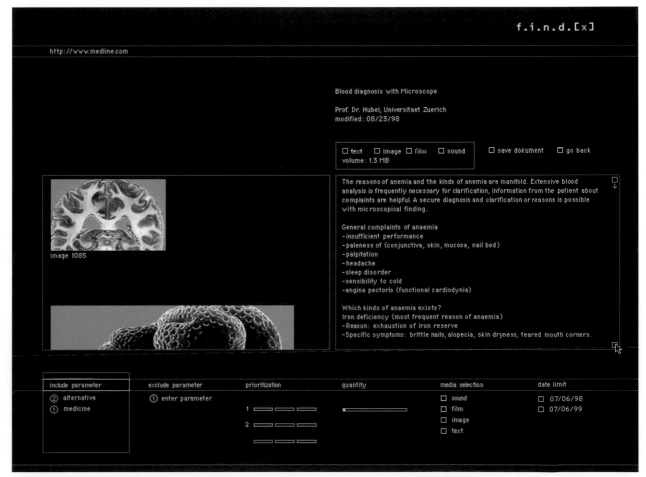

Design	The Attik
Project	Ford 24/7
Date	2001

The Ford 24/7 car was one of the highest profile concept cars of recent years. The car was designed by the internationally renowned designer Marc Newson, who conceived the idea of a multi-purpose vehicle that could change its form for different uses. The Attik was commissioned to create an information system that would also revolutionise the traditional car dashboard. The designers' solution was to strip back and remove every knob, button and switch and replace them with a clean curved panel that occupies the full width of the dashboard area. This touch-sensitive panel contains everything necessary for the car's on-board computer system. The information is viewed as a more filmic experience than a conventional touch screen interface, with morphing colours and information which changes according to the operator's requirements, in much the same as the car itself can be customised.

04 _ Time and space

u 7th J.. e
ndy Likes:
rses & Poetry
ndy Dislikes:

Sandy

I saw a man he wasn't there

Essay by William Owen
154/155

There is a class of maps that plot the things that are not there, that cannot be touched or won't be captured in a single instance. These are maps of information, ideas and organisations; of logical systems of thought, science, business or design; and of change – the mapping of events or actions unfolding over time.

The attraction of mapping intangibles (as opposed to using words or tables to represent them) is that the map can make the relationships of things to one another real and create an intuitive understanding of their dimensions and properties – whether these are concrete, abstract or metaphorical. The graphic language of maps lends itself to representation of the whole of a thing and its parts in a single view, within which we can oscillate rapidly between different levels of detail. Maps allow patterns to emerge and become real, by showing what lies between the visible incidents, artefacts or moments we can otherwise see.

(Information maps are not diagrams. Diagrams are graphic explanations: a map is a graphic representation, although it might explain by inference.)

The importance of mapping intangibles has increased in proportion to the speed of technological and social change. The dematerialisation of products and services and an onrush of excess of choice, facts and demands for our attention results in a disordered and unfamiliar world. In many areas of life the speed of change has created a problem of understanding at the most basic level of what things are, what their value is, who they are for and how to use them. What is lacking is any kind of consensual systemic image of novel objects, organisations or networks. Customers are having difficulty understanding services or product offerings; businesses are changing so rapidly they cannot retain a complete picture of themselves, their operations or of their customers; citizens lack the consistent philosophies or world views that form a foundation for understanding, or the information needed to come to a decision. All of us have difficulty understanding the rate and extent of change itself.

As an aside, it is interesting to note that the last period in which map-making became a popular medium for reorganising thought was in the 16th and 17th centuries. This was the highpoint of the Renaissance and the birth of the modern world, when scientists, alchemists and Rosicruceans attempted to resolve in maps and arcane tables the contradictions between the old world of faith and a new world of rational thought. Their cabalistic maps sought to explain an alternative relationship between man and the universe. Our information maps are more prosaic but are just as much an attempt to extract order from the noise of everyday life.

In commerce, it is difficult to move forward with confidence unless you know where you are today. The mapping of businesses as a precursor to strategic change has become a valuable activity in itself, practised by design companies, IT suppliers and management consultants. The map becomes 'a moment in the process of decision making', a means of possession and control over the enterprise, and a tool for persuasion – part of a business case.

The need to map business has arisen from the rapidly changing boundaries of commerce and the speed of thinking and action required to shift a business back into a competitive position. The rate of change has been driven by a combination of technical development that has automated (or augmented) human activities, and the breakdown of traditional boundaries of business organisations, with looser arrangements of networks of partnerships and short term contractual arrangements replacing strong vertical integration and permanent employee/employer relationships. This looks like a comparatively messy situation, so we map it to find the pattern.

Digital systems promise better business by placing a layer of technology over, or instead of, traditional business practices. Technology has spawned a blizzard of two- and three-letter acronyms – SCM (supply chain management), CM (channel management), KM (knowledge management), DSS (digital self service) CED (customer experience design) and CRM (customer relationship management) – each of which requires an understanding of the relationships, processes and dimensions that are affected. A sensible response is to map the existing and desired situation, and then to identify the gaps.

Businesses are not landscapes, but they do have their own geographies. These are comprised of a host of customer, supplier, regulator, partner and internal relationships; of processes with inputs and outputs, nodal points and directions of flow as well as a beginning and end; of numerous domains of competence of different sizes and characteristics, and diverse dimensions by which the nature and state of the business are monitored.

There is a class of maps that plot things that are not there – logical systems of thought, science, business or design; and change – the mapping of events or actions unfolding over time.

Nina Naegal
and A. Kanna
Time/Emotions
194/195

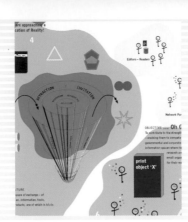
Damien Jaques
and Quim Gil
Ceci n'est pas un
magazine
192/193

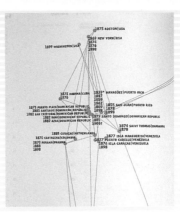
UNA (Amsterdam)
designers
2001 Diary
160/161

The signs and metasigns devised to map physical geography apply themselves well enough to logical systems. Network diagrams illustrate flow and dependencies, matrices show boundaries and absolute size, distribution maps show positions of entities relative to one other – such as competitive position referenced against selected axes or dimensions, and nested signs can represent hierarchies. Maps are particularly useful in revealing how complex activities such as customer interactions work. Businesses touch their customers in many different ways: different parts of a business may be involved in a particular relationship or transaction which may be mediated over multiple channels – shop, phone, SMS, letter, advertisement, etc. It may be critical to a business to understand what is known about a customer at each touchpoint, what value is being exchanged, who the customer is and how they can be characterised usefully and accurately, what is the cost to serve the customer and what is the customer's value over the lifetime of their relationship with the business. The problem is one to which mapping can be applied in order to understand complex patterns of communication and exchange – and to identify contradictory, unwelcome, inefficient or overpriced transactions of whatever kind.

The importance of taxonomy in mapping logical systems, such as this, or when mapping knowledge, cannot be overstated. It is essential to arrive at useful and coherent classifications of things before they can be ordered into their proper place. Inconsistent taxonomy produces a useless map. This is the point, then, at which cartography merges with librarianship and design strategy, and where we arrive at alternatives to standard tabular classifications of books and look instead at pictorial representations of families of information to enable the extraction, viewing and contextual understanding of any kind of symbolic record.

The Internet has created a new class of problem in mapping information. Digitally stored information resolves into a much finer grain than analogue information, reducing down from the book, magazine or journal to the chapter, the article, the image, even the phrase or word. Likewise it no longer has any physical host to provide any kind of 'natural' ordering. This has been highly beneficial, in so far as we can extract information much more quickly in a more convenient form, and we can make connections more quickly wherever a link has been inserted. What we lack, however, is a representation of the entire body of information or a means to rummage around it – with two important exceptions: the catalogue (e.g. Yahoo) and the search engine (e.g. Google). These are of course purely linguistic tools, strictly finite in their nature, smothering serendipity, and sometimes limited to the point of stupidity in understanding what it is we are really looking for.

The alternative to linguistic search is a graphical interface that may allow for less exact but ultimately more successful investigations. A highly successful example is Smartmoney's 'Map of the Market' (a chloropleth map of the market capitalisation of Fortune 500 companies that changes dynamically with the stock price). This is a graphical representation that gives a genuinely useful overview of states and trends combined with detailed information, interrogated by a graphic interface.

The Map of the Market succeeds because it layers information in two dimensions and uses a consistent taxonomy to divide the layers and a design strategy that reveals the dynamic quality of the activity it represents. Everything necessary to obtain an overview is visible simultaneously and in the correct proportion and state.

This essay, however, ends with an acknowledgement of failure. Most designers who have attempted to represent Internet-based information have produced maps that show nothing but network flows or nested texts. These maps have failed to replicate, in even the most rudimentary way, the sensory representation (and the massive boost to the memory and the imagination) one receives on entering a library and seeing, smelling and feeling the books on the shelf. One of the reasons for this failure has been an obsession with 3D perspective within the computer-oriented section of the design community. The idea that a perspectival simulation of the physical world will help us understand digital information is a fallacy, because perspective limits viewpoint and imposes distance where none exists. For proof, visit Cyberatlas.com, where there are numerous representations of the Internet in three dimensions that tell us nothing at all about what is there.

Design UNA (Amsterdam) designers / UNA (London) designers
Project Diary
Date 1998
Photography Anthony Oliver

To date the Dutch design consultancy UNA has produced twelve diaries, one for each year of the company's existence. Possibly as a reaction to the impending millennium hype, UNA produced a double year edition for 1999 and 2000, as a way of connecting the two centuries. An elaborate folding system was employed enabling the correct year to be visible. The diary has two covers, the first cover titled 'two thousand -1' and the second cover entitled nineteen ninety nine +1'. For 1999 the pages work quite conventionally, however at the turn of the century, the pages of the diary have to be turned back on themselves to reveal the new dates, and a fresh selection of photographs.

Design UNA (Amsterdam) designers
Project Diary
Date 2001

Dutch design consultancy UNA's 2002 diary sets out on a mission to find a significant event globally for each day of the year. The diary, as with previous UNA diaries represents a significant typographic achievement and, through its printing, exudes quality. As in previous examples, the designers have used folded sheets – French-folded in this case – to allow subtle images to appear. The dates, together with information about special events, occasions and festivals, are printed on the face of the sheet, while icons and images pertinent to the particular event are printed inside the French-fold. The pages are perforated along the French-fold edge, allowing the user to easily tear open the sleeve to better access the additional information.

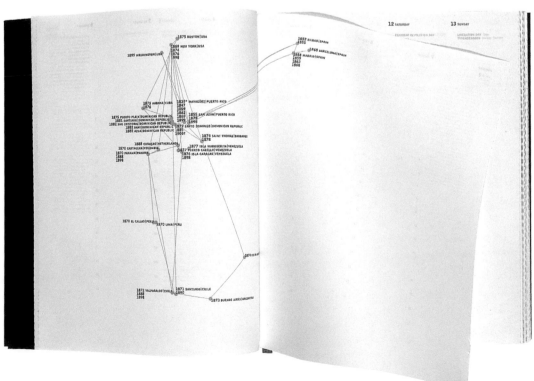

Design Tonne
Project Calendar52
Date 2002

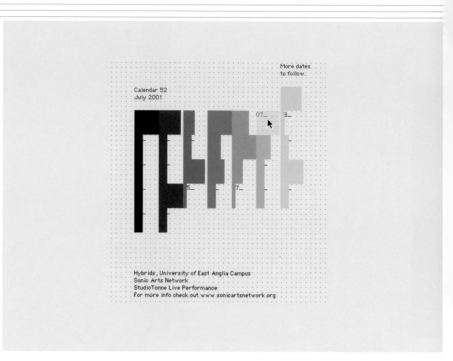

Calendar52 is an on-line visual exploration where the designers have challenged the conventions of visualising calendar dates with the use of experimental typographic systems. Each edition uniquely illustrates the corresponding calendar month, by referencing specific events you can jot down in your personal diary. Initially the project ran from June 2001 to May 2002; thereafter the 12 monthly editions will be archived and published in book format as a limited edition.

Although each monthly interface works differently from the last, the principle remains that by interacting with the site via the mouse, specific diary information is revealed as a date is hit. Interaction plays a large part in the workings of the site as Calendar52 is seen as a collective interactive environment where anyone can up-load diary information onto the site, thereby making the months dense with a variety of information about specific events and personal data.

Design Irwin Glusker
Project Phases of the Moon 2000
Date 1999

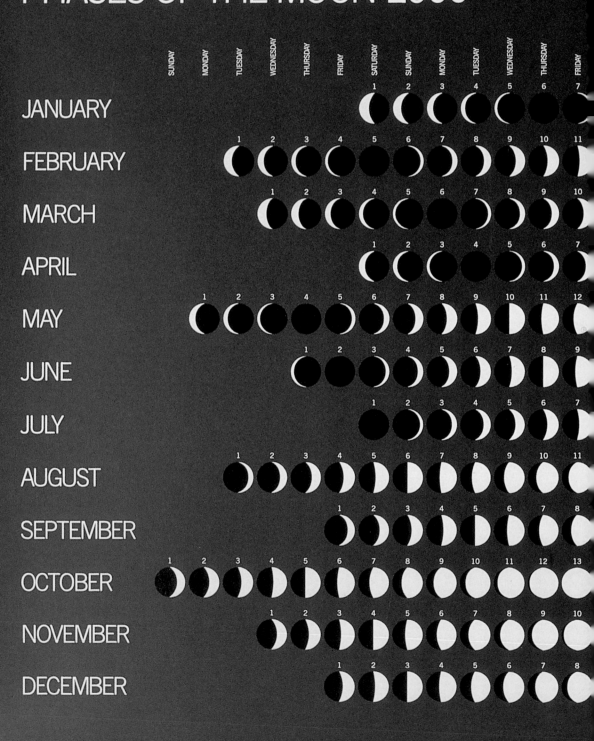

Although not the first or only example of a lunar-related calendar, this example from the Museum of Modern Art in New York is simple, beautiful, effective, and clearly works as a conventional calendar with each progressive crescent of the moon shown for each day of the month. The calendar is finely printed with each moon crafted with a full circle in a spot UV varnish and the crescent printed white out.

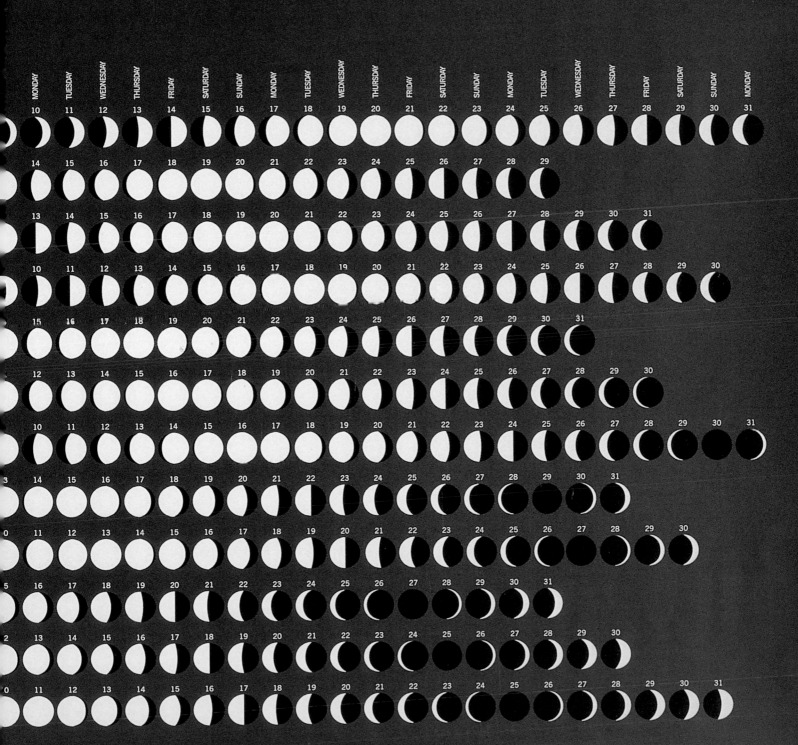

Design Büro für Gestaltung
Project Calendars 1998–2001
Date 1998–2001

1998

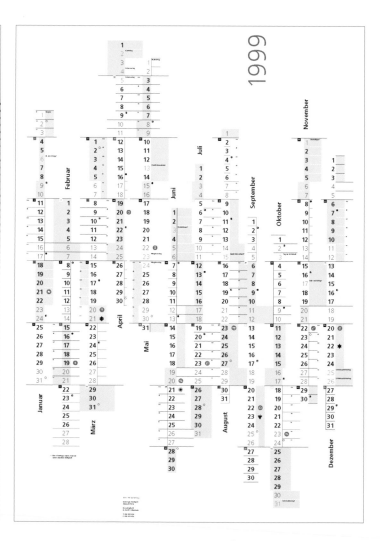

Produced as an ongoing self-initiated project to research
the structure that lies behind the 365 days, 52 weeks and
12 months of the year, the aim is to find a different solution
each year. The designers were less interested in the final
visual appearance of the poster, and were mainly
concerned with the process. Each poster measures 840 x
600mm and is reproduced in full colour. The calendars are
always typographic, working purely with the given
numerical data of the calendar.

Design Secondary Modern
Project 'Rokeby Venus'
Date 2001

Produced as a set of three A2 posters folded down to A4 and encolsed in a clear plastic sleeve, the designers of this piece are exploring a theme introduced by themselves in 1998, and continued each year since (the calendar shown is for 2001). The typography changes from year to year, as does the content. The 1998 calendar utilised colour photographs of skyscapers shot through the window of an aeroplane. Their 1999 version reduced the work to pure typography, set in a similar manner to the calendar shown. The 2000 calendar used a large, detailed line drawing of an urban landscape.

The 2001 calendar works as a triptych in the classic sense. Entitled 'Rokeby Venus', the nude study is a self-portrait by Jemima Stehli set-up as a transcription of the famous painting by Velazquez, c1647. The only difference is that the cupid in the original has been replaced with photographic studio equipment. The calendar data works as follows: every two months run down a single column on each long edge of the posters. A series of 13 vertical rules runs horizontally across half of each poster; within these rules is positioned the relevant month.

Design NB:Studio
Project Knoll calendar – Twenty-First Century Classics
Date 2001

April

01 Maya Lin
30° West chair

02 Maya Lin
30° West chair

03 Warren Platner
Lounge chair

04 Warren Platner
Lounge chair

05 Mies van der Rohe
MR armless chair

06 Mies van der Rohe
MR armless chair

07 Florence Knoll
Credenza

08 Florence Knoll
Credenza

09 Florence Knoll
Credenza

10 Jonathan Crinion
Arm chair

11 Jonathan Crinion
Arm chair

12 Eero Saarinen
Executive chair

13 Eero Saarinen
Executive chair

14 Florence Knoll
Oval table

15 Florence Knoll
Oval table

16 Florence Knoll
Oval table

17 Joseph & Linda Ricchio
Arm chair with wood seat

18 Joseph & Linda Ricchio
Arm chair with wood seat

19 Ettore Sottsass
Eastside arm chair

20 Ettore Sottsass
Eastside arm chair

21 Charles Pfister
Three-seat sofa

22 Charles Pfister
Three-seat sofa

23 Charles Pfister
Three-seat sofa

24 Vignelli Design
Handkerchief rattan arm chair

25 Vignelli Design
Handkerchief rattan arm chair

26 Harry Bertoia
High-back arm chair

27 Harry Bertoia
High-back arm chair

28 Ettore Sottsass
Eastside three-seat sofa

29 Ettore Sottsass
Eastside three-seat sofa

30 Ettore Sottsass
Eastside three-seat sofa

When the UK-based graphic design consultancy NB:
Studio was commissioned by the furniture company Knoll
International to produce a promotional calendar, the
designers' response was this elegant poster. The months
are set out in a conventional manner as are the dates within
each month. The names of days, however, are replaced
with the names of furniture designers and the names of
famous pieces of Knoll furniture. Above this information is a
keyline drawing of each classic piece of furniture. For
weekends, a single sofa extends over the two-day period.

Design	Proctor and Stevenson
Project	Calendar
Date	2000

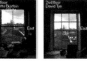
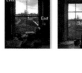

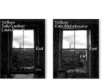

The Bristol, UK-based design company Proctor and Stevenson produced this A3 calendar for 2001. Each month, which was made up of two A3 pages, was given to a different designer within the company, which created a variety of responses within a single design piece.

April (shown here) was designed by Ben Tappenden. The first page maps out the design company's offices by showing the view out of every window in the building. Each image is credited with the name of the designer who sits by the window it represents. These photographs are positioned in rows according to the positions of the windows within the building – the top row is the third floor, the bottom row is the ground floor. A thin colour bar runs along one edge of each image to denote the orientation of the window – east is represented by a yellow strip on the right edge, south by an orange strip on the bottom edge, west by a green strip on the left edge.

The second page of April contains the dates for the month with an aerial satellite photograph of the area the company's building is located within, together with a series of detailed images showing fragments of the surrounding environment.

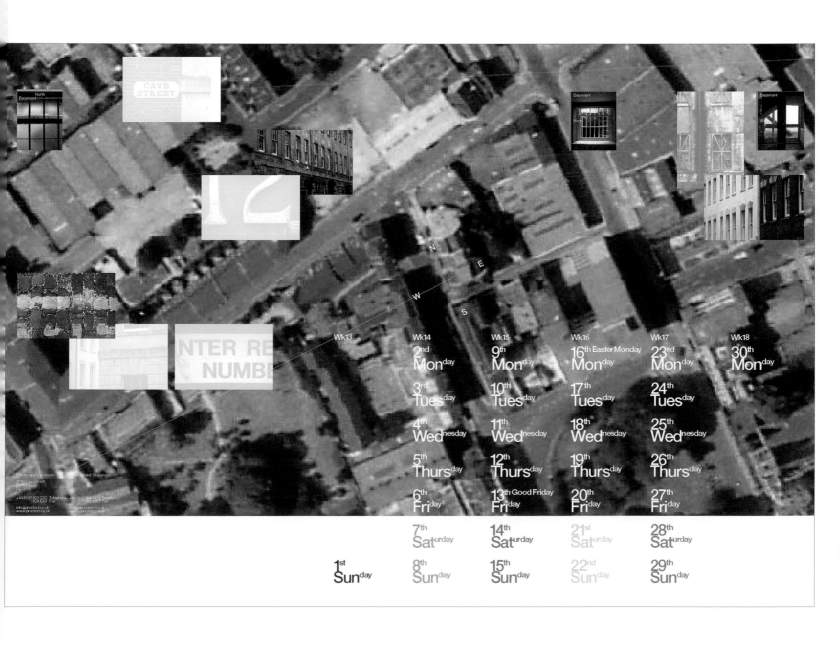

Design	Struktur Design	Design	Struktur Design
Project	1998 Kalendar	Project	Seven Days 1999
Date	1997	Date	1998

1998

	January	February	March	April	May	June	July	August	September	October	November	December
01	Thursday	Sunday	Sunday	Wednesday	Friday	Monday	Wednesday	Saturday	Tuesday	Thursday	Sunday	Tuesday
02	Friday	Monday	Monday	Thursday	Saturday	Tuesday	Thursday	Sunday	Wednesday	Friday	Monday	Wednesday
03	Saturday	Tuesday	Tuesday	Friday	Sunday	Wednesday	Friday	Monday	Thursday	Saturday	Tuesday	Thursday
04	Sunday	Wednesday	Wednesday	Saturday	Monday	Thursday	Saturday	Tuesday	Friday	Sunday	Wednesday	Friday
05	Monday	Thursday	Thursday	Sunday	Tuesday	Friday	Sunday	Wednesday	Saturday	Monday	Thursday	Saturday
06	Tuesday	Friday	Friday	Monday	Wednesday	Saturday	Monday	Thursday	Sunday	Tuesday	Friday	Sunday
07	Wednesday	Saturday	Saturday	Tuesday	Thursday	Sunday	Tuesday	Friday	Monday	Wednesday	Saturday	Monday
08	Thursday	Sunday	Sunday	Wednesday	Friday	Monday	Wednesday	Saturday	Tuesday	Thursday	Sunday	Tuesday
09	Friday	Monday	Monday	Thursday	Saturday	Tuesday	Thursday	Sunday	Wednesday	Friday	Monday	Wednesday
10	Saturday	Tuesday	Tuesday	Friday	Sunday	Wednesday	Friday	Monday	Thursday	Saturday	Tuesday	Thursday
11	Sunday	Wednesday	Wednesday	Saturday	Monday	Thursday	Saturday	Tuesday	Friday	Sunday	Wednesday	Friday
12	Monday	Thursday	Thursday	Sunday	Tuesday	Friday	Sunday	Wednesday	Saturday	Monday	Thursday	Saturday
13	Tuesday	Friday	Friday	Monday	Wednesday	Saturday	Monday	Thursday	Sunday	Tuesday	Friday	Sunday
14	Wednesday	Saturday	Saturday	Tuesday	Thursday	Sunday	Tuesday	Friday	Monday	Wednesday	Saturday	Monday
15	Thursday	Sunday	Sunday	Wednesday	Friday	Monday	Wednesday	Saturday	Tuesday	Thursday	Sunday	Tuesday
16	Friday	Monday	Monday	Thursday	Saturday	Tuesday	Thursday	Sunday	Wednesday	Friday	Monday	Wednesday
17	Saturday	Tuesday	Tuesday	Friday	Sunday	Wednesday	Friday	Monday	Thursday	Saturday	Tuesday	Thursday
18	Sunday	Wednesday	Wednesday	Saturday	Monday	Thursday	Saturday	Tuesday	Friday	Sunday	Wednesday	Friday
19	Monday	Thursday	Thursday	Sunday	Tuesday	Friday	Sunday	Wednesday	Saturday	Monday	Thursday	Saturday
20	Tuesday	Friday	Friday	Monday	Wednesday	Saturday	Monday	Thursday	Sunday	Tuesday	Friday	Sunday
21	Wednesday	Saturday	Saturday	Tuesday	Thursday	Sunday	Tuesday	Friday	Monday	Wednesday	Saturday	Monday
22	Thursday	Sunday	Sunday	Wednesday	Friday	Monday	Wednesday	Saturday	Tuesday	Thursday	Sunday	Tuesday
23	Friday	Monday	Monday	Thursday	Saturday	Tuesday	Thursday	Sunday	Wednesday	Friday	Monday	Wednesday
24	Saturday	Tuesday	Tuesday	Friday	Sunday	Wednesday	Friday	Monday	Thursday	Saturday	Tuesday	Thursday
25	Sunday	Wednesday	Wednesday	Saturday	Monday	Thursday	Saturday	Tuesday	Friday	Sunday	Wednesday	Friday
26	Monday	Thursday	Thursday	Sunday	Tuesday	Friday	Sunday	Wednesday	Saturday	Monday	Thursday	Saturday
27	Tuesday	Friday	Friday	Monday	Wednesday	Saturday	Monday	Thursday	Sunday	Tuesday	Friday	Sunday
28	Wednesday	Saturday	Saturday	Tuesday	Thursday	Sunday	Tuesday	Friday	Monday	Wednesday	Saturday	Monday
29	Thursday		Sunday	Wednesday	Friday	Monday	Wednesday	Saturday	Tuesday	Thursday	Sunday	Tuesday
30	Friday		Monday	Thursday	Saturday	Tuesday	Thursday	Sunday	Wednesday	Friday	Monday	Wednesday
31	Saturday		Tuesday		Sunday		Friday	Monday		Saturday		Thursday

Design, Typeset and Printed by Struktur Design. Studio 22, 1 Shireton Street, London EC1V 1NQ. T +44 (0)171 833 1606 F +44 (0)171 833 1606 E struktur@easynet.co.uk

Working with a given set of information – the days and dates of the year – Struktur tried to re-organise the data in an unconventional manner. For the 1998 calendar, an A2 poster showing the entire year was chosen as the platform. Working with the principle that there are a maximum of 31 days in any given month, the hierarchy of the calender shifted from the prominence usually given to the months to the days of the month, from one through to 31. The individual days of the year are listed in columns, with weekends printed white out of the background colour.

The 1999 calendar took the form of a desk diary, and in a development from the previous year, the information was re-structured grouping all the Mondays on one page, followed by all the Tuesdays, and so on, thus creating a daily calendar. At the back of the calendar is a page featuring public holidays, a vacation page, which contains all the days of the year, so the user can highlight personal holiday times, and finally a page called 'lunch', adding a time based element to the day.

The grid system present on each page is a graphic chart of each day of the year: the first column is January, the second column is February. On each page, the given day is represented with a white box, so on Monday, the chart shows white boxes for every Monday throughout the year. The colour palette uses the basic process colous – cyan, magenta, yellow and black – with each day using a combination of the two colours, working like a printer's tint book, starting with the first of January in 3 per cent of each colour, going through to the 31st of December printed in 100 per cent of each colour.

The white keyline grid that separates each of the boxes becomes increasingly thick as one journeys through the week until by Sunday, the white lines become thicker than the boxes, visually referring to the end of the week.

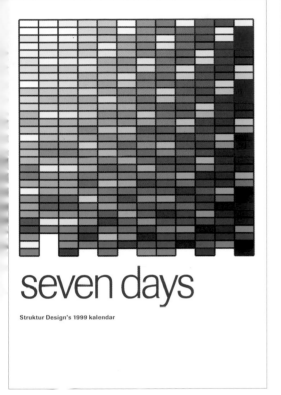

seven days

Struktur Design's 1999 kalendar

monday

jan	feb	mar	apr	may	jun	jul	aug	sep	oct	nov	dec
04	01	01	03	03	07	05	02	06	04	01	06
11	08	08	12	10	14	12	09	13	11	08	13
18	15	15	19	17	21	19	16	20	18	15	20
25	22	22	26	24	28	26	23	27	25	22	27
		29		31			30			29	

tuesday

jan	feb	mar	apr	may	jun	jul	aug	sep	oct	nov	dec
05	02	02	06	04	01	06	03	07	05	02	07
12	09	09	13	11	08	13	10	14	12	09	14
19	16	16	20	18	15	20	17	21	19	16	21
26	23	23	27	25	22	27	24	28	26	23	28
		30			29		31			30	

wednesday

jan	feb	mar	apr	may	jun	jul	aug	sep	oct	nov	dec
06	03	03	07	05	02	07	04	01	06	03	01
13	10	10	14	12	09	14	11	08	13	10	08
20	17	17	21	19	16	21	18	15	20	17	15
27	24	24	28	26	23	28	25	22	27	24	22
		31			30			29			29

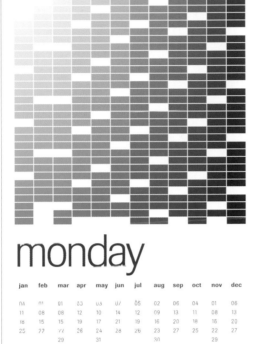

thursday

jan	feb	mar	apr	may	jun	jul	aug	sep	oct	nov	dec
07	04	04	01	06	03	01	05	02	07	04	02
14	11	11	08	13	10	08	12	09	14	11	09
21	18	18	15	20	17	15	19	16	21	18	16
28	25	25	22	27	24	22	26	23	28	25	23
		29			29			30			30

Design Struktur Design
Project Perpetual Kalendar
Date 1999

Design Struktur Design
Project Twentyfour Hour Clock
Date 2002

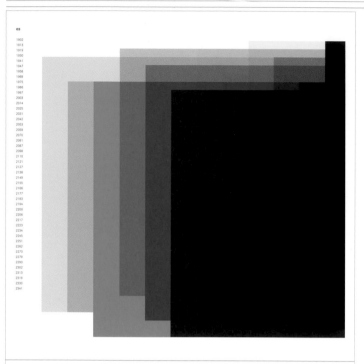

03
1902
1913
1919
1930
1941
1947
1958
1969
1975
1986
1997
2003
2014
2025
2031
2042
2053
2059
2070
2081
2087
2098
2110
2121
2127
2138
2149
2155
2166
2177
2183
2194
2200
2206
2217
2223
2234
2246
2251
2262
2273
2279
2290
2302
2313
2319
2330
2341

13
1916
1944
1972
2000
2028
2056
2084
2124
2152
2180
2220
2248
2276
2316

03	January	February	March	April	May	June	July	August	September	October	November	December
Monday									01			01
Tuesday				01			01		02			02
Wednesday	01			02			02		03	01		03
Thursday	02		01	03	01		03		04	02		04
Friday	03			04	02		04	01	05	03		05
Saturday	04	01	01	05	03		05	02	06	04	01	06
Sunday	05	02	02	06	04	01	06	03	07	05	02	07
Monday	06	03	03	07	05	02	07	04	08	06	03	08
Tuesday	07	04	04	08	06	03	08	05	09	07	04	09
Wednesday	08	05	05	09	07	04	09	06	10	08	05	10
Thursday	09	06	06	10	08	05	10	07	11	09	06	11
Friday	10	07	07	11	09	06	11	08	12	10	07	12
Saturday	11	08	08	12	10	07	12	09	13	11	08	13
Sunday	12	09	09	13	11	08	13	10	14	12	09	14
Monday	13	10	10	14	12	09	14	11	15	13	10	15
Tuesday	14	11	11	15	13	10	15	12	16	14	11	16
Wednesday	15	12	12	16	14	11	16	13	17	15	12	17
Thursday	16	13	13	17	15	12	17	14	18	16	13	18
Friday	17	14	14	18	16	13	18	15	19	17	14	19
Saturday	18	15	15	19	17	14	19	16	20	18	15	20
Sunday	19	16	16	20	18	15	20	17	21	19	16	21
Monday	20	17	17	21	19	16	21	18	22	20	17	22
Tuesday	21	18	18	22	20	17	22	19	23	21	18	23
Wednesday	22	19	19	23	21	18	23	20	24	22	19	24
Thursday	23	20	20	24	22	19	24	21	25	23	20	25
Friday	24	21	21	25	23	20	25	22	26	24	21	26
Saturday	25	22	22	26	24	21	26	23	27	25	22	27
Sunday	26	23	23	27	25	22	27	24	28	26	23	28
Monday	27	24	24	28	26	23	28	25	29	27	24	29
Tuesday	28	25	25	29	27	24	29	26	30	28	25	30
Wednesday	29	26	26	30	28	25	30	27		29	26	31
Thursday	30	27	27		29	26	31	28		30	27	
Friday	31	28	28		30	27		29		31	28	
Saturday			29		31	28		30			29	
Sunday			30			29		31			30	
Monday			31			30						
Tuesday												

13	January	February	March	April	May	June	July	August	September	October	November	December
Monday					01							
Tuesday		01			02			01				
Wednesday		02	01		03			02			01	
Thursday		03	02		04	01		03		02		
Friday		04	03		05	02		04	01		03	01
Saturday	01	05	04	01	06	03	01	05	02		04	02
Sunday	02	06	05	02	07	04	02	06	03	01	05	03
Monday	03	07	06	03	08	05	03	07	04	02	06	04
Tuesday	04	08	07	04	09	06	04	08	05	03	07	05
Wednesday	05	09	08	05	10	07	05	09	06	04	08	06
Thursday	06	10	09	06	11	08	06	10	07	05	09	07
Friday	07	11	10	07	12	09	07	11	08	06	10	08
Saturday	08	12	11	08	13	10	08	12	09	07	11	09
Sunday	09	13	12	09	14	11	09	13	10	08	12	10
Monday	10	14	13	10	15	12	10	14	11	09	13	11
Tuesday	11	15	14	11	16	13	11	15	12	10	14	12
Wednesday	12	16	15	12	17	14	12	16	13	11	15	13
Thursday	13	17	16	13	18	15	13	17	14	12	16	14
Friday	14	18	17	14	19	16	14	18	15	13	17	15
Saturday	15	19	18	15	20	17	15	19	16	14	18	16
Sunday	16	20	19	16	21	18	16	20	17	15	19	17
Monday	17	21	20	17	22	19	17	21	18	16	20	18
Tuesday	18	22	21	18	23	20	18	22	19	17	21	19
Wednesday	19	23	22	19	24	21	19	23	20	18	22	20
Thursday	20	24	23	20	25	22	20	24	21	19	23	21
Friday	21	25	24	21	26	23	21	25	22	20	24	22
Saturday	22	26	25	22	27	24	22	26	23	21	25	23
Sunday	23	27	26	23	28	25	23	27	24	22	26	24
Monday	24	28	27	24	29	26	24	28	25	23	27	25
Tuesday	25	29	28	25	30	27	25	29	26	24	28	26
Wednesday	26		29	26	31	28	26	30	27	25	29	27
Thursday	27		30	27		29	27	31	28	26	30	28
Friday	28		31	28		30	28		29	27		29
Saturday	29			29			29		30	28		30
Sunday	30			30			30			29		31
Monday	31						31			30		
Tuesday										31		

Produced at the end of the 20th century, the Perpetual Kalendar effectively completed Struktur's series of calendars, as this calendar can be used for every year from 1900 to 2343. The single publication contains 14 permutations of the calendar, which allows for every variation of the day/date sequence – 1st of January can fall on a Monday, Tuesday, Wednesday etc. (seven versions), and the day/date sequence alters every leap year, requiring a further seven variations.

Each spread from the calendar shows a full year, working as a clear typographic page and an illustrative page, based on the inherent grid system and flow of dates. A list of the relevant years appears down the side of each spread for ease of use.

Twentyfour Hour Clock was produced as a result of an open brief set by the London-based specialist printer Artomatic. The A2 silkscreen printed poster was designed as part of an ongoing research project looking at time systems, and works as a direct extension of the Struktur Design calendars and diaries (see pages 176/177/178). The poster sets out every second, minute and hour of a 24-hour period, with each time measuring unit reproduced in progressively larger point sizes.

Design	The Attik
Project	'NoiseFour' screen saver
Date	2001

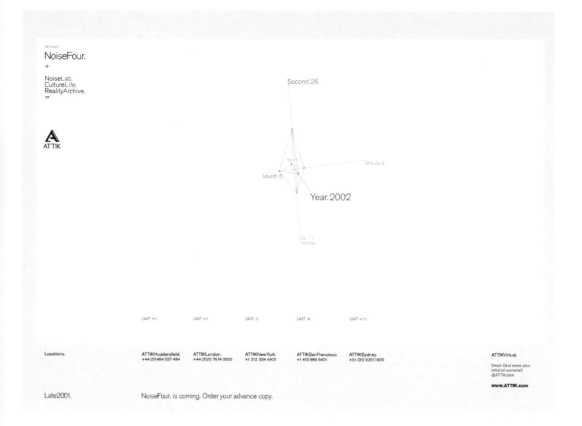

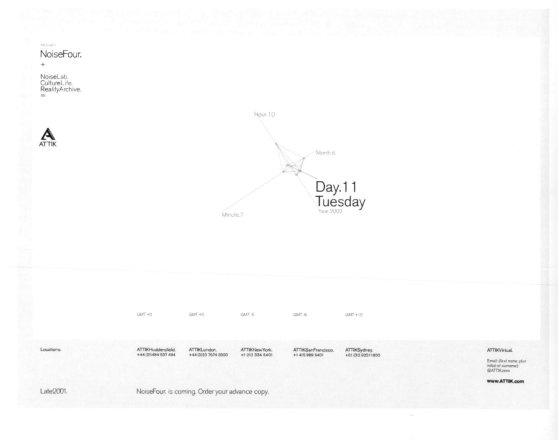

Sent out as an e-mail attachment to interested parties as a teaser for graphic design company The Attik's latest self-promotional book, 'NoiseFour', this screensaver once loaded onto a computer works as a three-dimensional clock showing seconds, minutes, hours, months, year and day of the week. The user can 'spin' the co-ordinates around by interacting with the clock using the mouse, causing the different time units to come to the fore. The appearance of the clock can also be manipulated further by dragging the time units forward which increases the size of the type on screen. This allows the user to have great control over which units of time they wish to see most prominently displayed.

Design Spin
Project 'Twenty-four Hours'
Date 2002

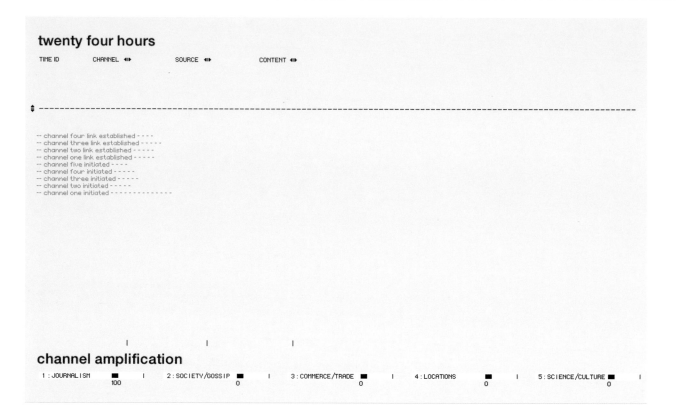

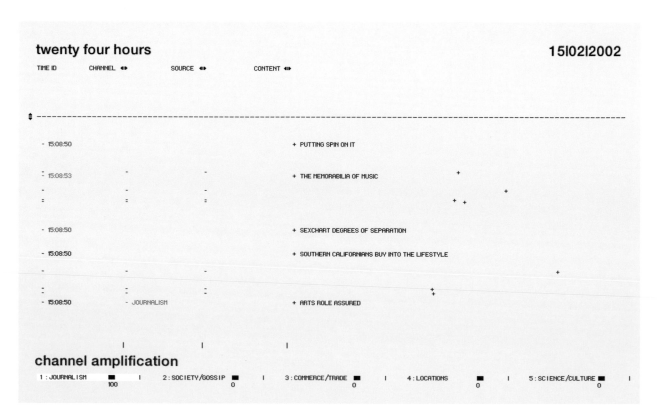

'Twenty-four hours' is a self-initiated on-line project by Spin, a London based multi-disciplinary design company. The interface scans news information from various international sources and up-loads the data onto the web site. The data, which first appears as a timecode, title and source, can be 'amplified' to show the full news story. Different filters can be used to channel the source material to personalise the information. The project has been built as a small homage to the millions of bits that make up the avalanche of information available on the web 24 hours a day.

twenty four hours

TIME ID	CHANNEL	SOURCE	CONTENT
- 15:08:50	- JOURNALISM	- CNN	+ PERFORMER ROLLS OFF OPERA STAGE STOPS SHOW
- 15:08:50	- LOCATIONS	- GWYNFRYN C	+ THIRSTY WORK
- 15:09:09	- JOURNALISM	- NEW YORK TIMES	+ GRABBING TV AUDIENCES TWEEN 8 AND 14
15:08:50	- COMMERCE/TRADE	- MARK HENDE	+ BUZZ ALDRIN TO LAUNCH MARTIAN CRUISE SERVICE
- 15:08:18	- SOCIETY/GOSSIP	- FBI	+ THE NUMBER OF HOMICIDES OF CHILDREN UNDER AGE 5 INCREASED OV

+ THIRSTY WORK

it started out as a simple girl-meets-boy story, but it soon whirled dizzyingly out of control. A girl met a boy, and then she met another boy, and then several other boys, all of whom met boys and girls of their own, who in turn met their own girls and boys. And four years after the first girl met the first boy, some 1,400 boys and girls had met and...

| - 15:09:18 | - SOCIETY/GOSSIP | - ANONYMOUS | + SOUTHERN CALIFORNIANS BUY INTO THE LIFESTYLE |

How do 1,400 hackers and crackers and Internet-lovers document their hook-ups? They + SIX DEGREES OF SEPARATION that shows how each person is connected to the other through bedroom dalliances, a chart that has now grown titanic in scale.

- 15:09:04	- SOCIETY/GOSSIP	- FMANJOO@WI	+ BLIND BLOW
- 15:08:50	- LOCATIONS	- JAMES MERW	+ TURNING MACS ON THIEVERY
- 15:08:50	- COMMERCE/TRADE	- R.D. BRIDG	

Picture a kiddie connect-the-dot puzzle on which some sardonic 5-year-old has connected every dot to every other dot, and you might have an idea of what the Sexchart looks like. At 46 KB, filled with ASCII dots and dashes that are almost impossible to track, the Sexchart is a little underground Internet project that tells you two things + JESUS 'REALLY DREADING' THIS NEXT BIRTHDAY as you might have guessed, and they're more obsessive than you'd ever imagined.

| - 15:09:34 | | | |

ish Daelnar, a 23-year-old woman who has maintained the Sexchart for most of its life, was the girl from whom the initial girl-meets-boy piece of the Sexchart spun. Daelnar lives in Santa Cruz, California, and though she is not herself a geek, she seems to know their kind well enough.

| - 15:09:24 | - COMMERCE/TRADE | - MOROJXHAB5 | + DARK HORSE IN DESERT RACE |

"I had dated a lot of guys in the 'Internet scene,'" Daelnar said. "And the chart was started specifically to make fun of me -- to show how many guys I dated." This was in 1997, when being in the so-called "Internet scene" actually meant something. It meant you knew about the Web, maybe had your own "home page," you looked askance at people on AOL, spent time chatting on IRC ... and various other stereotypes.

[+] [-]

channel amplification

1 : JOURNALISM ■	2 : SOCIETY/GOSSIP ■	3 : COMMERCE/TRADE ■	4 : LOCATIONS ■	5 : SCIENCE/CULTURE ■
100	0	0	0	0

twenty four hours

TIME ID	CHANNEL	SOURCE	CONTENT
- 15:09:43	- COMMERCE/TRADE	- ANONYMOUS	+ INVISIBILITY ACHIEVED
- 15:09:34	- SCIENCE/CULTURE	- RONALD BUC	+ MILLIONS OF BUTTERFLIES KILLED BY FREAK STORM
11:43:12 AM	- CATEGORY 4	- INSURANCE NEWS NET UK	+ S&P CUTS TRYG-BALTICA SUBSIDIARY RATINGS TO BBB+; ON WATCH DEV...
- 15:09:28	- LOCATIONS	- BEER BUOYS	+ BEER BUOYS
- 15:10:07	- LOCATIONS	- MELISSA@SPIN.CO.UK	+ AWKWARD MOMENTS

+ S&P CUTS TRYG-BALTICA SUBSIDIARY RATINGS TO BBB+; ON WATCH DEV...

A grazier has found Australia's largest dinosaur fossil while mustering his sheep near Winton, in Queensland's "fossil triangle".

| - 15:09:45 | - LOCATIONS | - LATESTNEW | + ONLY CANCERIANS WILL DO |

Palaeontologists from the Queensland Museum have just returned from the site. They say that the dinosaur they call "Elliot" is a sauropod, but could be a new type, unique to Australia's Largest Dinosaur Fossil Unearthed.

So far, the museum's Steve Salisbury and his colleagues have found parts of the third neck, ribs and backbone of the dinosaur, but they say there are more fossils to be found.

| - 15:09:56 | - JOURNALISM | - NEW YORK TIMES | + WHEN A SINK COULD BE ART FIT FOR A KING |

Salisbury says: "There are indications that Elliot is similar to previous finds, but we've already noticed a few differences". Size is the most obvious.
Even a fragment of the femur is a heavy load. Photo: Steve Salisbury, thanks to Australian Geographic

Without the tail and neck bones, Salisbury cannot say exactly how big the beast was, but there are enough clues to say it stood about four metres high and was 16 to 21 metres in length.

Salisbury adds that the fossils vertebrae appear similar to existing sauropod finds in Australia and worldwide. "But portions of the femur have a slightly different shape," he

| - 15:10:18 | - SCIENCE/CULTURE | - MASON | + UMBRELLA CONSPIRACY dealing with an endemic group of sauropods, rather than what's found elsewhere in the world." |
| - 15:10:02 | - COMMERCE/TRADE | | + KILLER COMPUTER |

[+] [-]

channel amplification

1 : JOURNALISM ■	2 : SOCIETY/GOSSIP ■	3 : COMMERCE/TRADE	4 : LOCATIONS	5 : SCIENCE/CULTURE ■
36	36	4	0	25

Design	Foundation 33
Project	Numerical Time Based Sound Composition
Composer	Daniel Eatock
Musician	Timothy Evans
Date	2001

This is a personal project by Foundation 33, exploring the point at which an audio experiment/composition becomes visual, or the point at which a visual composition becomes audible. The project moves into the realms of the concrete, where the visual is inseparable from the audio, one is not complete without the other. The piece is sent as an A3 sheet of paper with the tonal bands printed on it, together with the audio CD mounted on a sheet of pulp board.

The explanatory text reads as follows:
'A digital time display counts to one hour using four units: seconds, tens of seconds, minutes, tens of minutes. A numerical sound composition has been constructed using the ten sequential digits: 0, 1, 2, 3, 4, 5, 6, 7, 8, 9. Each digit has been assigned a tone. The tones are mathematically selected from a range of 20Hz to 20,000Hz – the two extremes audible to the human ear. The tones are logarithmically divided between the ten digits providing tonal increments that produce a musical scale. Every second a different combination of four tones is defined by the time counter.'

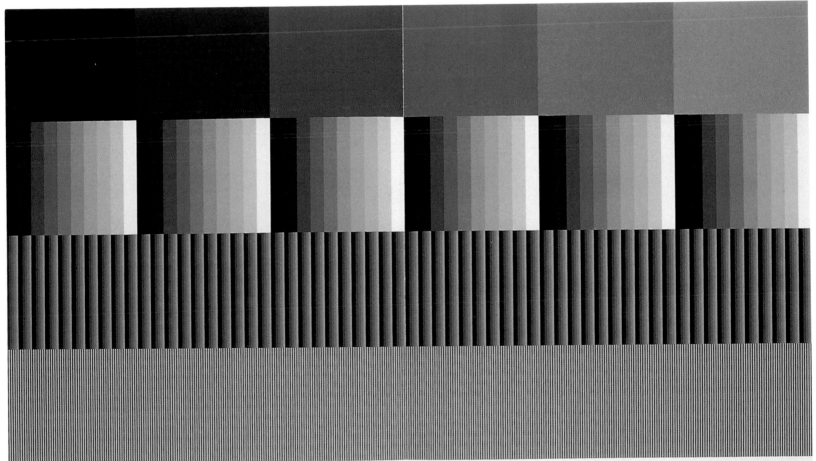

Numerical Time Based Sound Composition

Composer: Daniel Eatock / Musician: Timothy Evans

A digital time display counts to one hour using four units: seconds; tens of seconds; minutes; tens of minutes.

A numerical sound composition has been constructed using the ten sequential digits: 0, 1, 2, 3, 4, 5, 6, 7, 8, 9.

Each digit has been assigned a tone. The tones are mathematically selected from the range of 20Hz to 20,000Hz; the two extremes audible to the human ear.

The tones are logarithmically divided between the ten digits providing tonal increments that produce a musical scale.

Every second a different combination of four tones is defined by the time counter.

Above is a diagram that represents the hour long composition.

Foundation 33
33 Temple Street
London
E2 6QQ

020 7739 9903
info@foundation33.com

Design Cartlidge Levene
Project Canal Building brochure
Date 1999

Accept no minimal existence

A clever brochure designed to promote a development of apartments in Islington, London, includes photographs of the raw, unmodernised interior shell of the building, as the brochure was produced prior to the start of the redevelopment. A large section of the lavish brochure is dedicated to a map of the surrounding area, but unusually, the map is purely photographic, and no diagrams of streets and roads are included. The map is based on the walking times to various local amenities, but these routes are illustrated with more abstract images of tree bark, water and concrete. This mapping method is useful to people not familiar with the area, as it shows with a flick of the pages the texture of area the development is set within.

Towards the back of the brochure are two further maps, one a conventional line drawing of the area, and the other an aerial photograph showing a larger area of London. This image is overlaid with a grid system on a scale which equates to a three-minute walk for each square on the grid. A series of numbers is also printed on the image which relates to the page number of the photographic mapping system, allowing the two views to be cross-referenced.

Design Sagmeister Inc.
Project 'Made You Look' timeline
Date 2001

'Made You Look' is a collection of the work of New York-based graphic designer Stefan Sagmeister. At the beginning of the book is a timeline, which extends over the course of eight pages. The timeline is just that, a line that weaves its way back and forth across and up and down the page in a clean and pure fashion. At the top of the first page a small circle is annotated with the words 'Big Bang'. Nothing further happens until the sixth page, where another annotated circle is flagged 'Earth sees light of day'. The final two pages see a quickening of pace, towards the bottom of the pages 'Green blue algae appear, Jellyfish evolve, Plants appear, Amphibians come alive, Marine reptiles appear, Dinosaurs start to flourish, Birds emerge, and so on, until just before the end of the line, 'Neanderthals appear' and finally 'The entire history of graphic design'.

A footnote reads as follows: 'The little circle representing the entire history of graphic design is of course shown much too large here: In real life and scale it is about 1/100 000 of an inch, which is a very, very small circle. Now, my whole working life: Too bitsy to think about. That Aerosmith job that went on forever? Oh boy.'

Design Mark Diaper
Artist Tony Oursler
Project 'The Influence Machine'
Date 2002

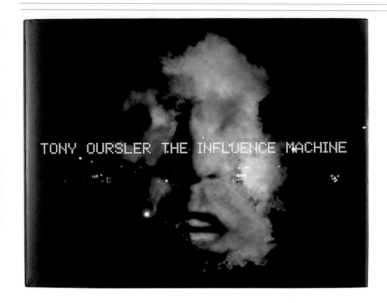

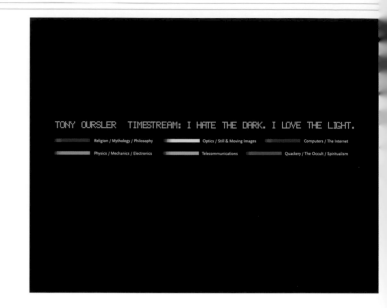

Timestream: I hate the dark. I love the light.' is a timeline developed by the artist Tony Oursler and designed by Mark Diaper for the Artangel/Public Art Fund book 'The Influence Machine'. The timeline, which extends over 26 pages of the book, is intended to chart the history of religion/mythology/philosophy, optics/still and moving images, computers/the Internet, physics/mechanics/electronics, telecommunications, quackery/the occult/spiritualism. A specific colour is attributed to each of these broad categories and is plotted horizontally over the pages starting in the 5th–2nd centuries BC with the Egyptian god Seth and ending with the Endoscope pill camera in 2000 AD.

The colour bars for each strand of information fade in and out and swerve up and down to make space for the various entries. Interestingly the red bar used to represent religion/mythology/philosophy fades out around 1705 AD as the orange of physics/mechanics/electronics becomes prominent.

Design Damien Jaques
Illustration Quim Gil
Project Mute – Ceci n'est pas un magazine
Date 2001

Ceci n'est pas
(We've crossed oceans of time to find you...)
un magazine

Comments? Ideas? Flames? *Metamute*'s new forum [http://www.metamute.com/forum] awaits you. Or contact us at the editorial address.

Mute's evolution in perspective

Over the last six months, *Mute* magazine has been in a suspended state of publication. During this time, we've been contemplating the implications of our magazine's content – the digital 'revolution' and its discontents – for its form and self-sustainability.

When *Mute* published its pilot issue, in 1994, the Net was anything but ubiquitous. *Mute*'s original '*Financial Times*' newspaper format was a deliberate attempt to debunk the information revolution's much vaunted inclusivity – hence our decision to make a printed object and our motto 'Proud to be Flesh'. Six and a half years later, we face a very different picture: the many-to-many publishing environment is now far more than a theory spouted by inspired techno-lotus eaters and our publishing gesture is dwarfed by the reality of today's Net.

So, our gawky teen phase of self-contemplation has resulted in a few structural and 'philosophical' adjustments. You might have seen the first signs of this in our fledgling e-letter *Mutella* and our recently relaunched *Metamute* website. Well, the long shadow of cyberspace has now fallen across our paper-bound and 'top-down' notion of content generation too. Like us, you'll have come across words such as 'prosumers' and 'user-generated content'. Such New Economy buzz-speak for the consuming producer (or producing consumer) often functions as an alibi for no editorial at all or, worse, a vampiric relationship to a community. Nonetheless, in sticking so monogamously to a traditional editorial model we have ignored the non-vampiric alternative.

If you think this is all a very long-winded way of saying we want to be in better dialogue with our readers, you're both right and wrong. Right because we do, wrong because that's only the start of it. Part of our objective is to continue producing *Mute* as a printed magazine; the other part is to develop discussion forums, tools/files/software exchange spaces, research areas and special publishing projects. This way, *Mute* can hopefully become a more accurate vehicle for exchanges that go on between us and you. You could say the editorial centre of gravity is shifting – from offline to on, and then imagine all that that implies.

1

THE DAWN OF TIME, *1994-1995*
Mute started as a printed newspaper with a simple online version, *Metamute* v. 0

2

WHEN DINOSAURS STALKED THE EARTH, *1996-2000*
A printed magazine with an online archive and *Metamute* v.1.0 (aka '*meta*' soon to be archived on *Metamute*)

3

THE PRESENT, *2001*
A printed magazine, the *Mutella* e-letter, *Metamute* v. 1.1, archive, events

 = *Mute* △ = talks/events ✳ = research

 = *Mutella* ⬠ = shop = online/offline services

 = *Metamute* archive ●● = code

Mute, a British magazine, wanted to show a state of play timeline with the intention of setting out future goals, directions and ambitions with as yet undeveloped technologies. The result is a very unusual and organic timeline, which resembles a map rather more than a line. The information is clustered into six modules; 1: The dawn of time 1994–1995, 2: When dinosaurs stalked the earth,1996–2000, 3: The present, 2001, 4: The near future. 5: The slightly more remote future, 6: Objective...oh God, why am I here?

A series of icons is used to illustrate the stages of development and expansion, while a satellite module represents the relationships between readers, editors, promoters, users and network participants.

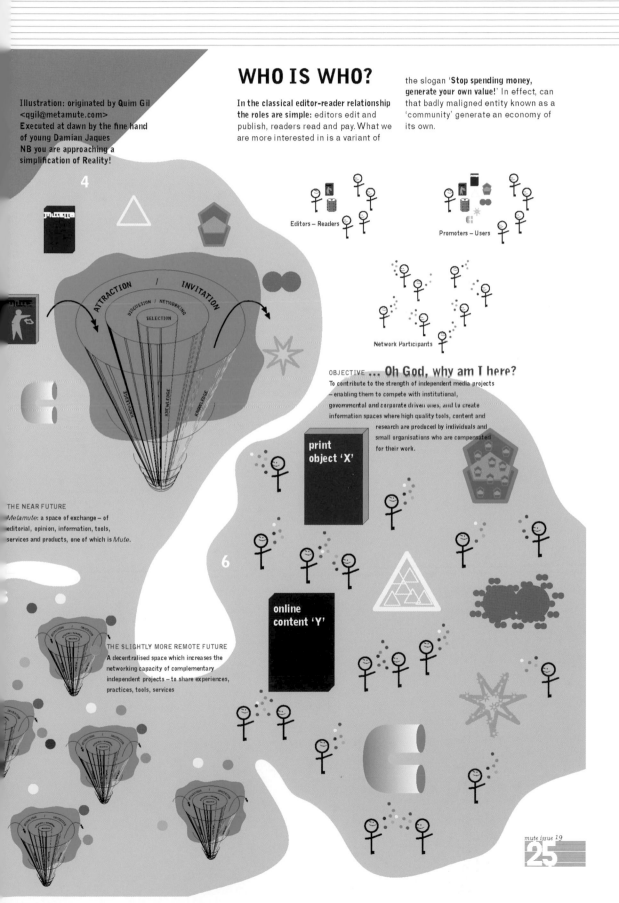

WHO IS WHO?

In the classical editor–reader relationship the roles are simple: editors edit and publish, readers read and pay. What we are more interested in is a variant of the slogan '**Stop spending money, generate your own value!**' In effect, can that badly maligned entity known as a 'community' generate an economy of its own.

Illustration: originated by Quim Gil <qgil@metamute.com>
Executed at dawn by the fine hand of young Damian Jaques
NB you are approaching a simplification of Reality!

4

ATTRACTION / INVITATION
DISCUSSION / NETWORKING
SELECTION
KNOWLEDGE KNOWLEDGE KNOWLEDGE

THE NEAR FUTURE
Metamute: a space of exchange – of editorial, opinion, information, tools, services and products, one of which is *Mute*.

Editors – Readers

Promoters – Users

Network Participants

OBJECTIVE **... Oh God, why am I here?**
To contribute to the strength of independent media projects – enabling them to compete with institutional, governmental and corporate driven ones, and to create information spaces where high quality tools, content and research are produced by individuals and small organisations who are compensated for their work.

print object 'X'

online content 'Y'

6

THE SLIGHTLY MORE REMOTE FUTURE
A decentralised space which increases the networking capacity of complementary independent projects – to share experiences, practices, tools, services

Design Nina Naegal and A. Kanna
Project Time/Emotions
Date 2000

24 HOURS – TIME/EMOTIONS (in collaboration with A. Kanna)
'Time /Emotions' is a new system to read the time. It's visualised by two combined patterns. The first pattern
symbolises the actual time and there fore it's created by a rule which uses the figures of that time as a guide.
The second pattern which shows the emotions is made out of many different shapes which were put down
by a rule, determining the shape, size, colour, rotation of the shape and placement of the shapes on the grid.
As the grid to put down the second pattern we used the first pattern as the emotions hinge on that moment
of time. The final pattern visualises the new system 'Time/Emotions'.

24 HOURS (24 books in slip case)
The system 'Time/Emotions' runs through 24 hours. Every hour has been analysed according
to our emotions and has then been put through the two rules to visualise the system of reading the time.
shown above> spreads of magazine accompanying exhibition

'Time/Emotions' was developed by Nina Naegal and A. Kanna as a new method for reading time. The image is generated by the overlaying of two different patterns; the first is a grid system formed by a time sequence, this gives a uniform base grid. The emotional pattern is then placed over the time grid. The emotional patterns are made out of many different shapes which are placed by a rule, determining the contours, size, colour and rotation of the shape as well as the position of the shapes on the time grid. Shown here are pages from a 24-part book which shows the various stages of emotion. Also shown is an A1 poster related to the project.

Artist Jem Finer
Project Long Player
Date 2000

Commissioned by Artangel, Longplayer was developed by Jem Finer and managed by Candida Blaker with a think-tank comprising artist and musician Brian Eno, British Council Director of Music John Kieffer, landscape architect Georgina Livingston, Artangel co-director Michael Morris, digital sound artist Joel Ryan, architect and writer Paul Shepheard and writer and composer David Toop. Longplayer was conceived as a 1000-year musical composition, which began playing on 1st of January 2000 and will play continuously and without repetition until 31st of December 2999.

Longplayer can be heard at listening posts in the United Kingdom, with plans to establish other listening posts at diverse sites around the world. The first site was established in a disused lighthouse at Trinity Buoy Wharf in London Docklands. Longplayer is also planned to stream in real time on the Internet.

The music is generated by a computer playing six loops taken from a pre-recorded 20-minute, 20-second composition, each of which is of a different pitch and advances at a different speed. The constant shifting of these layers creates ever-changing textures and harmonies. The instrumentation in the source music is primarily Tibetan singing bowls of various sizes.

Technology is embraced as a means to share an experience not only of music but also of a dream of time. There is no wish to send an ideological monument out into the future landscape, only the ambition to engender connections through time and space. Though it starts its life as a computer program, Longplayer works in such a way that its production is not restricted to just one form of technology. The resilience of Longplayer will be evidenced by its ability to adapt rather than to endure in its original form.

Design Imagination
Project The Talk Zone
Date 1999

Composed of two structures that literally and metaphorically talked to one another, The Talk Zone was the pavilion in the UK's Millennium Dome housing an exhibition that dealt with issues of communication. This timeline was produced as part of the overall design treatment for the Talk Zone, starting from either end of the structure and meeting at the entrance to the pavilion, between the two buildings. The large-scale timeline, which kept visitors entertained while they queued for entry, held both significant objects and information on the biological, social and technical histories of communication over the last 5000 years. Supplementing the visual information, soundbites spoken by the voices of the talk structures, punctuated the queue line at regular intervals, delivering facts about the way we communicate.

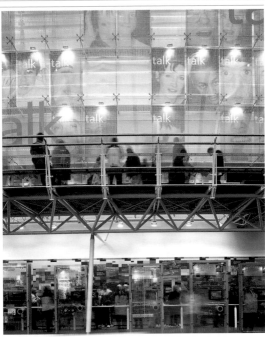

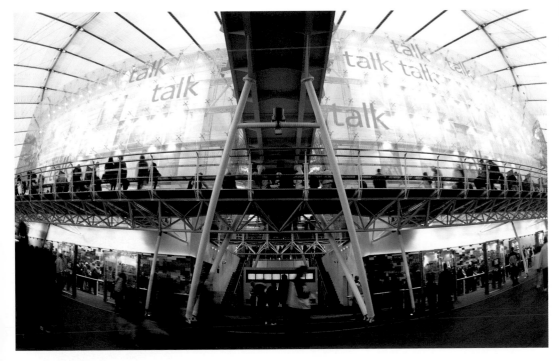

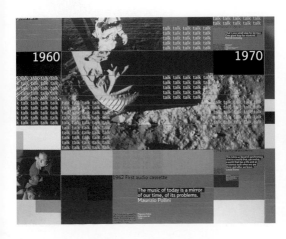

Design Studio Myerscough
Project Forest of Infinity
Date 1999

To celebrate the 25th anniversary of the specialist furniture supplier Coexistence, graphic design consultancy Studio Myerscough designed both a commemorative book and an exhibition held at the RIBA architecture gallery in London called 'Forest of Infinity'.

The exhibition was set out as a three-dimensional timeline showing classic pieces of furniture design which have been produced over the last 25 years. Each item was positioned under a white lozenge-shaped lampshade with the year printed on which was suspended from the ceiling, on the back of each lamp shade 2000 was printed back to front. There were mirrors at either end of the space so that the time line continued indefinitely. The '2000' on the back of the shades then reflected the correct way round, as all the products shown were still in production. The captions explaining each exhibit were printed next to the item on the floor.

1987 **Ghost**
Designed by Cini Boeri
and Tomu Katayanagi
Manufactured by Fiam Italia, Italy

Design MetaUnion
Project Deutschbritischamerikanische Freundschaft
Date 1995

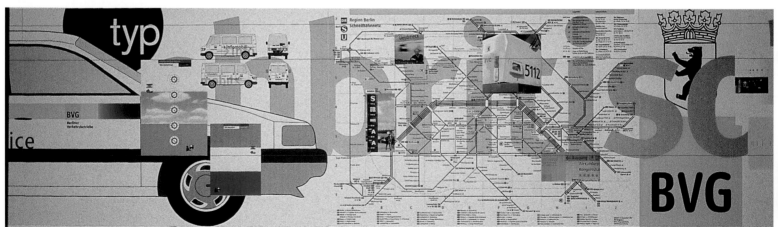

To celebrate the formation of MetaUnion in 1994, the London-based graphic design studio created a timeline/mural showing elements of work from Union Design, MetaWest and MetaBerlin – the three companies which in various ways had input into the new company (by becoming MetaUnion, the former Union Design was joining the international Meta group of design companies). The panels were one metre high and ran the full length of the studio, focussing on key works by the three companies in a loose chronological order.

The title of the piece, 'Deutschbritischamerikanische Freundschaft' (German, British, American friendship) runs down the full length of the mural set to an x-height of 600mm.

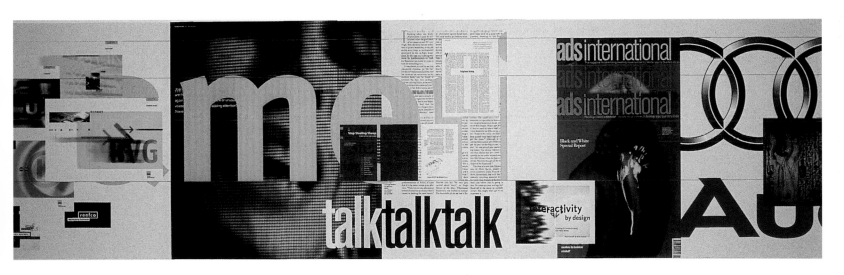

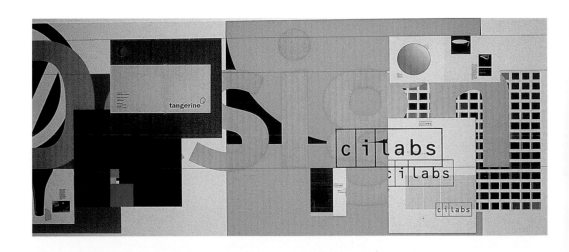

Design	Studio Myerscough
Project	Web Wizards
Date	2002

60 70 80 90 00

1963 1964 1968 1969 1971 1972 1973 1974 1975 1976 1977 1978 1979 1980 1981 1982 1983 1984 1985 1986 1987 1988 1989 1990 1991 1992 1993 1994 1995 1996 1997 1998 1999 2000 2001 2002

Technological developments

Hardware

Software

Arcade games

Home consoles

Digital Art and Design

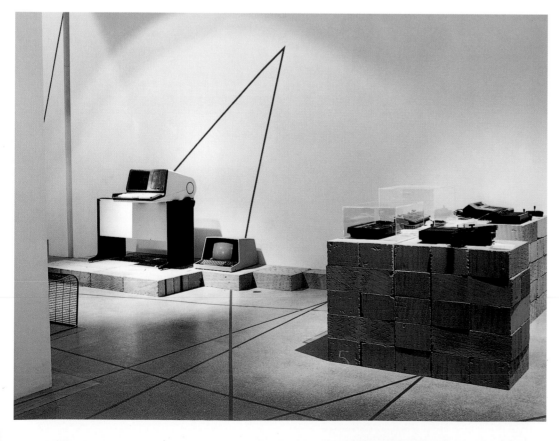

'Webwizards' was an exhibition held at the Design Museum in London, presenting some of the most innovative contemporary on-line art and design work. The exhibition, designed by Studio Myerscough, included a large scale timeline charting the history of computers and the Internet from the 1960s to the present day, which was printed along an entire wall.

Exhibits were connected with each other via lines printed across floors and walls, which made the entire event interrelated, with objects treated like coordinates within a virtual computer world.

Acknowledgments

I would like to extend my deep thanks to all those who have helped in creating this book, whether by kindly submitting work or for help and advice.

A special thank you should be extended to William Owen for his insight; Sanne, Tristan, Minnie and Monty for their constant support and understanding; Chris Foges, Laura Owen and all at RotoVision for their faith and patience.

rf-t

Roger Fawcett-Tang is creative director of Struktur Design which has developed a reputation for clean understated typography, attention to detail and logical organisation of information and imagery. It has won various design awards, and has been featured in numerous design books and international magazines. Roger compiled and edited Experimental Formats (RotoVision 2001). He is a contributing editor to Graphics International.

William Owen is a writer and a consultant in digital services and brand development for international corporations and institutions. He is the author of Magazine Design (Laurence King/Rizzoli 1990), Unsteady States (in Digital Prints, ed. Adam Lowe, Permaprint 1997) and of numerous articles and essays on design, culture and business for the European and American design press. He is a consulting editor to the international review of graphic design Eye and a visiting tutor at the Royal College of Art.